DESIGNS ON MODERNITY

MANCHESTER
UNIVERSITY PRESS

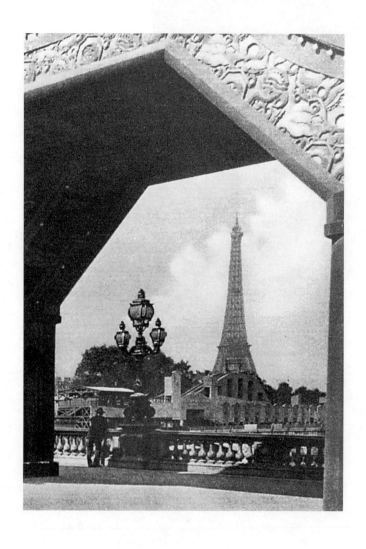

FRONTISPIECE 'Rue des Boutiques (pont Alexandre III)', detail of
photograph from *Encyclopédie des arts décoratifs et industriels
modernes au XXème siècle*, vol. 11, plate III

Designs on modernity

EXHIBITING THE CITY IN 1920s PARIS

Tag Gronberg

Manchester University Press

MANCHESTER AND NEW YORK

distributed exclusively in the USA by Palgrave

Copyright © Tag Gronberg 1998

The right of Tag Gronberg to be identified as the author of this work has been asserted by her in accordance with the Copyright, Designs and Patents Act 1988.

Published by Manchester University Press
Oxford Road, Manchester M13 9NR, UK
and Room 400, 175 Fifth Avenue, New York, NY 10010, USA A
www.manchesteruniversitypress.co.uk

Distributed exclusively in the USA by
Palgrave, 175 Fifth Avenue, New York,
NY 10010, USA

Distributed exclusively in Canada by
UBC Press, University of British Columbia, 2029 West Mall,
Vancouver, BC, Canada V6T 1Z2

British Library Cataloguing-in-Publication Data
A catalogue record for this book is available from the British Library

Library of Congress Cataloging-in-Publication Data applied for

ISBN 0 7190 5007 3 *hardback*
ISBN 0 7190 6674 3 *paperback*

First published 1998
First published in paperback 2003

10 09 08 07 06 05 04 03 10 9 8 7 6 5 4 3 2 1

Typeset in 11/13pt Goudy
by Graphicraft Typesetters Ltd, Hong Kong
Printed in Great Britain
by CPI Bath

For Paul

✿ CONTENTS

✆ PLATES

✆ ACKNOWLEDGEMENTS

The research on which this book is based was begun in connection with my PhD dissertation; my first thanks must therefore go to my supervisors Tim Benton and Briony Fer. Both provided an exceptional degree of encouragement and inspiration. I am also grateful to Pat Kirkham and Gill Perry who offered useful feedback on the ideas presented here. Jane Beckett, Margaret Iversen, Alex Potts, Lisa Tickner and Sarah Wilson kindly invited me to present earlier versions of the material as seminar papers to their students. Some of the arguments which appear in Chapters 4 and 5 were first rehearsed in journal articles as 'Speaking volumes: the *Pavillon de L'Esprit Nouveau*', *The Oxford Art Journal*, 1992, and 'Beware beautiful women', *Art History*, 1997.

For assistance at an early stage of the research, I would like to acknowledge the Elephant Trust and the Open University. A term's teaching relief which enabled me to finish the manuscript was made possible by the Birkbeck College Research Committee. Colleagues in the History of Art Department at Birkbeck College, individually and collectively, have played a crucial role in helping me to bring this work to completion (a particular thanks to Jane Gough and also to Nancy Jachec and Andrea Merckel for their help with photography). I thank too my students over the past years for being both tolerant and thought-provoking.

My research has been greatly facilitated by the librarians and staff at the British Library, the Central St Martins Library, the London Library, the Open University Library, the Royal Institute of British Architects' Library, the Victoria and Albert Museum Library, and in Paris at the Bibliothèque Nationale, the Bibliothèque des Arts Décoratifs, the Bibliothèque Forney, the Bibliothèque Historique de la Ville de Paris, the Bibliothèque de l'Institut d'Art et d'Archéologie and the Société Nouvelle d'Exploitation de la Tour Eiffel.

Caroline Arscott, Judy Attfield, Jeremy Aynsley, Charlotte Benton, Cheryl Buckley, Simon Caulkin, David and Linsey Cottington, Barry Curtis, Jonathan and Rina Fenby, Peter Graham, Andrew Hemingway, Mary Macleod, Sarat Maharaj, Gillian Naylor, Marcia Pointon, Alan Powers, Mo Price, Nancy Troy, Ginette Vincendeau and Dennis Walder all gave help and support. I owe a longstanding debt of gratitude to Kathy Adler and Tamar Garb for many years of conversation and shared ideas (and on their part, of patient listening); their friendship has helped me through some difficult moments.

In the work's final stages I received invaluable assistance from Valerie Orpen; Rita Winter was a meticulous copyeditor and I thank Sue Adler for

the index. At Manchester University Press, Matthew Frost has been an exemplary editor. Any errors of fact, interpretation or translation are of course my own. My biggest debt, however, is to my parents Leslie and Theresa Gronberg, and to Paul Overy whose encouragement sustained me in beginning the project as well as in finishing it. This book can be but a small repayment to the many people from whose help and friendship I have benefited so greatly over the past ten years.

The author and publisher have made every effort to obtain permission to reproduce copyright material. Copyright holders are encouraged to inform the publisher of any oversight if proper acknowledgement has not been stated.

Introduction: illusory cities

> At night, when the whole place is a blaze of light, the bridge becomes
> a waterfall. By a series of hidden pipes the water pours from both flanks
> of the bridge upon the river, lit till it is like a fire. At the same time a
> great fountain plays in the centre of the Seine, now leaping up into the
> black sky, now scattering in a cascade of innumerable sprays of glitter-
> ing drops which make a fine rain upon the dark river.[1]

In a review of the 1925 Paris Exhibition published in the British *Archi-
tectural Review*, a reporter recounted his evening visit to the exhibition
grounds. He was merely one, it appears, of a crowd of people who had
gathered around the River Seine to admire a most extraordinary sight –
the nocturnal metamorphosis of the pont Alexandre III (plate 1):

> Here is a show, spectacular, even vulgar, which has nothing that is not
> common to fireworks, unless it be the subtlety of the water itself. Yet
> what a piece of imagination. It appeals darkly and vividly, to the prim-
> itive appetite for grandeur of the human beings who, night by night,
> hang all across the bridge and against the river wall.[2]

This monumental display of *eau* and *lumière* was strategically situated,
not only in terms of its geographical position at the heart of the Exhibi-
tion, but also in relation to one of the major exhibits of the French sec-
tion: the rue des Boutiques, a street of temporary shops along the pont
Alexandre III built to an overall plan by Maurice Dufrène (plates 2
and 3). Here, a double row of boutiques (each façade designed by a
different architect) displayed a choice selection of artefacts produced
by Parisian-based *arts décoratifs* industries (plate 4).

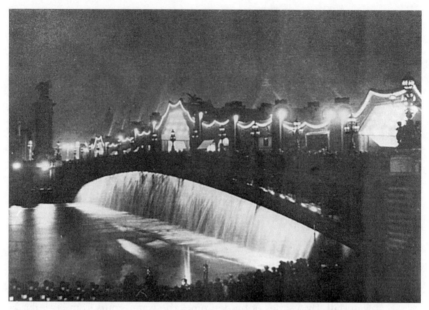

1 'Illuminations. The rue des Boutiques on the pont Alexandre III', photograph
from *Encyclopédie des arts décoratifs et industriels modernes au XXème siècle*, vol. 11,
plate XII

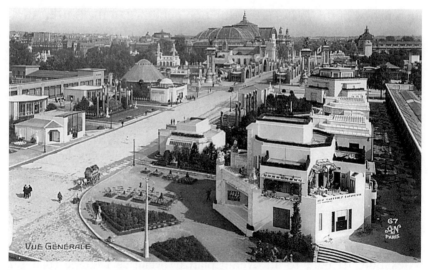

2 Panoramic view of the 1925 Paris Exhibition, looking towards the pont
Alexandre III

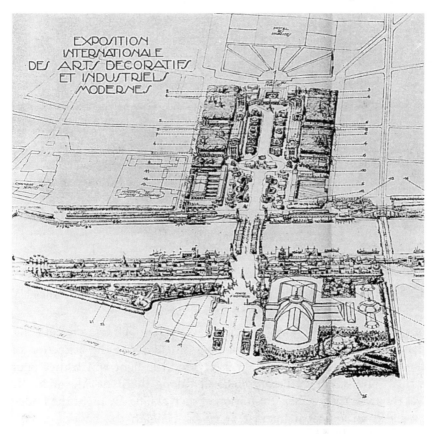

EXPO/ITION
INTERNATIONALE
DE/ ART/ DECORATIF/
ET INDU/TRIEL/
MODERNE/

3 Map of the 1925 Paris Exhibition showing the pont Alexandre III

The bridge, as transformed for the Exhibition, was a dramatic manifestation of *Paris ville lumière* – the nation's capital conceived not only as Paris by night but also as *the* city of commerce and luxury. The identification of Paris with luxury goods was by this date well established; one mid-1920s' guidebook to Paris emphasised:

> Paris, 'la ville lumière', is not only the political metropolis of France, but also the centre of artistic, scientific, commercial, and industrial life of the nation. Almost every branch of French industry is represented here, from the fine-art handicrafts to the construction of powerful machinery; but Paris is especially known for its 'articles de luxe' of all kinds.[3]

Paris 'city of light' involved the glamour of the shop-window as much as that on view in Parisian cabarets and music halls. Shops were acknowledged as a major device for 'staging' exhibits: the French government report on the 1925 Exhibition referred to the boutique *vitrine* as 'a kind

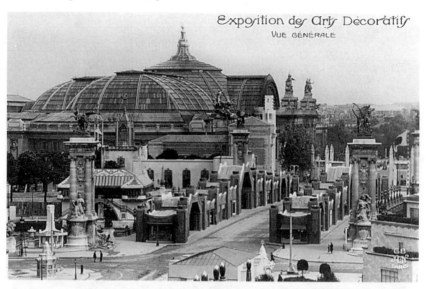

4 View of the pont Alexandre III and the Grand Palais at the 1925 Paris Exhibition

of theatrical presentation'.[4] Boutiques were identified as a crucial com-
ponent of the illuminated city, adding 'singularly to the attraction of
the street by their variety, their gaiety and the light which they pour
forth'.[5] The 'street' of luxury boutiques along the pont Alexandre III
was the most spectacular illustration of such claims. By night the bridge
produced an almost hallucinatory effect: beneath the boutiques with
their brightly lit windows emanated a spotlit cascade of water. The arti-
ficial light from the shop-windows seemed to erupt into both the sky
and the river – a flood of light flowing through the heart of the city.

The metaphor of Paris as an overflowing fountain served the
purposes of the Exhibition well. A contemporary guidebook to Paris
described the city's shops as: 'veritable temples of feminine coquetry
and lively springs, pouring countless productions of the good taste,
fancies and artistic turn of mind of French creators, over the whole
world'.[6] Small wonder then that images of the glittering *jet d'eau* pro-
liferated throughout the French section of the Exhibition, function-
ing indeed as a kind of identifying symbol for the Exhibition itself
(plate 5). The motif recurred in a variety of media – as a fountain and
again as glass finials for neon lights atop the Exhibition's Porte d'Hon-
neur (both designed by René Lalique), as well as in a textile design by
Bénédictus for the Grand Salon de Réception in the sequence of rooms
displayed as a project for a 'French Embassy'. And when *L'Illustration*
brought out its *numéro spécial* on the Exhibition, the magazine's front

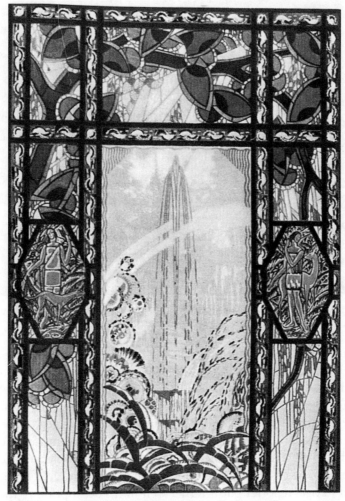

5 *Jet d'eau* motif at the 1925 Paris Exhibition. 'Le jet d'eau –
stained glass', photograph from *Encyclopédie*, vol. 3, plate LXXXI

cover was adorned with the illustration of a stained-glass window on
show in the Exhibition, a design based on a *jet d'eau* flanked by two
figures of the goddess Diana. In the context of the Exhibition, the *jet
d'eau* (as much as Diana, one of whose symbols is the crescent moon)
was associated with night-time illumination.

The spectacles of light staged in conjunction with the pont
Alexandre III were intimately associated with Paris as international
centre of shopping. But these light shows not only suggested glamour
and excitement, they were also the very means of conveying the status

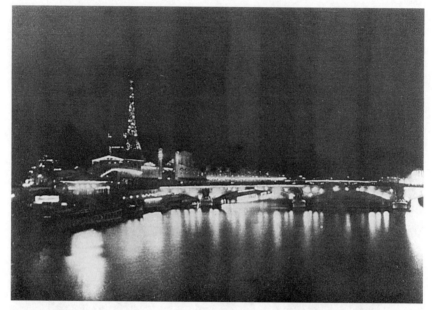

6 'Illuminations'. The 1925 Paris Exhibition by night, photograph from *Encyclopédie*, vol. 11, plate XIX

of luxury to the commodities on show in the boutiques along the bridge as elsewhere throughout the Exhibition. Like the light which streamed from the boutique window by night, the *jet d'eau* evoked a 'city of light' in which the main function of light was to produce the phantasmagoria of the commodity – to conceal as much as it revealed. (The term 'phantasmagoria' is in fact derived from early nineteenth-century displays based on the manipulation of light: the 'exhibition of optical illusions produced chiefly by means of the magic lantern'.)[7] The *Architectural Review* reporter put it rather well in his description of the 1925 Exhibition (plate 6): 'The whole place is fairer at night for night, like trees, hides and unifies. The illumination is done well, throwing up simple and impressive masses where daylight would reveal a cheap ornament or a thoughtless moulding.'[8] The dramatically lit water rising out of the Seine below the rue des Boutiques evoked a city whose allure was (like that of the commodity) illusory, the product of careful staging and lighting – a theatrical effect (plate 7).

It is therefore perhaps appropriate that contemporary critics often deployed theatrical imagery in order to assess the significance of the Exposition. Writing for an official report published in the wake of the 1925 Paris Exhibition, François Carnot (president of the Union Centrale des Arts Décoratifs, government deputy and long-time advocate for an

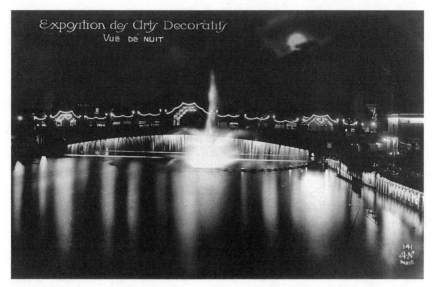

Exposition des Arts Decoratifs
VUE DE NUIT

7 The pont Alexandre III by night

exhibition of decorative arts) was unequivocally negative: 'once again, French architecture has been represented in the form of a stage-set [. . .] a city of illusion'.[9] One year after its closure, asked Carnot, what was left of the Exhibition? Nothing but memories and a proliferation of photographs. It had been a fundamental error, argued Carnot, to situate this Exhibition in the heart of Paris, cheek-by-jowl with major monuments such as the Invalides and the Grand Palais. The location in the historic city centre had resulted in a profusion of temporary exhibition architecture: display pavilions instead of functional (and permanent) architecture such as workers' housing and schools – in short, theatre stage-sets as opposed to real buildings, an illusory instead of an actual city. Far from bequeathing Paris the amenities it really needed, the Exhibition had proved itself an exercise in frivolity and display for its own sake.

This characterisation of large-scale Paris exhibitions as illusory (or 'dream') cities was nothing new, nor indeed was the condemnation of exhibition architecture as excessively showy and tasteless. It had all been said before – in connection, for example, with the last such event to be held in Paris, the 1900 Exposition Universelle.[10] For the 1925 Exhibition organisers, however, the idea of a temporary 'city within a city' which would somehow 'set the stage' did not conflict with the real needs of the nation or its capital. The Exposition Internationale des Arts Décoratifs et Industriels Modernes which opened for a seven month run in April 1925 was the culmination of over two decades of national and

municipal debate on the question of when, how and where to mount an exhibition of French decorative arts. One of the prime functions of the 1925 Arts Décoratifs Exhibition (as of earlier Paris exhibitions) was to define an identity – and a supremacy – for French goods on the international market-place. 'We have invited all nations', pronounced the *Catalogue général officiel*, but in fact the French section of this 'international' exhibition took up approximately two-thirds of the 23-hectare site.[11] To the extent that other countries were represented at the 1925 Exhibition (and with neither Germany nor the United States participating, there were some significant absences), these functioned more as a foil to the presentation of French *arts décoratifs*.[12] The *Catalogue général officiel* was quite frank in admitting that what was at stake with such exhibitions, what had always been at stake in the protracted and interrupted planning for 1925, were political and economic interests. But for a post-war France, it claimed, the Exhibition as 'temporary Parisian capital' was endowed with a specific mission and symbolic force: 'this is the work of men who having returned from the war, announced, in peacetime, that a new style is born. This was to be the setting [*décor*] for the men of the future'.[13] *Arts décoratifs* industries were recognised as playing a key role in the process of post-war reconstruction:

> Since the armistice, and even before, Parliament considered repairing and rebuilding. There were ministeries of reparation and reconstruction. Those arts called 'applied' were an obvious part of the Parisian and French luxury trade. The original idea for an Exhibition of modern decorative arts, planned for 1916, was resurrected by those people who had set up the peace process.[14]

The decorative arts were here specifically identified with French luxury industries and the Exhibition as 'city' with the centre of those industries – Paris.

Further insight into the ways in which the Exhibition evoked and related to notions of the modern city is afforded by yet another instance of the theatrical metaphor, this time in an arts magazine: 'An exhibition of this type is not concerned with real architecture. Architecture is there in order to function as a stage-set and as the backdrop for stage lighting.'[15] The significance of exhibition architecture, proclaimed Guillaume Janneau (a well-known arts commentator of the period), lay in its role as a setting, as a brilliantly lit backdrop to staged events. Janneau's assertion is a reminder that the function of the 1925 Paris Exhibition as a marketing device for the French nation was not restricted to its pavilions or to the objects on display. The Exhibition

grounds formed the site of numerous events, one of the most dramatic of which was the Fête du Théâtre et de la Parure. Presented as an extension of the French section, the Fête took place on the evening of the sixteenth of June under the direction of the fashion designer Paul Poiret.[16] The idea of an exhibition as spectacle by night as well as by day – as providing evening entertainment – was in itself not innovatory. Similarly, the promotion of Parisian *haute couture* through affiliation with the theatre (actresses clad in high fashion both on and off stage) was by 1925 an established practice.[17] The Fête du Théâtre et de la Parure is interesting rather for what it reveals more generally about the Exhibition's presentation of *décoration*. The Fête involved fashion and theatre, both of which were important as a means of displaying the decorative arts in 1925 (they constituted two of the Exhibition's five major categories).[18] Poiret worked with professional fashion models as well as with theatrical *metteurs en scènes* and actors from the Comédie-Française, the Opéra, the Opéra-Comique and dancers from Parisian music halls to put on a performance which took the form of a fashion parade 'judiciously interspersed' with short theatrical sketches and dance routines. Fashion mannequins alternated with dancers (Jeanne Ronsay and her school performed a 'Vision of the Orient', Loie Fuller danced a textilian 'Rainbow' and Ida Rubinstein enacted the 'Golden Archangel'), the work of *grands couturiers* with that of costumes by Léon Bakst, René Piot and Norman Bel Geddes. The Fête thus presented *l'art décoratif* in the form of a sumptuous performance – as a theatrical event in which the female body was accorded a starring role not simply for the purposes of entertainment but also as a marketing device.

The Fête was (like the Exposition itself) an ephemeral means of displaying the decorative arts, but a number of photographs of dance troupes who performed at the Fête appear in the Exhibition's official twelve-volume commemorative publication, the *Encyclopédie des arts décoratifs et industriels modernes au XXème siècle*.[19] These carefully posed photographs function as part of the Exhibition's permanent 'encyclo-paedic' representation of *décoration*, indications of how the Fête (but also the Exhibition more generally) represented the 'decorative'. The photographs show the Tiller Girls dancing 'The River of Diamonds' (plate 8) and Les Artistes du Casino de Paris in a tableau labelled 'The Precious Gemstones'. Written somewhat later in the 1920s, Siegfried Kracauer's now well-known essays on 'mass ornament' referred to the Tiller Girls in order to associate the 'geometric precision' of their act with the rhythms of mass-production and the assembly line. But here in 1925 – as suggested by the names of the 'girls'' dance routines with

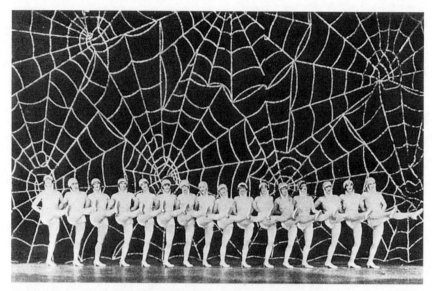

8 'The River of Diamonds', danced by the Tiller Girls at the Fête du Théâtre et de la Parure. Photograph from *Encyclopédie*, vol. 10, plate XI

their references to *diamants* and *pierres précieuses* – such performances served to enhance an atmosphere of glittering luxury. (The Exhibition was apparently referred to at the time as a 'giant jewel box'.)[20] Like the parade of *haute couture*, these photographs of dance present *décoration* in the form of the luxuriously adorned female body.

The dances depicted in the *Encyclopédie*, however, do not display the female body only as decorated surface. The splayed-out reclining bodies in the 'Vision d'Orient' take the form of a Busby Berkleyesque flower, and the pattern of the Tiller Girls' precision leg-kicks is extended by the giant 'diamond'-encrusted spider's web which forms the stage backdrop. With these dances the female body enacted decoration not only on a human but also on a more monumental scale. The classification of the event is in this respect revealing. The Fête du Théâtre et de la Parure was not categorised as part of the fashion section of the Exhibition, and although it involved theatre designers and performers, it was not identified as theatre. *Groupe* 4, entitled 'Arts du théâtre, de la rue & des jardins', included separate *classes* for 'arts du théâtre' and 'arts de la rue' and the Fête was officially classified as part of the section devoted to 'arts de la rue'. The Fête (and by implication, the Exhibition too) therefore presented the decorative and the street – decoration and the city – as somehow inextricably linked. This dramatic emphasis on fashion and on music-hall performance thus suggested not only a luxurious but also a distinctively feminised urban environment.

Janneau's use of the stage metaphor can be considered, however, not only in the rather literal sense of the Exhibition *fêtes* but also for what it indicates more generally concerning the role of such exhibitions. In an essay of 1896 on the Berlin Trade Exhibition, the sociologist Georg Simmel had argued that the primary function of exhibitions consisted in bringing together diverse commodities in the context of spectacle and entertainment. For Simmel, the presentation and staging of the commodity was indeed the main business of exhibition display:

> Commodity production . . . must lead to a situation of giving things an enticing external appearance over and above their usefulness . . . one must attempt to excite the interest of the buyer by means of the external attraction of the object, even indeed by the means of the form of its arrangement.[21]

Walter Benjamin, who shared Simmel's preoccupation with exhibitions as both a symptom and a means of the commodity fetishism characteristic of nineteenth-century capitalism, similarly described such events as spectacles of the commodity. In his 1930s' 'Paris – Capital of the nineteenth century', he wrote: 'The world exhibitions glorified the exchange-value of commodities. They created a framework in which their use-value receded into the background. They opened up a phantasmagoria into which people entered in order to be distracted.'[22] According to Simmel, exhibition architecture shared the phantasmagoric quality of the commodities it so artfully displayed. Such architecture, he claimed, embodied both 'the character of a creation for transitoriness' (transitoriness in the form of 'fashion' being, as Benjamin put it, the means whereby the commodity was to be 'worshipped') as well as the 'eternity of forms' – this in order to deny the illusory quality of the whole enterprise.[23] Not only the exhibition's layout then but also its architecture functioned to produce an 'aesthetic appeal' for the commodity.

Most revealingly, however, Simmel identified exhibitions with the devices of commercial display; in his 1896 essay he proclaimed that the purpose of exhibitions was to evoke the 'shop-window quality of things'.[24] The 1925 Paris Exhibition, perhaps more overtly and dramatically than any other such French exhibition, took on this guise of 'shop-window'. The Exhibition was distinctive in its emphasis on 'exchange value'. Despite the presence of the word 'industriels' in its title, it included none of the spectacular displays of industrial manufacture that had characterised previous Paris exhibitions. The exhibitions of 1889 and 1900, for example, had in various ways put machinery and technology on show; both included a Galerie des Machines, and in 1900 the Palais de l'Électricité afforded viewers the dramatic sight of

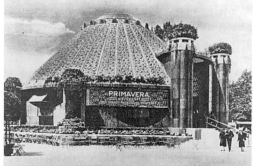

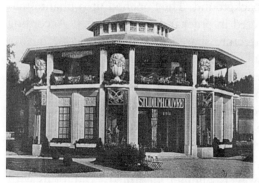

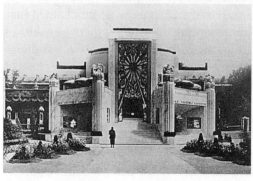

9 Pavillon Pomone
(Grands Magasins du Bon
Marché)

Pavillon Primavera
(Grands Magasins du
Printemps)

Pavillon du Studium-Louvre

Pavillon de la Maîtrise
(Grands Magasins des Galeries
Lafayette)

photographs from *Encyclopédie*,
vol. 2,
plates IV, IX, XLVII and
XXXVI

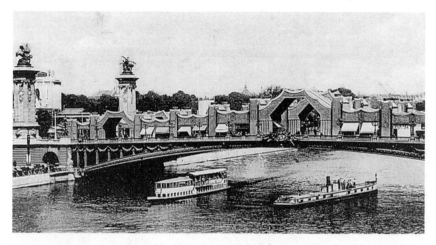

10 View of the pont Alexandre III at the 1925 Exhibition

steam-driven dynamos 'pumping life into the whole exhibition'.[25] The exhibition regulations in 1925 expressly prohibited the display of primary materials or technological processes. By contrast with earlier (and much larger) Paris exhibitions, that of 1925 was dominated by a range of exhibition devices which displayed exhibits in the context of consumption. This was particularly true of the French section which included ostentatious pavilions sponsored by the Parisian department stores (the Magasins du Louvre, the Galeries Lafayette, the Magasins de la Place Clichy, the Magasins du Printemps and the Magasins du Bon Marché) (plate 9) as well as a proliferation of 'boutiques' – outdoors, across the Seine on the pont Alexandre III (plate 10) and with the Galeries des Boutiques Françaises on the esplanade des Invalides as well as indoors, where boutiques appeared as part of the sections devoted to advertising and education. Although actual shopping was not possible in either the department store pavilions or in the boutiques, such displays reinforced the idea of Paris as the city *par excellence* of consumption – the shopper's mecca – an identity further underscored by the Exhibition's proximity to some of the major sites of Parisian shopping, including the luxury shops in areas such as the place Vendôme and the rue de la Paix.

As 'shop-window' the 1925 Exhibition (like those of 1889 and 1900) constituted the stage-set not only for the objects exhibited but also for the city of Paris itself. Contemporary commentators were well aware of the Exhibition as a mechanism for showing off the city: 'Everyone seemed to be in agreement that Paris should be put on show but not disfigured.'[26] Such exhibitions were an important means of selling Paris

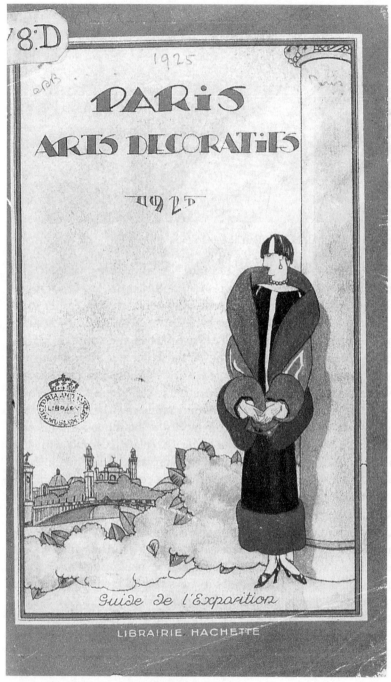

11 Cover of *Paris Arts Décoratifs 1925* guide

(or rather 'Paris'). The Paris which they represented was simultaneously dream (like the phantasmagoria of the commodity) and dream-machine. If, as Walter Benjamin claimed, 'world exhibitions were places of pilgrimage to the fetish Commodity', then that pilgrimage had itself been commodified in the form of the tourist industry.[27] In 1925 as during the nineteenth century, the exhibition visit formed an important adjunct of Parisian tourism. Detailed instructions for visiting the 1925 Exhibition were included in several contemporary tourist guidebooks (plate 11).[28] This tourist Paris involved the presentation of the city as spectacle and object of visual pleasure. Although the 1925 Exhibition did not include any monumental structures comparable to the Eiffel Tower erected on the occasion of the 1889 Exposition Universelle, it afforded numerous opportunities for the visual delectation of the urban setting. The four towers designed by the architect Charles Plumet as a dramatic feature of the Exhibition grounds each included a restaurant from which the view extended into the distance. From these *belvédères*, visitors were encouraged to identify the delights of the table with those of the cityscape.

But perhaps the most spectacular sights afforded by the 1925 Exhibition were those at street level. In addition to temporary viewing platforms such as the Plumet towers, the Exhibition plan appropriated numerous existing *points de vue* in order to stress Paris as visually beautiful. The view from the Right Bank across the pont Alexandre III (another legacy of the 1900 Exhibition) to the Invalides was a potent reminder of the extent to which Paris exhibitions reiterated – and drew attention to – the splendours of the city. The French exhibits on show in 1925 thus derived an 'aesthetic appeal' not only from their appearance at an exhibition, but also through their identification with Paris. Such exhibitions involved a symbiotic relationship with the city: the exhibition staged 'Paris' in order that 'Paris' might play its part in – and enhance – the exhibition's showcasing of French commodities. The emphasis on urban spectacle in 1925 therefore involved not only a promotion of the French capital as travellers' destination on behalf of the tourist industry, but also an insistence on (and reassertion of) the glamour of Paris in the interests of the post-war drive to establish the status of French goods on the international market-place.

Interpretations of exhibitions as a means of manufacturing the 'phantasmagoria' of the commodity suggest a rather different notion of the 'illusory' from that used by Carnot in his attack on the 1925 Exhibition. According to Carnot, the Exhibition constituted an 'illusion' in failing to reflect the ('real') post-war needs for Parisian working-class housing. Dominated on the one hand by the seventeenth-century

grandeur of the Invalides and on the other by the historicist bombast of the Grand and Petit Palais (remnants of the 1900 Paris Exposition Universelle), the Exhibition failed to bear, he claimed, 'any trace of its era'. Considered in relation to a notion of 'phantasmagoria', however, the 1925 Exhibition, with its strategic identification of pavilions with shops, appears as a vivid manifestation of modernity. An essay on the complex and protracted 'Genèse d'une exposition' in the *Catalogue général officiel* concluded with a reference to future historians of the event: 'These cursory notes aim only at paving the way for historians who cannot fail to study one of the most beautiful works of this century.'[29] In retrospect, this confidence seems misplaced; few such histories have materialised. References to the 1925 Exhibition have largely been confined to studies of the decorative arts – in particular the vast literature on Art Deco. This is indicative of the Exhibition's status in the context of academic research and publications. Until very recently, historians of art, design and architecture have perpetuated the condemnation of the 1925 Exhibition as ostentatious (in its emphasis on luxury goods) and lacking in artistic innovation. Far from considering the Exhibition as an index of modernity worthy of study in its own right, most scholarly histories of 1920s' Parisian visual culture either ignore the event or refer to it as the foil for the small number of avant-garde architectural exhibits on show in 1925 (such as Konstantin Melnikov's Soviet Pavilion and in particular Le Corbusier's Pavillon de L'Esprit Nouveau).[30]

Nancy Troy's *Modernism and the Decorative Arts in France: Art Nouveau to Le Corbusier* (1991) is the notable exception.[31] The book's final chapter deals with the 1925 Exhibition and argues that Modernist historians have too easily acquiesced with the criticisms voiced in the 1920s. Le Corbusier, one of the most vociferous critics, condemned the Exhibition in terms similar to those of Carnot who had railed against what he saw as an 'Exhibition mentality' at the expense of a concern with issues of 'normal usage'.[32] Le Corbusier claimed that his Pavillon de L'Esprit Nouveau at the 1925 Exhibition (which included a modular housing unit) was built 'for real' in pointed contrast to the surrounding 'plaster palaces writhing with decoration' (plate 12).[33] Most importantly, the Pavillon represented a city based on the principles of standardisation and mass-production, as opposed to that quite different version of the city evoked by the luxury goods so ostentatiously displayed throughout the Exhibition. The Pavillon de L'Esprit Nouveau was a forceful manifesto statement. Le Corbusier used the Exhibition as a means of formulating an oppositional stance in order to showcase the arguments

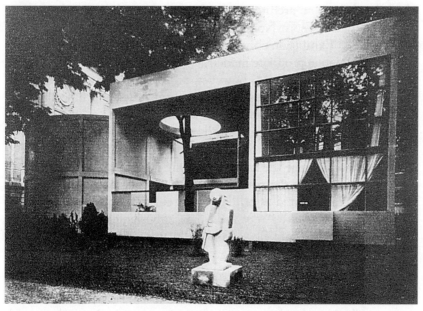

12 Le Corbusier's 'Pavillon de L'Esprit Nouveau'. Photograph from *Encyclopédie*, vol. 2, plate LXV

concerning architecture and town-planning which he (and others) had published in the arts journal *L'Esprit Nouveau*. But as Nancy Troy has convincingly demonstrated, this opposition was in certain senses more for show than for real. She argues that a more considered historical assessment reveals that the institutional and economic context of French decorative arts production was just as important in shaping the avant-gardism of Le Corbusier's Pavillon de L'Esprit Nouveau as in bringing about the Exhibition itself.[34]

Although in so many cases overlooked or shunned by later historians, as the object of rejection the 1925 Exhibition played a crucial role in one of Modernism's most important and influential manifestos, not only in the case of the Pavillon de L'Esprit Nouveau itself but also in the associated L'Esprit Nouveau publications, such as *The Decorative Art of Today* (published in 1925 to coincide with the Exhibition) and the *Almanach d'architecture moderne* (1926). Just as the *Encyclopédie* documents and commemorates the Exhibition's representation of *décoration*, so Le Corbusier's books provided a framework for interpreting the Pavillon exhibit for readers once the Exhibition had closed. Here Le Corbusier pronounced to a public much wider than that which had actually attended the Exhibition those points of disagreement through

which he defined an architecture and design suitable for modern urban living. In these L'Esprit Nouveau publications of the mid-1920s therefore, the 1925 Exhibition constitutes a shadowy presence as that 'other' against which an appropriate modernity is defined. The very vehemence of this Modernist refutation, however, prompts speculation. *Designs on Modernity* investigates the ostensibly unacceptable (and indeed largely unacknowledged) modernity staged by the Exhibition, a modernity which, I shall argue, had much to do with the explicit 'shop-window' effect of this event. Theatricality and illusion – the concepts used both to condemn and praise the Exhibition – are foregrounded as a means of exploring and tracing the parameters of that other modernity in which the city was represented as brilliantly lit, enticing spectacle.

In *The Decorative Art of Today* Le Corbusier formulated a parable in order to demonstrate how profoundly standardisation had already transformed the modern city:

> Lenin is seated at the Rotonde on a cane chair; he has paid twenty centimes for his coffee, with a tip of one sou. He has drunk out of a small white porcelain cup. He is wearing a bowler hat and a smooth white collar. He has been writing for several hours on sheets of typing paper. His inkpot is smooth and round, made from bottle glass.[35]

This is a description of standardised 'purist' objects composed as the symphony of geometric forms – the endlessly reiterated circle (cane chair, coins, cup, hat, collar, inkpot) as well as the rectangle of the typing paper.[36] Significantly, the geometric form of the circle defines not only standardised clothing (the bowler hat and collar) and implements (the porcelain cup and inkpot) but also the architectural setting ('the Rotonde'). Just as the urban environment (Paris – 'the Rotonde') has been revolutionised ('Lenin') by mundane, mass-produced objects, so mass-production housing and town-planning could – according to Le Corbusier – impose geometry (and hence order) on the existing chaos of the city. Some indication of what this further 'reform' of the city might entail and look like was put on show in the form of dioramas next to the Pavillon which depicted two of Le Corbusier's town-planning schemes: the Contemporary City and the Plan Voisin for Paris.

As a means of establishing a relationship between *décoration* and the city, the Esprit Nouveau town-planning dioramas can be considered as a riposte to the Exhibition's Fête du Théâtre et de la Parure – the frivolity of entertainment confronted by the seriousness of urbanism. It is apparent that the 1925 Exhibition involved not merely, as so many

commentators reiterated, a 'city-within-a-city' (a 'dream' city super-imposed on the urban fabric of central Paris) but also the staging of different and conflicting cities. Lenin confronts the Tiller Girls and the modern city is thereby depicted in terms of the café as opposed to the music hall, as the site of intellectual preoccupation rather than as visual spectacle. What is the significance of the 'reform' represented here by Lenin, writing in the Rotonde? What chaos has been eradicated by the substitution of the geometry of the bowler hat for that of the chorus line? Such questions might provide the basis – not to say the provoca-tion – for writing a history of the 1925 Exhibition. In the chapters that follow, however, I shall not concentrate exclusively on the Exhibition nor only on the interests at stake in the Modernist discourse of L'Esprit Nouveau. My aim is rather to consider the implications of the different ways in which the Exhibition represented Paris as modern, Paris which of all cities remains now as much as in the 1920s so precariously (and so tantalisingly) balanced between illusion and reality.

Why study an exhibition, this exhibition in particular? As I hope to demonstrate, the contradictory versions of the city put on show in 1925 are in certain ways still relevant (and not only in the sense that publications such as the *Encyclopédie* and Le Corbusier's L'Esprit Nouveau books have all appeared in fairly recent reprints). Questions as to how to define the appropriately 'modern' city have become increasingly the subject of public attention and will undoubtedly persist into the fore-seeable future. Such debates concern not merely the appearance and viability of the urban environment but also (and perhaps most crucially) the identities and subjectivities involved with different representations of the city. Not merely a historical phenomenon, the 1925 Exhibition can function as a constant reminder of the extent to which today's 'real' cities are built up of many (and often incompatible) *cités d'illusion*.

Notes

1 H. de C., 'A general view', *Architectural Review*, July–December 1925, vol. 58, p. 4 and p. 6. An earlier overview of some of the issues dealt with here and in subsequent chapters appeared as 'Cascades of light: the 1925 Paris Exhibition as *ville lumière*', in the special Art Deco issue of *Apollo*, July 1995, vol. 142, no. 401, pp. 12–16.

2 H. de C., 'A general view', p. 6.

3 *Paris and its Environs with Routes from London to Paris: Handbook for Travellers*, Karl Baedeker, Leipzig, George Allen & Unwin, London, and Chas. Scribner, New York, 19th rev. edn, 1924, pp. xxix–xxx.

4 'Rue et jardin', *Encyclopédie des arts décoratifs et industriels modernes au XXème siècle en douze volumes*, Imprimerie Nationale, Office Central d'Éditions et de Librairie, Paris, n.d., vol. 1, p. 81. In all subsequent notes, this publication will be referred to as the *Encyclopédie*. All translations of French quotations are the author's own.

5 'Décor et mobilier de la rue – section française', *Encyclopédie*, vol. 11, p. 41.

6 *Paris and its Monuments: Promenades in the Neighbourhood – International Exhibition of Modern Decorative and Industrial Arts*, The Tourists' Handy Guides, Thiolier Guides, 1925, p. 19.

7 See the reference for 'phantasmagoria' in *The Shorter Oxford English Dictionary*, 1970, p. 1485: 'an exhibition of optical illusions produced chiefly by means of the magic lantern, first given in London in 1802'.
 See also Jonathan Cary, *Techniques of the Observer: On Vision and Modernity in the Nineteenth Century*, MIT Press, Cambridge (Mass.) and London, 1992, pp. 132–3.

8 H. de C., 'A general view', p. 6.

9 'Rapport de M. François Carnot, président de l'Union Centrale des Arts Décoratifs', *Annuaire*, Union Centrale des Arts Décoratifs, Paris, 1926, p. 149.

10 Maurice Talmeyr, a journalist for *Le Correspondant* (25 April 1900, p. 401) contended that fifty years of universal exhibitions had produced only 'stage-sets' and 'scenery' as opposed to true architecture. Quoted in Rosalind H. Williams, *Dream Worlds: Mass Consumption in Late Nineteenth-Century France*, University of California Press, Berkeley, Los Angeles and Oxford, 1982 and 1991, pp. 71–2. A multi-volume illustrated series on the 1900 Paris Exhibition was published in St. Louis under the title *Parisian Dream City*. Cited by Norma Evenson, *Paris: A Century of Change, 1878–1978*, Yale University Press, New Haven and London, 1979, p. 137. Evenson quotes from another source: 'The profound cause of this great artistic degradation is the universal exhibitions and the invasion of exotic styles' (p. 158).

11 The figure of 23 hectares appears on the first page of the essay 'En guise de préface à une visite de l'Exposition', in the *Catalogue général officiel – Exposition Internationale des Arts Décoratifs et Industriels Modernes*, Ministère du Commerce et de l'Industrie des Postes et des Télégraphes, Imprimerie de Vaugirard, Paris, 1925, n.p. (hereafter referred to as the *Catalogue général officiel*). According to the report on the 1925 Exhibition published by the British Department of Overseas Trade, the French section of the Exhibition took up about two-thirds of the site; see *Reports on the Present Position and Tendencies of the Industrial Arts as Indicated at the International Exhibition of Modern Decorative and Industrial Arts, Paris, 1925: With an Introductory Survey by Sir H. Llewellyn Smith*, HMSO, London, 1926, p. 11.

12 See Charlotte Benton, 'The International Exhibition of Modern Decorative and Industrial Arts, Paris, 1925', in Tim Benton, Charlotte Benton and Aaron Scharf, *Design 1920s*, The Open University Press, Milton Keynes, 1975, pp. 62–8.

13 É. Richard, 'Découverte d'un style', *Catalogue général officiel*, n.p.

14 É. Richard, 'Genèse d'une exposition', *ibid.*, n.p.

15 Guillaume Janneau, 'Pour 1925', *Le Bulletin de la Vie Artistique*, 1.4.24, p. 144.

16 Paul Poiret was well known for staging extravaganzas (such as his Orientalising 1911 1002nd Night party) in order to market his fashions. See Peter Wollen's 'Fashion/orientalism/the body', *New Formations*, Spring 1987, no. 1, pp. 5–33; another version appears as 'Out of the past: fashion/orientalism/the body',

Raiding the Icebox: Reflections on Twentieth-Century Culture, Verso, London, 1993, pp. 1–34. I am particularly indebted to Wollen's arguments on the significance of spectacle and luxury *vis-à-vis* early twentieth-century conceptions on modernity.

17 See, for example, the section on 'The theatre of experience' in chapter 8 'Le High Life', in Valerie Steele, *Paris Fashion: A Cultural History*, Oxford University Press, New York and Oxford, 1988, pp. 151–62.

18 The exhibits at the 1925 Exhibition were categorised according to five *groupes*:

 Groupe 1 Architecture
 Groupe 2 Mobilier
 Groupe 3 La Parure
 Groupe 4 Arts du théâtre, de la rue & des jardins
 Groupe 5 L'Enseignement

 Each *groupe* was divided into *classes* (of which there were a total of thirty-six).

19 See note 4 above. The *Encyclopédie* is also available as a reprint by Garland Publishing, Inc., New York and London, 1977.

20 See David Frisby, 'Siegfried Kracauer: "exemplary instances of modernity"', *Fragments of Modernity: Theories of Modernity in the Work of Simmel, Kracauer and Benjamin*, Polity Press, Cambridge and Oxford, 1985, pp. 148–9. 'By night the skillfully illuminated exhibition was said to resemble a casket of jewels' (Madeleine Ginsburg, 'Introduction', *Paris Fashions: The Art Deco Style of the 1920s*, Bracken Books, London, 1989, p. 21).

21 David Frisby, 'Georg Simmel: *Modernity as an Eternal Present*', *Fragments of Modernity*, p. 95.

22 Walter Benjamin, 'Paris – the capital of the nineteenth century, III. Grandville or the World Exhibitions', *Charles Baudelaire: A Lyric Poet in the Era of High Capitalism*, New Left Books, London, 1973, p. 165.

23 Frisby, 'Georg Simmel', p. 95. Benjamin proclaimed: 'fashion prescribed the ritual by which the fetish Commodity wished to be worshipped' (Benjamin, *Charles Baudelaire*, p. 166).

24 Frisby, 'Georg Simmel', p. 95.

25 John Allwood, 'An architectural fantasia', *The Great Exhibitions*, Studio Vista, London, 1977, p. 101.

26 Adolphe Dervaux, 'L'Exposition des Arts Décoratifs et Industriels Modernes', *L'Architecte*, May 1925, p. 46.

27 Benjamin, 'Paris', p. 165.

28 See, for example, *Paris arts décoratifs: guide de l'Exposition*, Librairie Hachette, Paris, 1925; and (in English) *Paris: Black's Guide Books. Black's Guide to Paris*, A. & C. Black, London, 1925; see also note 6 above.

29 É. Richard, 'Genèse d'une exposition', *Catalogue général officiel*, n.p.

30 See, for example, Christopher Green, 'Painting and architecture: Léger's modern classicism and the international avant-garde', *Léger and the Avant-Garde*, Yale University Press, London, 1976, p. 291; and Kenneth Silver, 'Perchance to dream', *Esprit de Corps: The Art of the Parisian Avant-Garde and the First World War, 1914–1925*, Princeton University Press, Princeton, 1989, p. 374.

31 Nancy J. Troy, *Modernism and the Decorative Arts in France: Art Nouveau to Le Corbusier*, Yale University Press, New Haven and London, 1991; see especially the chapter 'Reconstructing Art Deco: Purism, the department store, and the Exposition of 1925'.

32 'Rapport de M. François Carnot', p. 149.

33 Le Corbusier, *The Decorative Art of Today*, translated and introduced by James I. Dunnett, MIT Press, Cambridge Mass., 1987, p. xiv and p. 139. All further references will be to this edition. (See note 35 below.)

34 Troy, *Modernism and the Decorative Arts*, p. 160.

35 Le Corbusier, 'Iconoclasts', *The Decorative Art of Today*, p. 7. The scene is identified as taking place in pre-war Paris. *The Decorative Art of Today* was published in 1925 as *L'Art décoratif d'aujourd'hui* by Éditions Georges Crès et Cie., Paris; it consisted of articles (written in anticipation of the Exposition) from the journal *L'Esprit Nouveau*. On dating issues of *L'Esprit Nouveau*, see R. Gabetti and C. Olmo, *Le Corbusier e L'Esprit Nouveau*, Einaudi, Turin, 1975; Susan L. Ball, *Ozenfant and Purism: the evolution of a style 1915–30*, UMI Research Press, Ann Arbor, Michigan, 1981 and *L'Esprit Nouveau: Le Corbusier et l'industrie 1920–1925*, Museum für Gestaltung, Zurich and Wilhelm Ernst & Sohn Verlag, Berlin, 1987.

36 In the chapter on 'Type-needs/type-furniture' (footnote 1, p. 76) in *The Decorative Art of Today*, Le Corbusier includes a lengthy footnote on the significance of the need to standardise letter paper for use in the typewriter. He concludes: 'In all things that are in universal use, individual fantasy bows before human fact.'

Villes lumières

It is, one must grant, primarily a woman's city we are observing.[1]

Exhibiting Paris as a 'woman's city'

Paris as *ville lumière*, world centre of luxury shopping, was heavily pre-dicated on notions of femininity.[2] The 1925 Exhibition validated the notion of a 'dream city' by promoting Paris as the object of woman's desire: 'Whereas men go to London for suits & shirts, women all dream of being dressed in Paris.'[3] This notion of Paris implied a feminised city – the French capital as a 'woman's city'. In *Paris on Parade* (a book pub-lished in the United States in the mid-1920s), for example, we read: 'It is, one must grant, primarily a woman's city we are observing. Paris's chief and most characteristic concern is with the outer adornment of women.'[4] As 'woman's city' the chief function of Paris was identified as catering to the needs of the feminine toilette, what *Paris on Parade* referred to as 'the commerce of vanity'. Paris thus signified *the* international centre of feminine self-adornment.[5] At the 1925 Exhibition, the products of this 'commerce' were prominently displayed; one of the five Exhibition *groupes* was devoted to 'parure' and this *groupe* was in turn subdivided into five *classes*: 'clothing, accessories, fashion, perfumes, jewellery'. Although men's clothing was represented in the French section of the Exhibition, the displays were predominantly of women's fashion, with an emphasis on the luxury end of the market and on expensive fashion accessories.[6] Within this *groupe*, one category of object perhaps more than any other epitom-ised the idea of Paris as a 'woman's city': *le nécessaire* – the vanity case

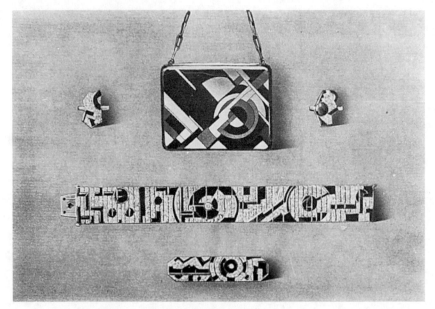

13 'Nécessaire [vanity case]'. Photograph from *Encyclopédie*, vol. 9, plate LXXXVIII

(plate 13). The lavishly decorated and often heavily bejewelled *nécessaire* constituted a very particular form of fashion accessory, simultaneously woman's handbag and jewellery. The *nécessaire* signalled a transformation of the processes of the feminine toilette from a private into a public ritual. Paris as a 'woman's city' was embodied by its elegantly clad women making up out-of-doors, in the street (plate 14).

Whose interests were served through the representation (both in the case of the 1925 Exhibition and elsewhere) of Paris as a woman's city? Ostensibly, those of women. The English book *In and about Paris* published in 1927 claimed that:

> Paris is above all, a woman's town [. . .]. Paris much more than (say) London ministers to the amusement of shopping – a specifically feminine employment. [. . .] back in Paris, after a sojourn in London, I realise that France is always politely murmuring, 'Place aux dames!'[7]

A variety of guides were published instructing women on how to carry out this specifically feminine 'employment' in the world's capital of shopping. American visitors could consult the Bonney sisters' *Shopping Guide to Paris*, with its useful tips concerning not only where to shop and what to buy, but also how to circumnavigate arcane French systems of payment in department stores.[8] The trilingual (French, English, Spanish) *Le Livre d'adresses de madame (annuaire de la Parisienne)* was addressed to women

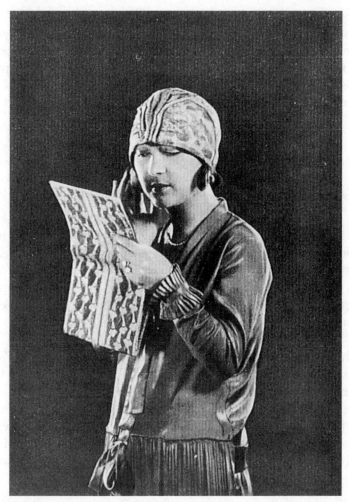

14 Woman making up. 'Chapeau et sac', photograph from
Encyclopédie, vol. 9, plate LXIII

shoppers in France as well as those from abroad. Various procedures of
shopping were outlined: either from a distance, through catalogues, or
from the comfort of one's own hotel room in Paris itself.[9] Women in-
experienced or lacking in confidence could contact the publishers of the
Livre d'adresses for personalised advice on how best to proceed. Similarly,
the Bonney sisters extended an open invitation to American shoppers to
drop into their Paris flat for tea and a chat. The promotion of shopping
in Paris, however, involved the interests of commerce and of inter-
national trade as much as those of women. The Exhibition's *Encyclopédie*
emphasised the importance of the *couture* industries from the point of

view of both national income and prestige, stressing that the 'art' of the *couturier* played an important role in the French balance of payment. Women's clothing was cited as a major export, totalling almost two and a half billion francs in 1924.[10] The Anglo-Saxon books portraying Paris as a 'woman's city' made explicit the economic importance of these industries. Robert Wilson, the author of *Paris on Parade* noted that:

> *La couture*, as the French call the dressmaking business, is Paris's largest industry. It is the thing that gives the city much of its distinctive atmosphere. It is a chief contributor to the Parisian spirit. Taken with its accessories – fabrics, linings, embroideries, laces, buttons – it is one of France's largest industries, ranking with steel and automobiles. It even had a strategic role in the Great War.[11]

The discourse of Paris as a 'woman's city' was thus a powerful means of promoting French economic interests during the post-war years of reconstruction. *Couture* was also, as indicated by *Paris on Parade*, a crucial means of articulating Frenchness. During the war, a variety of government and private initiatives had been formulated with the aim of preserving the *couture* industries from 'Germanisation'.[12]

'Paris as a woman's city', however, had not only to do with French interests, and it was no coincidence that a book such as *Paris on Parade* was published in the United States. The Parisian *couture* industries involved financial and economic interests abroad as much as in France. In writing about 'Our Parisian village', Wilson described not so much the American tourist in Paris as those businesses and individuals engaged in selling American goods to a French market as well as in buying French goods to sell in the United States. Parisian fashions apparently played a large part in the case of the latter:

> Besides its sellers our American village in Paris has its commercial buyers. The buying of Parisian articles by the emissaries of American department stores, clothing manufacturers, and exclusive city shops is a business that has expanded mightily since the war. There are now about twelve hundred American men and woman travelling twice a year or oftener across the ocean on this professional errand and bringing with them into the leisurely city a breeze of American zip and bustle. They buy principally things in which style changes, and principally women's things.[13]

The American 'village' was served by its own English-language newspapers – such as the evening Paris *Times* – and according to Wilson: 'our village press [...] gets the de-luxe advertising in Paris, and that is something the greatest French dailies cannot claim'.[14] These advertisements on behalf of the Parisian luxury industries addressed a large North

American audience via the intermediaries of Paris-based buyers. Indeed, the presence of these buyers in Paris had an impact beyond the United States. Seventh Avenue buyers were credited as the financial force that had changed *couture* from a series of small-scale businesses (mainly catering to individual, wealthy clients) to an industry that directly or indirectly clothed women 'from New York to Tokyo'.[15] *Couture* was often cited as the evidence of a superior French 'taste' – as a kind of emanation of Paris itself: 'There is something peculiar in French taste which makes the city [Paris] the undisputed mistress of fashion. It is impossible to transplant the workers, for once they are separated from their base their skill evaporates.'[16] But such assertions of the pre-eminence of Paris were not only in the interests of France. As the city where women dreamed of being dressed, 'Paris as a woman's city' referred to the development of *couture* into a large-scale international industry, an industry based on sustaining the glamour and prestige of Paris.

The Exhibition's promotion of 'a woman's city' – the emphasis on *couture* industries – reinforced a particular identity for the Exhibition as a showcase for French artistic skills and genius. The official Exhibition rubric made clear that the 1925 Exhibition was not an exhibition of art but rather of an *art décoratif* characterised as art.[17] The Exhibition regulations prohibited the display of fine art (such as painting and sculpture) for its own sake. In 1925 art was to appear solely for the purposes of establishing a setting for the exhibits of *arts décoratifs*.[18] The idea of art (or rather, of certain ideas associated with 'high' art) was, nevertheless, central to the aims of this Exhibition. In response to one of the innumerable *enquêtes* on the question of the participation of *artistes* which preceded the 1925 Exhibition, the president of the Société des Artistes Décorateurs specifically cited fashion as evidence of the beneficial effects of art on industry.[19] The preoccupation with *la mode* on the part of *artistes décorateurs* was based not only on ideas of the 'influence' of decorative art on the fashion industries, but also on the status of such industries as in some ways analogous to art itself. Fashion – the 'eighth art' as one commentator called it – had appeared in the first post-war Salon d'Automne in 1919 and then every year up until the time of the 1925 Exhibition.[20] The idea of Parisian *haute couture* as the manifestation of an individual 'artistic' creativity was essential to its promotion on the international market: 'The Parisian dressmaker's business is almost always, despite its size, an extremely personal thing with him [. . .] behind all the other celebrated names is flesh-and-blood personality putting its own genius into the masterpiece it "signs".'[21] Paul Poiret, for example, played on this analogy between 'art' and fashion in describing the relationship

between *couturier* and client as comparable to that between portraitist
and sitter: 'Visit the great dressmakers, and you will not feel that you
are in a shop, but in the studio of an artist, who intends to make of
your dresses a portrait and a likeness of yourself.'[22]

Parisian *couturiers* such as Poiret and Jacques Doucet had worked
to raise their social status through an affiliation with the world of art,
by collecting art and associating with artists.[23] At the same time, the
identification of *haute couture* with art operated to establish the value
(both cultural and financial) of *couture*. It was this affiliation with art
that differentiated *couture* from industrial production in general and
from ready-to-wear (or home-made) clothing in particular.[24] The status
of *couture*, as of art, was sustained largely through the guarantee of its
originality in the form of a signed 'name', a fact half-mockingly acknow-
ledged by *Paris on Parade* in the chapter entitled 'Model by Pack-Ann':

> Paris, to the average woman, means, primarily clothes. Clothes and style.
> The names and the creations of Parisian clothes are familiar to her also.
> She knows about Worth and Lanvin and Paquin. In the fashion pages
> of magazines she has seen the names of Jenny and Vionnet.
>
> These are the names that thunder an imperious authority in America
> and throughout the rest of the world too.[25]

Part of the effort which went into maintaining the 'authority' of such
names took the form of continuous copyright battles on the part of
Parisian *couturiers*. During the inter-war years, Madeleine Vionnet
became renowned as an energetic proponent of copyright for fashion
designs. References to Vionnet's determination to protect her own
designs by copyright featured prominently in the advertisements for her
products during the 1920s (plate 15).[26] These advertisements asserted
that: 'the creations of Madeleine Vionnet bear her signature'. Vionnet's
signature took the form not of writing but of a fingerprint affixed to
each garment ('son empreinte digitale') – society's most basic sign of
individual identity (as with the illiterate's contractual signature or for
the purposes of police criminal records) translated to the sphere of
elegance. Vionnet's fingerprint functioned as an almost literal illus-
tration of French copyright law which, as Molly Nesbit has shown,
defined the distinction between cultural and industrial labour partly on
the basis of evidence of an individual personality. To qualify as 'art' it
was necessary that a 'human mark, the trace of a cultural act, could be
discerned'.[27] The copyright battles of the Parisian *grands couturiers* were
but one particularly well-publicised and well-known instance of the
efforts of a whole range of French *artistes décorateurs* to establish their

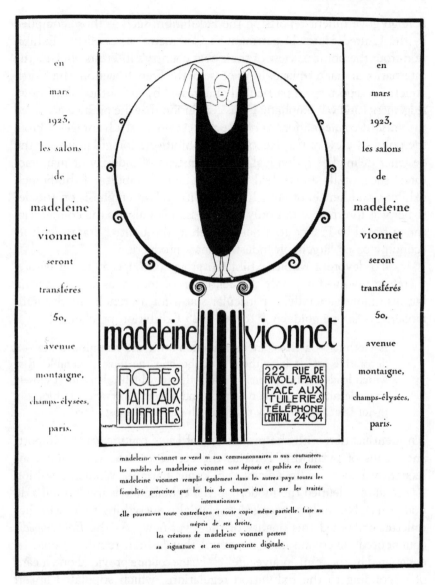

15 1920s' advertisement for Madeleine Vionnet

rights and to maintain their professional status *vis-à-vis* both plagiarism and industrial mass-production.[28]

The high profile accorded the 'imperious authority' of *haute couture* 'names' by the 1925 Exhibition was thus symptomatic of a wider range of interests than those of the fashion industries alone; the exhibition of 'names' served to define both professional and national identities.

Foreign government reports on the Exhibition, such as those compiled by the United States Department of Commerce, assessed the Exhibition from the point of view of their own country's interests *vis-à-vis* the international market-place. In the case of the French section, the North American reporter was particularly impressed by the authorial acknowledgements and was emphatic in his conclusion that the prestige accorded the *artiste décorateur* afforded France real commercial advantages.[29] From the point of view of this Report, the Exhibition's foregrounding of the designer defined as individual author (instead of industry or manufacturer) successfully established the status and desirability of the French exhibits, and hence, of French commodities. This emphasis on the designer was interpreted not only as the lesson but also as the commercial threat posed by France to a nation such as the United States, with its economy based largely on industrial mass-production.

To devote a whole exhibition group (Groupe 3) to 'la parure' therefore involved not only the definition of *couture* as an *art décoratif* but also more generally, a particular status for a French 'art décoratif moderne'. As one guidebook to the 1925 Exhibition proclaimed:

> Is clothing – at least in its affiliation with the feminine toilet – a decorative art? It is, without a doubt, and the most venerable, that which leads all the others. It is also the art which relates most closely to modernity as it lives on surprise and novelty. In France, fashion is a major issue, a supremacy to which all our rivals must accede.[30]

An identification with the production of *haute couture* was an important means of promoting Paris as the centre of modernity and consequently France as 'in advance' of other nations. Women's fashion – *la couture* – defined the modern as the ephemeral, as the 'toujours du nouveau'.[31] Not only women's dress, but also everything to do with her toilette, embodied this quality of the 'ever-new'. As the *Encyclopédie* commented: 'everyone finds it natural that fashion textiles should be designated by the term "nouveauté"'.[32] *Haute couture* provided one means of responding to the Exhibition regulations, which stipulated an *art décoratif* characterised by 'new inspiration and real originality'.[33] The Exhibition's promotion of Paris as a woman's city involved an inversion of those metaphors used elsewhere to construe the 'regressive' as opposed to the truly modern. Adolf Loos, for example, writing in late 1890s' Vienna, had deployed sartorial arguments in order to claim London as the capital of modernity. According to Loos, it was the discretion and anonymity of the Englishman's suit that functioned as the prime indicator of modernity.[34] Fashion (as manifested by rapid changes

in female dress), on the other hand, constituted a kind of barometer of the fluctuations of a deviant sensuality.[35] For Loos, 'Paris' as the acknowledged site of fast-changing *couture* signified the means of catering to degenerate tastes through the endless production of simulacra of the female body: 'clothing sharply emphasized rounded voluptuousness and ripe femininity. Whoever did not already possess these had to counterfeit them: *le cul de Paris*.'[36] By contrast with the counterfeit 'cul de Paris', Loos advocated the Englishwoman's tailored suit as evidence of that nation's 'advanced' potential for platonic love: 'the woman may be no more than a good friend to the man'.[37]

The Exhibition's *Encyclopédie*, by contrast, praised feminine coquetry and explicitly deployed the imagery of theatrical illusion in order to define the well-dressed, fashionable woman as an artist of stage effects:

> There is hardly any social ritual that is not allied to the theatre: in the fashionable tearoom, at the Longchamp racecourse, supper at a friend's, an evening in a theatre box and, even far from Paris, at a mountain hotel or on a fashionable beach, the modern woman is, like her coquettish ancestors, a stage performer.[38]

Modern life was defined as a sequence of social rituals analogous to theatrical *mises-en-scène* in which woman dressed herself for the star role. This idea of femininity as inherently 'theatrical' – of woman putting her fashionably clad and adorned body on show – was further played out at the 1925 Exhibition with a prize-winning display sponsored by the *couturière* Jeanne Lanvin (plate 16). This took the form of a *loge d'artiste* – an actress's dressing room.[39] Here, an inanimate mannequin dressed in a Lanvin gown was seated in front of a dressing-table adorned with Lanvin perfume bottles – an exhibit which neatly encapsulated scenarios of the stage, the toilette and of *haute couture*. The *loge d'artiste* presented *décoration* through a conflation of feminine self-adornment (the 'art' of the toilette) and of décor (the illusion of the stage-set).

The idea of Paris as a feminised or 'woman's city' related to (indeed formed part of) the well-established discourse of the 'Parisienne'. In Ralph Nevill's 1924 book *Paris of To-Day* the city was vaunted in terms of this figure:

> the beautiful city possesses one great and wonderful asset in the Parisienne who is unique [. . .].
> Largely due to her is it that a feminine grace subtly pervades the whole city and more than makes up for occasional squalid features which would not be tolerated in our more orderly if less attractive London.[40]

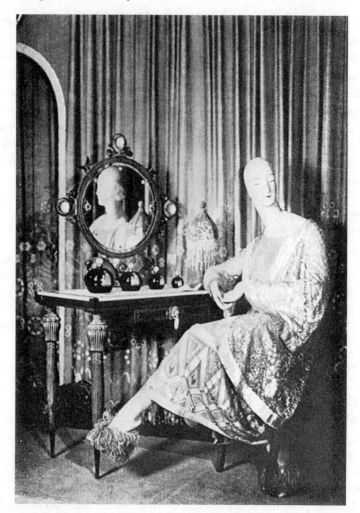

16 'Actress's dressing room by Jeanne Lanvin'. Photograph from *Encyclopédie*, vol. 10, plate IV

The 'feminine grace' of the 1920s' Parisienne was defined by contrast with the Anglo-Saxon woman:

> The Parisienne regards male admiration as a just attribute to her charms and admits that she frankly likes it. [. . .] As for despising dress, as some English women pride themselves on doing, that seems to the Parisienne too absurd for discussion. Being a woman she desires to be a real one, and not a gaunt slatternly creature of uncertain sex. As a matter of fact, between the extreme of these two feminine types – the dainty Parisienne and the Anglo-Saxon harridan in beetle-crusher boots – there is a great gulf fixed [. . .].[41]

The differences between Paris and London established by this repres-
entation of the Parisienne relate partly to the business of tourism – they
evoke the 'beautiful' French capital as object of a tourist gaze. (Books
such as *Paris on Parade*, *In and about Paris* and *Paris of To-Day* form a
category of literature generated by and for the tourist trade.) But there is
another gaze implied here, that of 'male admiration'. And it is precisely
the artifice of fashion (so derided by Adolf Loos) which is credited as dis-
tinguishing the Parisienne from the 'Anglo-Saxon harridan' as 'dainty'
and as a 'real' woman – in other words, as desirable. (Similarly, *Paris on
Parade* attributed the 'luxury of Paris itself' to the fact that it was a 'city
preoccupied with adorning the adored'.)[42] Paris as a 'woman's city' there-
fore involved not only woman's 'dream' of being well dressed, but also
the legitimation of a desiring male gaze. A consideration of the 1925
Exhibition in terms of this feminised city – as one more representation
of Paris as a 'woman's city' – reveals the extent to which the Exhibition
produced and reproduced gendered as well as national identities.

The boutique and the *pavillon*

Like the notion of Paris as a 'woman's city', the epithet *Paris ville
lumière* involved a particular set of representations aimed at promoting
the French capital nationally and internationally. Both constituted long-
standing identities for Paris which were reformulated during the recon-
struction years. Among the various versions of the 'city of light' offered
by the 1925 Exhibition, some quite explicitly coincided and overlapped
with the invocation of a 'woman's' Paris. The Fête du Théâtre et de la
Parure (as we have seen) fused the idea of Paris as international centre
of *haute couture* with that of Paris as the city by night, the artificially
illuminated city of entertainment and spectacle. (And the Exhibition
by night appeared frequently as the *mise-en-scène* in contemporary fash-
ion illustration.)[43] But it was undoubtedly Dufrène's rue des Boutiques,
with its spectacular nocturnal lighting effects, which most forcefully
evoked this feminised *ville lumière*. Along the pont Alexandre III, forty
boutiques showcased an impressive range of Parisian luxury industries,
with the products of *haute couture* predominating.[44] This was an urban
thoroughfare comprised entirely of brilliantly lit shop-windows in which
the boutique defined not only *la rue* but also Paris itself.

The identification of boutique window and city operated by day
as well as by night. Strolling along the street of shops on the pont
Alexandre III provided the Exhibition-goer with dramatic views of the
city centre (plate 17). Here the boutiques were viewed against the

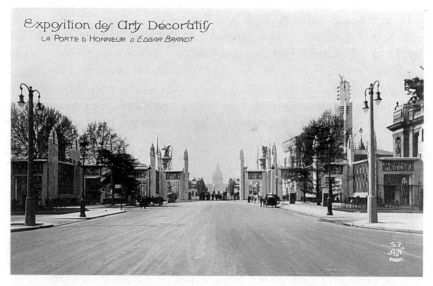

17 Panoramic view of the 1925 Exhibition, from the Porte d'Honneur across the pont Alexandre III to the Invalides

18 View of the Eiffel Tower from the rue des Boutiques. Photograph from *Encyclopédie*, vol. 11, plate III

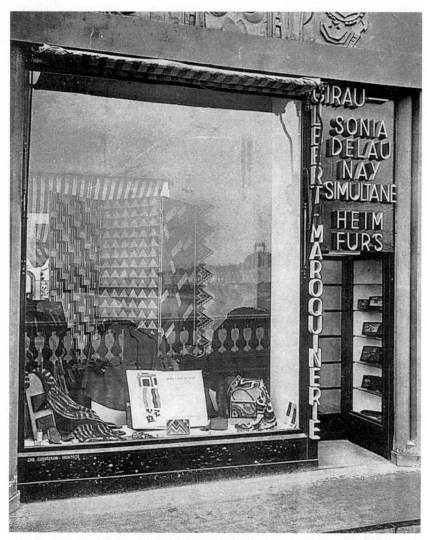

19 Boutique Simultanée, plate 1 of René Herbst, *Devantures, vitrines, installations de magasins à l'Exposition Internationale des Arts Décoratifs Paris 1925*

backdrop of Paris, thus establishing a visual connection between luxury commodity and city (plate 18). At the same time, the light of day turned each boutique window into a kind of mirror. This mirroring effect appears in a photograph of Sonia Delaunay's Boutique Simultanée published in René Herbst's album *Devantures et vitrines de magasins à l'Exposition de 1925* (plate 19).[45] Framed by the shop-window, Paris appears as a shimmering screen which in turn frames the exhibits on

show in the *vitrine*. Like the camera, the shop-window could capture the image of Paris on a glass surface. By day as well as by night *Paris ville lumière* involved the orchestration of urban looking, the look of the window-shopper as much as the look of the audience in the music hall. The conceit of the Exhibition as a 'capitale provisoire' was symptomatic of the organisers' concern with just how the 1925 Exhibition would frame the exhibits on show. Official publications repeatedly stressed that as opposed to the classifications of a 'fair' or a 'museum' (or, indeed, of previous Paris exhibitions) the 1925 Exhibition would consist of every-day settings – a 'présentation vivante'.[46] Although the boutique was only one of several devices claiming this status of 'présentation vivante' in 1925, the prominent siting of the rue des Boutiques in the centre of the Exhibition reveals the degree to which it was Paris as both 'a woman's city' (world centre of shopping) and as *ville lumière* that defined the Exhibition as a 'city within a city'.

Le Corbusier's Pavillon de L'Esprit Nouveau (positioned to one side of the Grand Palais) involved a very different representation of the city from that afforded by the street of boutiques on the pont Alexandre III. By contrast to the bridge (located at the heart of both the Exhibition and of Paris) with its dramatic vistas of the monumental centre of the French capital, the depiction of Paris in the Pavillon's town-planning exhibition directed the viewer's gaze away from the spectacle of the contemporary city to that of the city of the future. The Plan Voisin, Le Corbusier's scheme for the redevelopment of Paris, was presented in the form of a diorama, 'the aim of which is to objectify for the eyes that innovation [*cette nouveauté*] for which our spirit is not yet prepared' (plate 20).[47] Where the street along the pont Alexandre III deployed the boutique as the context for the display of exhibited objects, Le Corbusier presented the conjunction of town-planning projects and model home. The Pavillon's didactic lightshows on the subject of architecture and town-planning were a challenge to the *ville lumière* promoted by the Exhibition's enticing displays of luxury goods: 'Light is the organising principle of architecture. Light is also human pleasure. It belongs to every-one (by right). Wealth cannot turn it to profit; sunlight belongs to everyone (so to speak); and, to dream of it, is the business of urbanism.'[48] Light was construed as ordering an architecture which would in turn (through *urbanisme*) impose order on the city. This *ville lumière* – the product of natural sunlight rather than the artificial lighting of 'Paris by night' – symbolised the clear light of reason.[49] The claim for a universal 'right' to sunlight contrasted sharply with the exclusivity of expensive goods on show throughout the Exhibition.

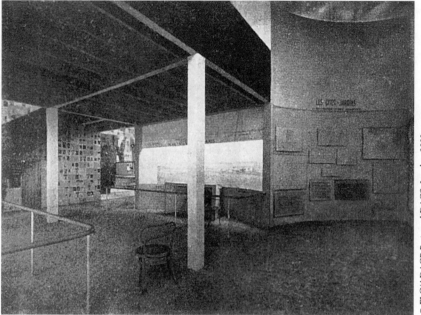

20 'Diorama of the "Plan Voisin de Paris"', photograph from Le Corbusier, *Almanach d'architecture moderne* [published 1926], p. 151

The Esprit Nouveau version of *Paris ville lumière* advocated 'utensils' produced by anonymous industry as opposed to artistically crafted objects of display. 'Glitter is going under', asserted Le Corbusier in *The Decorative Art of Today*.[50] Glitter, that is, in the sense of gleaming jewels or artificial lighting – of the Exhibition as 'a giant jewel box'. Le Corbusier proposed instead the unornamented sheen of industrially produced, standardised objects, the 'sparkling taps' of a wash-basin, for example, 'artefacts that are polished and absolutely pure . . . products . . . shining, clean'.[51] Le Corbusier's eulogy of wash-basins and bidets in *The Decorative Art of Today* stands in direct line with the Loosian praise of the plumber as 'pioneer of cleanliness' and as the 'quartermaster of culture'(plate 21).[52] Like Loos (whose essay 'Ornament and crime' was enthusiastically cited in *The Decorative Art of Today* as 'that sensational article'), Le Corbusier identified cleanliness and the products of plumbing as the signs of progress as opposed to 'water for looking at' – as embodied by the myriad fountains that adorned the 1925 Exhibition and nowhere more ostentatiously than with the waterfall emitted by night from the pont Alexandre III.[53] According to Le Corbusier, the pleasure involved in the contact with smooth shining surfaces of machine-made objects had as much to do with touch as with sight:

Maison Pirsoul.

AUTRES ICONES LES MUSÉES

21 Chapter heading with illustration of bidet in Le Corbusier's *The Decorative Art of Today*, 1925, p. 15

the machine brings shining before us disks, spheres, the cylinders of polished steel, polished more highly *than we have ever seen before*: shaped with a theoretical precision and exactitude *which can never be seen in nature itself*. Our hand reaches out to it, and our sense of touch *looks* in its own way as our fingers close around it.[54]

As for Loos, so for Le Corbusier such smooth and polished surfaces designated positively as the unornamented and the undecorated – as the lack of visual enticement.[55]

In his essay 'The decorative art of today' in the book of that name, Le Corbusier put forward an explicitly Loosian argument:

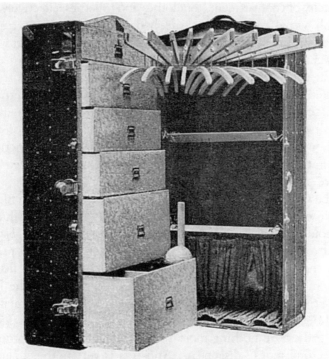

Malle « Innovation ».

22 Innovation trunk as illustrated in Le Corbusier, *The Decorative Art of Today*, 1925, p. 98

Decoration: baubles, charming entertainment for a savage. . . . But in the twentieth century our powers of judgement have developed greatly and we have raised our level of consciousness. [. . .] It seems justified to affirm: *the more cultivated a people becomes, the more decoration disappears.* (Surely it was Loos who put it so neatly.)[56]

This essay is illustrated with the kind of elegant leather goods – luggage and wallets – so admired by Loos, a pointed contrast not only to the 'trashy' decorated objects cited in the article but also to the *nécessaires*, the richly ornamented and bejewelled vanity cases on show in the 1925 Exhibition. Even more of a contrast with the *nécessaire*, however, was that implied by another illustration in the same essay – that of an Innovation trunk (plate 22). Whereas the *nécessaire* implied making-up and adornment, Le Corbusier advocated the Innovation trunk in terms of classification and order. The *nécessaire* played a role in rendering the (female) body spectacular. The Innovation trunk, however, with its

multiplicity of compartments for clothes and toiletries, effectively 'packed away' all visual references to the body. The Innovation trunk also featured prominently in the *Almanach d'architecture moderne*, where Le Corbusier claimed it as a 'real *modern decorative art*' as opposed to the 'objet dit de Paris'.[57] The simplicity and practicality of the trunk was contrasted with the Parisian *arts décoratifs* industries concerned with manufacturing 'decoration which "enriches"' (precisely those industries so prominently displayed along the pont Alexandre III).[58] More importantly, however, for Le Corbusier, the Innovation trunk functioned as an inspiration for the architect, a model for the mass-produced 'built-in furniture' that would '"enliven" the wall'.[59]

Le Corbusier's preoccupation with the Innovation trunk reveals a double concern with the architectural wall. On the one hand, the wall should be composed of components based on '*type objects* that respond to *type needs*' (in other words, mass-produced and practical), and on the other, it should not be construed as a visually distracting surface. In his account of the metal Ronéo doors used in the Pavillon de L'Esprit Nouveau, Le Corbusier stressed that: 'Ronéo metal doors are without visible door frames; they are smooth and can be hidden in the wall; they are nothing more than a human entry; the doorway as "architectural motif" disappears. And this is yet another liberation.'[60] As with the Innovation trunk, the Ronéo doors afforded Le Corbusier the opportunity to disparage the *arts décoratifs* industries as obsolete. At the same time (again like the trunk) the Ronéo metal doors were cited as the means of designing a visually inconspicuous doorway and wall. For Le Corbusier, however, standardised objects such as the metal door were the means of producing an order which defined not only the wall but the identity of modern architecture itself:

> the power of architecture (the potential of architecture) is integral to the spirit that orders the grouping of the elements that make up the house; – because architecture *emanates*, and does not clad; it is more an odour than a drapery, *a state of aggregations*, more than an enveloping surface.[61]

'Order' was also, according to Le Corbusier, evident in nature. He used images such as the 'snail' and the 'cell' to evolve a range of metaphors which stressed modern architecture as 'emanation' and 'aggregation' as opposed to 'surface'.[62]

The Pavillon de L'Esprit Nouveau project (that is, the Pavillon and accompanying texts) thus defined itself as the antithesis of other Exhibition displays such as the pont Alexandre III, where the rue des

Boutiques was constructed as a sequence of eye-catching architectural surfaces. Whereas Le Corbusier's intention in using Ronéo doors in the interior of the Pavillon was to redefine the doorway as an almost invisible 'passage d'homme' (as opposed to an ostentatious architectural motif), Dufrène's design for the pont Alexandre III transformed the bridge as component of urban transport into a means of visual display. (Similarly, elsewhere in the Exhibition, a Galerie des Boutiques masked two entrances to a railway station).[63] Unlike the cities advocated by Le Corbusier in his town-planning exhibits, the Exhibition as a 'city within a city' clearly prioritised the requirements of spectacle over efficient transport. As opposed to the 'real materials' Le Corbusier claimed to have used in building the Pavillon as a prototype for housing in the modern city, the 'street' on the pont Alexandre III was an overtly temporary surface superimposed on the permanent structure of the bridge, fake shops constructed out of *pierre liquide*.[64] The rue des Boutiques unabashedly represented the city street as a sequence of alluring façades.

One of these boutiques in particular epitomised all that Le Corbusier so vociferously rejected with his Pavillon de L'Esprit Nouveau project. Sonia Delaunay's Boutique Simultanée was one of several fashion boutiques on the bridge, but it was distinctive in that Delaunay was, like Le Corbusier, a well-known member of the Parisian avant-garde. Delaunay's exhibit (with its fashions, textiles and fashion accessories) clearly sustained the motif of Paris as a 'woman's city'. With *The Decorative Art of Today*, on the other hand, Le Corbusier took up the Loosian advocacy of the well-dressed gentleman as *the* signifier of modernity: 'But at the same time, the railway engines, commerce, calculation, the struggle for precision, put his frills in question, and his clothing tended to become a plain black, or mottled; the bowler hat appeared on the horizon.'[65] Whereas for the purposes of the Exhibition, Delaunay presented her designs in conjunction with the Parisian furrier Heim, Le Corbusier stressed his affiliation with technology and mass-production industries (such as Ronéo). Le Corbusier's modern city was ostensibly based on anonymous, unostentatious components, on standardised objects and architecture as embodied by the anonymity of the suited male body. The city defined by the Boutique Simultanée was construed in terms of the fashionably dressed Parisienne as well as the up-to-date shop-window. With the Boutique it was women's fashion – as opposed to urbanism – that defined *nouveauté*.

Both Boutique and Pavillon promoted a notion of modernity in terms of geometry, but where Simultaneous fashions and textiles involved geometry as the product of an individual artistic style, geometry

was for Le Corbusier associated with the anonymity of the machine: 'The machine is all geometry. Geometry is our greatest creation and we are enthralled by it.'[66] Sonia Delaunay's abstract-patterned Simultaneous clothing was made up of expensive materials (such as fur and silk); these fashions and fashion accessories mapped geometry on to the body of the wearer in order to create a luxurious and ornamented surface. For Le Corbusier, on the other hand, geometry was the means of effecting the radical replanning and rebuilding displayed in the Pavillon diorama of 'the enormous Plan Voisin for Paris with a large geometric grid in its centre'.[67] With the Voisin Plan, geometry as structure was opposed to geometry as surface decoration, order to visual display. At the 1925 Exhibition, Simultaneous fashions – like the Tiller Girls – identified geometry with woman. In both cases, geometry played its part (as clothing and as dance routine) in transforming the female body into a spectacle of luxury. Le Corbusier followed Loos in rejecting surface ornamentation as illusion and deceit: 'decoration hides faults in [...] manufacture and the poor quality of [...] materials: decoration is disguise'.[68] According to L'Esprit Nouveau, geometry ('divine' and 'precise') was manifested by the machine not the adorned female body.

At the 1925 Exhibition, descriptions of appropriately modern and (most importantly) truly French *arts décoratifs* were repeatedly defined through references to feminine allure. Contemporary French furniture and interiors were, for example, described via analogy with developments in women's dress:

> In the days when women covered their faces with thick veils, apartments were dark & the windows blind. Today's sporty women love light & easy ventilation. Their desire for floods of light has prompted decorators to discover light colours & architects to open up large bays in the walls.
> Even the shape of furniture changes according to women's fashion.[69]

This distinctively French modernity was explicitly associated with the seductiveness of the female body and identified as quite different from a Loosian 'puritan reform'.[70] The Exhibition's emphasis on femininity can be regarded as a refutation of Loosian theory in favour of an earlier (and significantly, a French) theorisation of the role of ornament. Woman's body had been deployed as an extended metaphor for the processes of ornamentation in Charles Blanc's 1875 *Art in Ornament and Dress*, which he presented as the extension of his earlier (1867) *Grammaire historique des arts du dessin*.[71] *Art in Ornament and Dress* consists of two sections, a short introduction on 'The general laws of ornament' followed by lengthy exposition of these 'laws' in the form of a treatise on 'Personal adornment'.

Like Loos, but in very different terms, Blanc had argued a theory of ornamentation through reference to dress and self-adornment. Chapter 14 in *Art in Ornament and Dress* – in the section on 'Personal Adornment' – is devoted to woman's toilette. Ostensibly a list of handy tips on the suitable adornment of the female body, this essay identifies woman as the natural artist of self-ornamentation. For Blanc, woman's 'art' in modifying bodily imperfections by deceiving the eye through the shape and accessories of her dress was not only a demonstration of ornamentation but also a metaphor for the function of ornament itself. Blanc argued that woman's toilette was the paradigmatic means of recuperating a lost harmony and geometry of the body. According to Loos (as we have seen) this notion of decoration as disguise was epitomised by woman's fashion and her attempt to arouse a male sexual desire by substituting the artificial body of her dress for the defective body it covered. The leader of women's fashion was thus inevitably, claimed Loos in his essay on 'Ladies fashion', the 'coquette'.[72] When Blanc, on the other hand, referred to the 'intuition of coquetry' (inherent in all women) as the principal motivation of self-adornment, he intended no such disparagement.[73]

In their discussion of female fashion, both Loos and Blanc associated ornamentation with sexuality and desire. Something concerning the nature of that desire is revealed in the language used to espouse the theory. In the case of Blanc, for example, an essay on 'all the details which form a woman's dress', advocated the bodice as a means 'to hide, yet to display'.[74] Similarly, in connection with hats, a particular form of veil – made of a material called 'tulle illusion' – is described as: 'perhaps only a means of attracting attention, and of making conspicuous what there is an appearance of wishing to conceal'.[75] Blanc characterised this double movement in terms of theatricality, the stage-set producing, he claimed: 'a double pleasure, first of all that of being deceived, and then that of becoming aware of the deception'.[76] The 'tulle illusion' implies femininity itself as veil, beautiful only as illusion and deceit. More specifically, the illusion promoted by Blanc's theory of ornamentation seems to be analogous to that associated with fetishism – the obsessive looking at artificial substitutes for the body. Described as devices for both escaping and ensnaring the gaze, the 'bodice' and the 'hat' reflect the dynamic of the fetishist's simultaneous acknowledgement and denial of an incomplete and flawed female body.[77] The glittering web of the Tiller Girls' 'Rivière de Diamants' might thus be construed as the 'tulle illusion' writ large – a dramatisation of the idea of decoration as simultaneously displaying and reconfiguring the female body. The imagery of diamonds was all too apt: in his *Art in Ornament and Dress*, Charles Blanc had argued that the value of diamonds and other jewels

lay not in any inherent quality of the gem but rather in 'a new crystal-lisation' effected in the cutting of the stone: 'they are never perfectly beautiful without the lapidary's aid. [. . .] He perfects the beauty of the gems, by calling geometry to the sun's aid.'[78] The diamond was thus represented not only as a specifically feminine adornment, but also as analogous to woman herself who, like the jewel, could never be 'per-fectly beautiful' in her natural (unadorned) state. Like the diamond, woman's body required surface modification – the work of *la toilette* – in order to achieve the condition of beauty.

Le Corbusier's anti-decorative stance in 1925 involved an em-phatic rejection of illusionism and theatricality, and in particular (as revealed by his choice of the black-suited, bowler-hatted man as an icon of modernity) the rejection of visual ostentation and display asso-ciated with the female body. As indicated by the example of the Bou-tique Simultanée, at the 1925 Paris Exhibition, eye-catching, decorative surface was a characteristic not only of women's dress (such as Simul-taneous fashion) but also of architecture (the boutique façade and its *vitrine*) and hence of the city street itself. Le Corbusier claimed 'our pavilion is architecture, not decorative art'.[79] The boutique, on the other hand, seemed to confound this opposition, appearing at the Ex-hibition as both architecture and as decoration (temporary ornament to the permanent fabric of the city). As an exhibition display device, the boutique explicitly represented not only *l'art décoratif* but also the city street in terms of spectacle and a desiring look. Emblematic of 'Paris as a woman's city', the boutique implied two looks: that of woman engaged in her toilette (the look into the *nécessaire*) and that of the *flâneur* with his admiration of the well-dressed Parisienne. Le Corbusier's challenge with the Pavillon de L'Esprit Nouveau project to decoration as 'deceptive' surface was thus not merely a critique of the displays of lavishly decorated commodities at the Exhibition but also an attempt to contest the means whereby the modern city was represented.

The town-planning dioramas on show in the Pavillon de L'Esprit Nouveau formed part of this contestation as did Le Corbusier's praise (in *The Decorative Art of Today*) of the Eiffel Tower, *the* symbol of the city of Paris: 'In 1925, it dominated the Exhibition of Modern Decor-ative Arts. Above the plaster palaces writhing with decoration, it stood out pure as crystal.'[80] Le Corbusier found geometric perfection in nat-urally generated forms rather than in the faceted diamond (product of the skill and artistry of the lapidary): 'the matrix of amethyst split and polished, or a lump of rock crystal set on my desk is [. . .] an exemplar of the glittering geometries that enthrall us that we discover with delight in natural phenomena'.[81] Le Corbusier proposed an 'engineer's aesthetic'

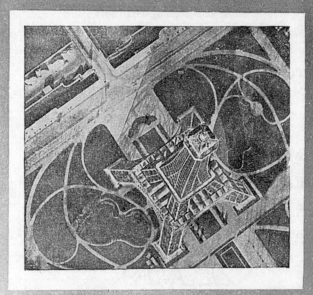

LE CORBUSIER

L'ART DÉCORATIF D'AUJOURD'HUI

LES ÉDITIONS G. CRÈS ET Cⁱᵉ
21, RUE HAUTEFEUILLE, 21
PARIS

23 Front cover of Le Corbusier's *The Decorative Art of Today*, 1925

as opposed to the aesthetic of the diamond, the crystalline 'purity' of the Tower implying an analogy between construction with standardised components and natural processes of crystallisation. It was in this sense that the Eiffel Tower was acknowledged as both worthy antecedent for the Pavillon and appropriate cover illustration to *The Decorative Art of Today* (plate 23). Le Corbusier was not alone, however, in appropriating the Eiffel Tower. An advertisement for Sonia Delaunay's Simultaneous

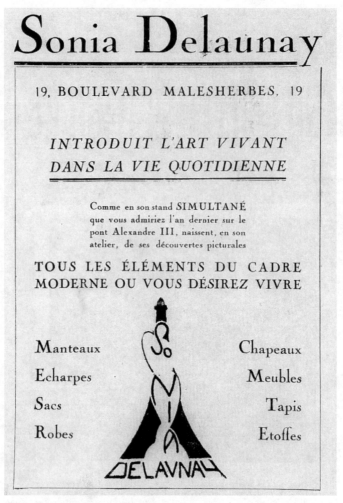

24 Advertisement for Sonia Delaunay in *Programme de la Comédie des Champs-Élysées*, 1925–26, n.p.

designs which appeared in a theatre programme for the Comédie des Champs-Élysées (just around the time of the Exhibition) prominently displayed a logo based on the visual conflation of her name with the shape of the Eiffel Tower (plate 24). Here the word 'Sonia' was transcribed in the form of a curvaceous female figure – an evocation of Paris as 'a woman's city' (with its 'authority of names') as opposed to that of the 'engineer'.[82]

In the context of French reconstruction, metaphors of light took on a particular significance, but far from self-evident such metaphors were

energetically contested. At the 1925 Exhibition, the Pavillon de L'Esprit Nouveau and the Boutique Simultanée offered conflicting versions of a *Paris ville lumière*: here the 'machine for living in' confronted the 'théâtre de présentation'.[83] Le Corbusier's notion of a *ville lumière*, geometrically ordered and flooded with sunshine, was a response to post-war Parisian housing shortages but it also resonated symbolically. In the mid-1920s, such paeons to light referred not only to the health of the individual but also to that of the nation. By comparison with Le Corbusier's urbanistic polemic, the spectacles of *eau* and *lumière* at the pont Alexandre III might seem like a vulgarised, fairground restaging of past pageantry and ritual (such as that associated with the French royal court).[84] But this bombastic display signalled a modernity highly pertinent to the revitalisation of post-war France: the cascades of light celebrated specifically modern and urban rituals – those of shopping and consumption. The illuminated *jet d'eau* therefore conjured up a city quite as modern as that proposed by the Pavillon de L'Esprit Nouveau. In order better to understand Le Corbusier's vehement rejection of that city – his assertion of an aesthetic of the 'engineer' as opposed to that of the shop-window – it is necessary to examine in more detail the status of the boutique in 1920s' Paris.

Notes

1 Robert Forrest Wilson, 'An apéritif on the terrace', *Paris on Parade*, The Bobbs-Merrill Company, Indianapolis, 1924–25, p. 113.

2 For an argument on Paris as sexualised and feminised, see Elizabeth Wilson, 'The city of the floating world: Paris', *The Sphinx in the City: Urban Life, the Control of Disorder, and Women*, Virago Press, London, 1991.

3 'Groupe de la parure', *Encyclopédie*, vol. 9, p. 9. Shane Adler Davis has written as follows on women's shopping in relation to nineteenth-century Paris exhibitions: 'The Exposition became linked to commercial enterprise in 1878; to the public mind, the two institutions – Exposition Universelle and department store – were equivalent in their common goal of paying tribute to womanhood.' See Shane Adler Davis, ' "Fine cloths on the altar": the commodification of late nineteenth-century France', *The Art Journal*, Spring 1989, vol. 48, no. 1, pp. 85–9.

4 Wilson, 'An apéritif on the terrace', p. 113. For a rather different discussion of Paris as a 'woman's city', see Andrea Weiss, *Paris was a Woman: Portraits from the Left Bank*, Pandora, London and San Francisco, 1995.

5 Wilson entitled chapter 4 of his book 'The commerce of vanity'.

6 According to the official report on the 1925 Exhibition published by the British Department of Overseas Trade: 'Of the women's costumes, especially in the French Section, it is observed that "very many of them appeared to be exceptional pieces which were certainly not to be seen anywhere in the daily life of the people of Paris".' 'Introductory survey – 2. Representative character', Reports on the Present Position . . . , p. 13.

7 Sisley Huddleston, 'Around the Champs-Élysées', *In and about Paris*, Methuen & Co. Ltd, London, 1927, p. 179.

8 Thérèse and Louise Bonney, *A Shopping Guide to Paris*, Robert M. McBride & Co., New York, 1929, pp. 115–16. Thérèse Bonney is today better known as a photographer.

9 *Le Livre d'adresses de madame (annuaire de la Parisienne): répertoire des principaux spécialistes & fournisseurs parisiens ainsi que de multiples adresses d'ordre pratique; pour tout ce qui intéresse la femme et la maîtresse de maison*, Rédaction & direction Mme. J. Bredeville, Paris, 43rd edn, 1922.

10 'Vêtement – section française', *Encyclopédie*, vol. 9, p. 21. See also Germaine Deschamps: 'Les industries de la *couture*, de la mode, de la lingerie et de la fourrure sont un des principaux facteurs de notre expansion économique dans le monde: en 1925, elles occupaient le second rang dans notre commerce d'exportation.' (Germaine Deschamps, *La Crise dans les industries du vêtement et de la mode à Paris pendant la période de 1930–1937*, Librairie Technique et Économique, Paris, 1938, p. 2 – according to Deschamps, the years 1925–29 were 'des années de prospérité exceptionnelle' for these industries.)

11 Wilson, *Paris on Parade*, p. 36. Deschamps confirms the economic importance of these Parisian industries; see Deschamps, *La Crise*, p. 1.

12 Wilson, *Paris on Parade*, p. 68: 'where were some of the shaggy workers of *la couture* during the fuss with Germany? If they were right in their studios designing models, they were doing the patriotic thing; for the French government must not cost Paris her leading industry'. See David Cottington, *Cubism and the Politics of Culture in France 1905–1914*, PhD Thesis, University of London, 1985, pp. 64–5 on the committee for the defence of *grande couture* established by Paul Poiret and other *couturiers* during the First World War.
 On *couture* and the First World War, see also Steele 'War and fashion', *Paris Fashion*, pp. 235–41.

13 Wilson, 'Our Parisian village', *Paris on Parade*, p. 294. Concerning the Parisian *haute couture* houses, Meredith Etherington-Smith points out: 'Obviously, the first show was crucially important, for this was where the commercial buyers, those who would purchase models to copy for general distribution, chose their models. The American stores, by virtue of their spending power, traditionally had the first show to themselves.' (Meredith Etherington-Smith, *Patou*, Hutchinson, London, 1983, p. 43.)

14 Wilson, *Paris on Parade*, p. 298.

15 Etherington-Smith, *Patou*, p. 23.

16 Huddleston, *'Around the Champs-Élysées'*, p. 177.

17 'Avant-propos', *Exposition Internationale des Arts Décoratifs et Industriels Modernes*, Imprimerie de Vaugirard, Paris, 1924, n.p.

18 'The Exhibition regulations exclude "paintings, sculpture and work which does not form part of a decorative ensemble"'. ('Meubles et ensembles de mobilier – hygiène, air et lumière'), *Encyclopédie*, vol. 4, p. 14.

19 M. Bokanowski, 'L'Exposition de 1925 et les artistes – notre enquête', *L'Amour de l'Art*, January 1924, 5e année, no. 1, p. 32.

20 Huddleston, 'Around the Champs-Élysées', p. 177.

21 Wilson, *Paris on Parade*, p. 37.

22 Paul Poiret, *My First Fifty Years*, Victor Gollancz, London, 1931, p. 295.

23 See Malcolm Gee on, among others, Paul Poiret as collector in chapter V 'Collectors – 5. The artistic connection', *Dealers, Critics, and Collectors of*

Modern Painting: Aspects of the Parisian Art Market between 1910 and 1930, PhD Thesis, Courtauld Institute of Art, University of London, 1977, pp. 194–6. Jacques Doucet's role as collector is discussed on pp. 200–4.

24 The associations of art can be seen as an attempt to maintain the 'mystique' of *haute couture* in a period when certain firms were adopting processes of standardisation; at Lelong, for example: 'the processes of his workrooms are sharply standardized' (Wilson, *Paris on Parade*, p. 75). In his book on Patou, Etherington-Smith makes the point that certain *couturiers* designed for both the private client and the mass-production market; see Etherington-Smith, *Patou*, p. 22.

25 Wilson, 'Model by Pack-Ann', *Paris on Parade*, p. 24.

26 Versions of this advertisement appeared in the arts magazine *La Renaissance de l'Art Français et des Industries de Luxe* in 1923 and 1924.

27 Molly Nesbit, 'What was an author?', *Yale French Studies*, Winter 1987, no. 73, p. 236.

28 Questions of copyright *vis-à-vis* the *arts décoratifs* had been an important issue since the late nineteenth century in France; see, for example, Debora L. Silverman, *Art Nouveau in Fin-de-Siècle France: Politics, Psychology and Style*, University of California Press, Berkeley, Los Angeles and London, 1989, p. 358.

 On the efforts of the Société des Artistes Décorateurs (founded in 1901) to modify the July 1793 law on artistic property with a view to the rights of *artistes décorateurs*, see Suzanne Tise, '1900–1914', in Yvonne Brunhammer and Suzanne Tise, *French Decorative Art: The Société des Artistes Décorateurs 1900–1942*, Flammarion, Paris, 1990, p. 18.

29 Department of Commerce, 'General observations', *Report of the Commission Appointed by the Secretary of Commerce to Visit and Report upon the International Exposition of Modern Decorative and Industrial Art in Paris*, Washington DC, 1926, p. 20 and p. 37.

30 Henri Clouzot, 'La Parure', *Paris Arts Décoratifs 1925 – Guide de l'Exposition*, Librairie Hachette, Paris, 1925, p. 224.

31 'Le principe [. . .] de la mode, est de faire toujours du nouveau' ('Parfumerie – section française'), *Encyclopédie*, vol. 9, p. 73.

32 'Parure', *Encyclopédie*, vol. 1, p. 65.

33 British Department of Overseas Trade, 'Rules and regulations', *Reports on the Present Position . . .* , p. 17.

34 Adolf Loos, 'Men's fashion', *Adolf Loos: Spoken into the Void. Collected Essays 1897–1900*, Oppositions Books, MIT Press, Cambridge (Mass.) and London, 1982, pp. 10–14. Loos's essays (1897–1900) were published as *Ins Leere gesprochen*, Paris–Zurich, 1921. These were published by Georges Crès & Cie. in France in 1921. For an extended and powerful argument on the significance of fashion in the theorisation of modern architecture, see Mark Wigley's important *White Walls, Designer Dresses: The Fashioning of Modern Architecture*, MIT Press, Cambridge (Mass.) and London, 1995. See also note 71 below.

35 Loos, 'Ladies' fashion', *Adolf Loos*, p. 100. This essay was originally published in the *Neue Freie Presse*, 21 August 1898 and then republished in *Dokumente der Frau*, 1 March 1902.

36 Loos, 'Ladies' fashion', p. 100.

37 *Ibid.*

38 'Parure', *Encyclopédie*, vol. 1, p. 65.

39 This was not the first time that an actress's dressing room had been used as an exhibition display device. See Suzanne Tise for a description of the exhibit

identified as a project for Sarah Bernhardt's dressing room at the 1904 Salon des Artistes Décorateurs, in Brunhammer and Tise, *French Decorative Art*, p. 30.

40 Ralph Nevill, *Paris of To-Day*, Herbert & Jenkins Ltd, London, 1924, pp. 16–17. On the significance of the nineteenth-century Parisienne, see Abigail Solomon-Godeau, 'The other side of Venus: the visual economy of feminine display', in Victoria de Grazia (ed.), *The Sex of Things: Gender and Consumption in Historical Perspective*, University of California Press, Berkeley, Los Angeles, London, 1996.

41 *Ibid.*

42 Wilson, *Paris on Parade*, p. 310.

43 See, for example, the illustration from *Art, Goût, Beauté* illustrated in Ginsburg, *Paris Fashions*, p. 21.

44 These included Fourrures Blondell, Fourrures Weil, Jungmann & Cie., T. Corby, Fourrures Max, Revillon & Cie., Sonia Delaunay et Heim, Maisons Dony, H. Vergne, Lina Mouton, Becker fils, Société des Chaussures 'Cecil' and Redfern. Most of the firms showing on the pont Alexandre III were Paris-based.

45 René Herbst, *Devantures et vitrines de magasins à l'Exposition de 1925*, Éditeur Charles Moreau, Paris, 1925, plate 18.

46 See, for example, the essay 'En guise de préface à une visite de l'Exposition' in the *Catalogue Général Officiel*.

47 Le Corbusier, 'Le Plan Voisin de Paris', *Almanach d'architecture moderne*, Éditions Connivences, Paris, n.d., p. 177. Originally intended to be number 29 of *L'Esprit Nouveau* (to coincide with the 1925 Exhibition), the essays appeared as a book in 1926. The Connivences edition is a facsimile reprint of the original book published by Les Éditions G. Crès et Cie.). All further references will be to the *Almanach*.

48 Le Corbusier, 'Le Pavillon de L'Esprit Nouveau', *ibid.*, p. 147.

49 Wolfgang Schivelbusch points out the dual significance of the epithet '*Paris ville lumière*': 'City of light, *ville lumière* – Paris gained this popular epithet thanks first to the eighteenth-century Enlightenment, of which it was the centre, and then to its brightly lit amusement boulevards, a product of the nineteenth century.' Wolfgang Schivelbusch, *Disenchanted Night: The Industrialisation of Light in the Nineteenth Century*, translated from the German by Angela Davis, Berg, Oxford, New York and Hamburg, 1988, p. 3. Christopher Prendergast also discusses lighting and the imagery of light in connection with Paris in *Paris and the Nineteenth Century*, Blackwell, Cambridge (Mass.) and Oxford, 1992, pp. 31–2, 222 (footnote).

50 Le Corbusier, 'The hour of architecture', *The Decorative Art of Today*, p. 135.

51 Le Corbusier, *The Decorative Art of Today*, p. 17 and p. 106.

52 Loos, 'Plumbers', *Adolf Loos*, p. 49.

53 Le Corbusier, *The Decorative Art of Today*, p. 134. Loos, *Adolf Loos*, p. 76. On the relationship of Loosian theory to Le Corbusier's writings, see Stanislaus von Moos, 'Le Corbusier et Loos', *L'Esprit Nouveau*, 1987, pp. 122–33 (published in English as 'Le Corbusier and Loos', *Assemblage*, 4, October 1987, pp. 24–37.

54 Le Corbusier, 'The lesson of the machine', *The Decorative Art of Today*, p. 112.

55 See, for example, Loos's pronouncement on leather goods and metalwork: 'smooth and polished, no ornament, no decoration' (A. Loos, 'The leather goods and gold- and silversmith trades', *Adolf Loos*, p. 7. The essay was originally published in the *Neue Freie Presse*, 15 May 1898.

56 Le Corbusier, 'The decorative art of today', *The Decorative Art of Today*, p. 85.

57 Le Corbusier, 'Procédés et matériaux nouveaux', *Almanach*, p. 196. See also Stanislaus von Moos, 'Malle INNOVATION', *L'Esprit Nouveau*, 1987, pp. 270–1.

58 *Ibid.*

59 *Ibid.* See Stanislaus von Moos, 'Mobilier encastrable INNOVATION', *L'Esprit Nouveau*, 1987, pp. 272–3.

60 Le Corbusier, 'Les Portes "Ronéo"', *Almanach*, p. 195. See also S. von Moos, 'Porte métallique RONÉO', *L'Esprit Nouveau*, 1987, pp. 184–5.

61 Le Corbusier, 'Inauguration du Pavillon de L'Esprit Nouveau à l'Exposition Internationale des Arts Décoratifs Modernes le 10 juillet 1925 – Une maison-outil', *Almanach*, p. 138.

62 For a reference to the 'snail', for example, see Le Corbusier, 'Le Pavillon de L'Esprit Nouveau,' *Almanach*, p. 147.

63 A sequence of sumptuous boutiques adorned in black, red and gold designed by Henri Sauvage masked one of the entrances to the Invalides underground station. 'Architecture – section française', *Encyclopédie*, vol. 2, pp. 31–2.

64 The rue des Boutiques on the pont Alexandre III occupied a prominent position in the centre of the advertisement for 'la pierre liquide' (Agence Générale 'Les Matériaux Réunis') in the *Catalogue Général Officiel*, n.p.

65 Le Corbusier, 'A hurricane', *The Decorative Art of Today*, p. 54.

66 Le Corbusier, 'The lesson of the machine', *ibid.*, p. 103.

67 Le Corbusier, 'Inauguration', *Almanach*, p. 137.

68 Le Corbusier, 'The decorative art of today', *The Decorative Art of Today*, p. 87.

69 'Meubles et ensembles de mobilier – section française – programmes modernes', *Encyclopédie*, vol. 4, p. 25. This identification of a specifically 'French' furniture and interior design via association with the female body was not new. The critical language of the debates on Bing's Art Nouveau design (in 1895 and again at the 1900 Paris Exhibition) is revealing in this regard. See D. Silverman, 'National initiative to international awakening: the maison de l'art nouveau Bing' and 'Conclusion: the 1900 Paris Exhibition', *Art Nouveau*, pp. 270–314. Also, Paul Greenhalgh, *Ephemeral Vistas: The Expositions Universelles, Great Exhibitions, and World's Fairs, 1851–1939*, Manchester University Press, Manchester, 1988, in particular pp. 188–95 of the chapter 'Women: exhibited and exhibiting'.

70 'La Décoration peinte et sculptée', *Encyclopédie*, vol. 2, p. 25.

71 C. Blanc, *Art in Ornament and Dress*, Chapman & Hall, London, 1877. Blanc's book was published in 1875; the English translation in 1877. See Mary McLeod, 'Undressing architecture: fashion, gender, and modernity', in Deborah Fausch *et al.* (eds), *Architecture: In Fashion*, Princeton Architectural Press, New York, 1994, pp. 38–123 for a historical contextualisation of Blanc's theory of dress *vis-à-vis* architecture. McLeod's essay provides a valuable overview of the use of sartorial metaphors in the theorisation of architecture.

72 Loos, 'Ladies' fashion', p. 102.

73 Blanc, *Art in Ornament and Dress*, p. 159. And the 'title' to chapter 15 is 'In spite of the innumerable variations which the art of dress admits, it is subject, like all other arts to the three invariable rules of beauty–order, proportion, and harmony'. For a discussion of French nineteenth-century debates on the significance of the feminine toilette, see Tamar Garb, 'The sex of art: in search of *Le Génie Féminin*', *Sisters of the Brush: Women's Artistic Culture in Late Nineteenth-Century Paris*, Yale University Press, New Haven and London, 1994.

74 Blanc, '14. Of all the details which form a woman's dress [. . .]', *Art in Ornament and Dress*, p. 151.

75 Blanc, '10. Fashion is closely connected with head-dressing in women, that is to say, the art of adapting the bonnet to the head, and of suiting it to the whole of the dress', *ibid.*, p. 115.

76 Blanc, 'Progression', *ibid.*, p. 23.

77 In Freud's terms, a 'castrated' female body. Laura Mulvey was one of the first to reconsider Freud's theory of fetishism as part of a feminist critique of visual representation; see her essay 'Fears, fantasies and the male unconscious *or* "You don't know what is happening, do you Mr. Jones?" ', originally published in 1973, reprinted in Laura Mulvey, *Visual and Other Pleasures*, Macmillan, Hampshire and London, 1989, pp. 6–13.

There is now a large literature on fetishism. Two recent publications include Sarah Whiting, Edward Mitchell, Greg Lynn, *Fetish*, Princeton Architectural Journal, vol. 4, 1992; and Emily Apter and William Pietz, *Fetishism as Cultural Discourse*, Cornell University Press, Ithaca and London, 1993.

78 Blanc, '16. Of all the arts which are treated in this book, the jeweller's and goldsmith's are the most valuable', *Art in Ornament and Dress*, p. 235.

79 Le Corbusier, 'Inauguration', *Almanach*, p. 134.

80 Le Corbusier, 'Argument', *The Decorative Art of Today*, p. xxv.

81 Le Corbusier, 'The decorative art of today', p. 98.

82 See the advertisement labelled as appearing in the *Programme de la Comédie des Champs-Élysées 1925–26* in Sonia Delaunay's *Album de presse*, Paris, Bibliothèque Nationale, Département des Estampes et de la Photographie, microfilm number M221715. An English version of the advertisement appears as M221714. By this date, the practice of both Robert and Sonia Delaunay was clearly identified with the theme of the Eiffel Tower; at the 1925 Exhibition Robert Delaunay exhibited a new version of the subject in Mallet-Stevens' entrance hall for an Ambassade Française.

83 The phrase 'machine for living in' appears as part of Le Corbusier's argument for 'Mass-production houses' in *Towards a New Architecture*, The Architectural Press, London, 1972, p. 240: 'We must look upon the house as a machine for living in or as a tool'. This book was originally published in 1923 by Éditions Georges Crès et Cie, Paris as *Vers une architecture*. Further references will be to the 1972 English edition (based on Frederick Etchells' 1927 translation). Le Corbusier subsequently referred to the Pavillon de L'Esprit Nouveau as 'une maison-outil' (*Almanach*, p. 138).

84 For other discussions of the ways in which the 1925 Exhibition involved references to a French 'past', see N. Troy, 'Reconstructing Art Deco', *Modernism*, p. 188; and Romy Golan's discussion of the Exhibition in *Modernity and Nostalgia: Art and Politics in France between the Wars*, Yale University Press, New Haven and London, 1995, in particular the sections 'Rusticizing the modern' and 'A young man's home'.

La boutique *and the face of modern Paris*

Since the war, Parisian commerce has produced a lively and charming face. At each street corner, *flâneurs* (if one can call them such) are surprised anew.[1]

The boutique had a venerable pedigree, but in the 1920s it could appear as unequivocally modern.[2] Despite its potentially picturesque connotations (evocations of medieval bridges laden with shops, for example) the rue des Boutiques on the pont Alexandre III (plate 25) had far more to do with notions of the modern city than with the nostalgia for a Vieux Paris associated with the display of that name at the 1900 Exhibition.[3] The idea of representing the modern-day city in terms of boutiques was not an innovation of the 1925 Exhibition. By this date in Paris, the architectural format of the boutique figured not only as a means of exhibition display but also as an important component of town-planning (*urbanisme*). This was apparent at the seventeenth annual exhibition of the Paris Salon d'Automne in 1924, whose Art Urbain section assigned pride of place to the project for Une Place Publique by the architect Robert Mallet-Stevens (plate 26).[4] Prominently positioned in the Grand Palais rotunda, the Place Publique took the form of a life-size model for a city square made up of ten boutiques selling expensive products such as *haute couture*, textiles, jewellery and components of interior design. The statutes revealed that the inclusion of 'Art Urbain' was a recent innovation on the part of the Salon:

> As a consequence of the changes in art and its increasingly intimate relationship with the needs of everyday life, the Salon d'Automne has

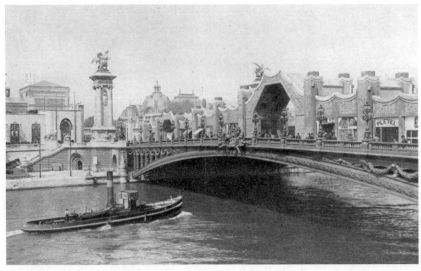

25 View of the rue des Boutiques on the pont Alexandre III in 1925

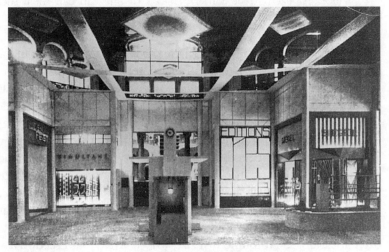

26 The Place Publique at the Salon d'Automne, Paris 1924

created a section for Urban Art [*Art Urbain*] in order to participate in the return to a rational order [*l'ordre logique*].[5]

The 1924 Salon d'Automne presented the boutique as a manifestation of post-war reconstruction and it was as *décoration urbaine* that the boutique was assigned a role in the national 'return to order'. The boutique's appearance at the heart of the 1925 Exhibition can therefore be understood not only as a means of displaying a range of *arts*

décoratifs but also in relation to the boutique's status as *décoration*. How – and in what terms – the boutique had come to be identified as *décoration urbaine* is the subject of this chapter.

My attempt to understand the significance of the boutique as an aspect of *urbanisme* will involve close scrutiny of the 1924 Place Publique which constituted a kind of dress rehearsal for the rue des Boutiques in 1925. Both projects took the form of an urban space defined as a sequence of luxury boutiques and the range of goods on show in these shops was much the same in 1925 as in 1924: women's fashions and fashion accessories, *bibelots* for the adornment of person as well as of home. In both cases, although the overall project was the responsibility of one man (Mallet-Stevens and Dufrène respectively), each boutique façade was designed by a different architect and the designers of the exhibits on show included many of the better-known Parisian *couturiers* and *artistes décorateurs*. First, however, I turn to a consideration of just how the Parisian boutique signified the modern in the years following the First World War.

Little shops

Characterisations of Paris as 'city of light' or as a 'woman's city' often involved (as demonstrated in the previous chapter) a notion of the French capital as the mecca of shopping. In *Paris on Parade*, Robert Forrest Wilson referred to the French capital as 'a gigantic gift and luxury shop'.[6] This association of specifically French forms of luxury with 'the shop' was energetically promoted by the post-war journal *La Renaissance de l'Art Français et des Industries de Luxe*. An essay on Parisian shop fronts in the December 1919 issue of this magazine claimed that:

> Travellers are (for once) unanimously agreed that Paris, world capital, is the only city in the universe with luxury boutiques: they are a particularly Parisian speciality; neither Rome nor Brussels nor even London can compete, and Kirby Bear appears much more elegant here than in the fog of his native city.[7]

The *Renaissance* (as suggested by its title) called for the revival of luxury industries as a means of ensuring a French cultural hegemony. The boutique was conceived as playing an important role in this assertion of a post-war 'renaissance' in so far as it was a means of conferring the status of luxury to the commodity. According to the 1919 essay, even the Anglo-Saxon teddy bear could be appropriated as an *article*

de Paris – rendered 'elegant' – through an appearance in the *vitrine* of the Parisian boutique. The boutique, it would seem, bequeathed to the commodity all those qualities so often attributed to the city of Paris itself: elegance, luxury, desirability. This (as indicated by the example of Kirby Bear) had less to do with the intrinsic qualities of the commodity than with the boutique as a means of display.

A preoccupation with the Parisian boutique was not confined to France. In England, for example, the *Architectural Review* published a breathless piece of writing under the title of 'Little shops of Paris'. Here again we find the association of Paris with the feminine: 'The idle wanderer among the streets of Paris cannot but be tickled at the elegance of the little shops whose sole purpose in life is to pander to the tastes of that most capricious, exacting and elusive creature, the lady of fashion.' What is revealing about this essay, however, is the effort invested in validating the boutique as the manifestation of woman's 'caprice':

> At first glance they can and are frequently dismissed by shallow-minded persons as being of no more account for serious attention than the hats, scarves, scent bottles, jewels and such-like works of the flesh and the devil which adorn their discreetly bedecked windows.
>
> This is, however, a mistaken and shortsighted view. For, apart from their obvious and rather vulgar desire to be nothing if not 'chic', there is an underlying sense of beauty of fitness, and, above all, a very high standard of quality.

The 'elegance' which preoccupied the author, Darcy Braddell, was characterised by exclusivity, and the effect of exclusivity was attributed (at least in part) to scale – these were *little* shops. Braddell constantly stressed the diminutive in order to evoke the precious: 'Gazing at its windows one observes but a small collection of enchanting little objects, exquisite little fripperies, chosen with discretion from the store within.'[8] These 'small shops' represented the luxurious, it would seem, through a rejection not only of the large-scale but also of quantity. Wilson used the word 'gigantic' in formulating his metaphor of Paris as a 'luxury gift shop', but this imagery gained its force partly because of the incongruous juxtaposition of the luxurious and the enormous. In fact, the 1920s' Parisian boutique presented its wares as luxurious by defining itself as definitively other to that category of shop which really was 'gigantic' – the *grand magasin*. This had to do not only with actual size but also with techniques of display. In Thérèse and Louise Bonney's *Shopping Guide to Paris*, Parisian department stores come across as outdated and

cumbersome institutions. The Bonneys' *Guide* claimed that American department stores were far more efficiently organised than their French counterparts, and that American shoppers in Paris were likely to find shopping in the *grands magasins* a bewildering experience. A few exceptions were listed:

> The one in which you will find yourself most at home will probably be Printemps, because there has been a certain Americanization of this store, evidencing itself in the featuring of popular American products like Parker fountain pens, Eversharp pencils, the beauty products of Harriet Hubbard Ayres, Elizabeth Arden [...] and in the partial adoption of American methods in some departments.[9]

The fundamental distinction, however, between luxury shop and *grand magasin* lay not so much in the range of stock as in the means whereby these two kinds of shop presented commodity to street. 'The French department store', claimed the Bonneys, 'is an amorphous thing [...] oozing out on to the sidewalks.'[10] This form of display was characterised by a profusion of cheap offers heaped on to the pavements in order to tempt the shopper into the store where the more expensive goods were put on show. Commodities were disgorged on to the street in order to overwhelm the consumer with sheer quantity. The *grand magasin* was pictured as a monumental and invasive structure overflowing its tackier goods on to the pavement, swelling in scale to occupy the whole street.

How different the Parisian 'small shop' where (in Braddell's words) the shop-windows were 'discreetly bedecked' and where 'exquisite little fripperies' were chosen with 'discretion'. Judicious presentation – a selective and discrete display to the street – identified the commodity as luxurious and the boutique as modern. 'One cannot help wondering', lamented Braddell, 'why the shopkeepers of fashionable Paris should have this sense of quality [...] and why those of London should lack it.' What London shops lacked, according to Braddell, was a sense of 'art'. He credited 'art' as the means of reconciling the contradictory attributes of discretion and attention-seeking embodied by these exquisite little Parisian shops:

> The practice is to take no notice at all of the styles of the building that is above or on either side but to consider the shop-front [...] as a picture frame [...]. The shop-front, however, has to fulfil more than the duties of a picture frame, for besides being becoming to its contents it must attract itself at long range, eg. from the other side of the street.[11]

The shop, or more accurately the shop *front*, established that differ-
entiation ('some very distinctive characteristic') so crucial to the mar-
keting of commodities. This was owing to the fact that the shop front
could be superimposed on to and insinuated into a variety of different
architectural settings. The shop might be not only a later vintage but
also different in style from the building to which it was attached. Accord-
ing to Braddell, the shop façade had as much to do with the commodity
it 'framed' as with architecture – this was indeed what rendered the
'small Paris shop' such an interesting architectural form. Similarly, in a
review of the 1925 Exhibition, the critic of the magazine *Beaux-Arts*
proclaimed the boutique shop front as 'one of the most rich architec-
tural motifs'. Here the boutique façade was credited as an exciting
manifestation of modern architecture thanks to its dramatic staging of
the commodity:

> the precious object, symbol of the merchandise on sale in the shop
> interior, is presented to the rapid glance of the passerby. Boutiques too
> have been simplified. The commercial tabernacle with its isolated,
> unique object has replaced the antique dealer's display.[12]

Other writers on the subject, however, were not so straightforwardly
enthusiastic. The architect René Herbst, both designer of and com-
mentator on shop fronts, was clearly rendered uneasy by this licence –
the ability of the shop front to exist as a self-contained entity – and
interpreted the result as potentially chaotic:

> There are two different conceptions of exterior decoration for shops.
> One, which is the more generally accepted, leaves the fancy of the
> designer absolutely free to exert itself without thinking at all of the
> remainder of the building. The other, which is less frequently met
> with, seeks to fit itself into the whole conception of the structure.
> The latter is undoubtedly to be preferred, but it is very exacting, and
> it is rarely successful unless the shop front is designed by the architect
> of the building itself.[13]

While constantly reiterating the fact that the prime function of the
shop was to display its merchandise, Herbst's main concern was how to
effect this without compromising the architectural unity of the building
and the street. Herbst clearly considered the boutique to be an import-
ant aspect of contemporary architecture while at the same time stressing
its potential for disrupting an architectural urban harmony.

 The views of Braddell and Herbst represent two different argu-
ments concerning the 'small shop' (the luxury boutique) as means of

achieving a refurbishment of the urban fabric and post-war 'renais-
sance' of French prestige. According to Braddell, the shop front's intimate
affiliation with the commodity resulted in an insouciant disregard for
previous architecture – renewal is (in effect) conceived as the result of
commodification processes. For Herbst, on the other hand, the architec-
tural promiscuity resulting from this link with commodification threatened
to produce incoherence:

> We are rather apprehensive of the result which will be obtained on the
> new Boulevard Haussmann when the twenty holes in the stately façade
> of its new Hotel are dressed according to the various trades that occupy
> them. Each tenant employs his own architect or designer, and no design
> as a whole has been contemplated.[14]

This suggests a somewhat ambivalent status for the boutique – deter-
mined as it was by both the commodity it displayed and the architect
who designed it. As architecture, the boutique accorded with an idea of
harmony and order; in its relation to the commodity, however, the
shop front might be construed as merely one more victim of the vagar-
ies of fashion. Herbst's preoccupation with the shop front is indeed
shot through with unease: 'It is indeed preferable to see a shop which
blends in with the overall architecture than a parasitic installation as
ugly and disgusting as fungus on a tree.'[15] For Herbst, the boutique –
superimposed on the surface of an existing building for the purposes of
displaying the commodity – threatened to degenerate from the status of
architecture proper to that of parasitic monstrous carbuncle.

An architectural face-lift for Paris

During the 1920s in France then, the word 'boutique' signified luxury
in a set of specific ways: by reference to the feminine, by association
with Paris, in relation to the small-scale and the exclusive and in con-
nection with particular types of window display. At the same time, as
revealed by Herbst's description of the boutique as potential parasite, the
boutique somehow involved an anxiety expressed in terms of a tension
between 'architecture' and 'façade', between structure and surface. This
ambivalence related, to some extent, to the state of architectural debates
on how to redefine Paris as modern in the post-war era. The first decades
of the twentieth century in Paris saw both the final phases of Haus-
smannisation with the completion of boulevards such as the boulevard
Raspail in 1913 and the work on the boulevard Haussmann in 1927

and the institutionalisation of urbanism as an academic discipline and profession.[16] Neither of these developments, however, succeeded in producing any fundamental transformation of Paris 'capital of the nineteenth century'. By the 1910s and 1920s, Haussmannisation could hardly be regarded as in any sense truly modern; on the contrary, at this period Haussmann's architectural legacy was often described as an outdated form of standardised monotony.[17] Equally, while contemporary circumstances such as population growth, housing shortages, traffic congestion and the projected rebuilding of the periphery of Paris (with the demolition of the fortified walls and the military zone) seemed to constitute a promising environment for urbanistic practices, such proposed solutions remained largely at the level of theory and plans.[18]

In any case, as at the time of Napoléon III, this twentieth-century concern with 'modernising' Paris had as much to do with promoting the French capital as spectacle (and consumer experience) as with solving problems such as housing and hygiene. The question was how to represent Paris as being up-to-date while at the same time distinctively French: 'when Paris resembles Chicago and New York, the Americans, whom we want so much to attract, won't come here anymore'.[19] One solution was not to expand (let alone do away with) Haussmann's Paris but rather to rejuvenate the streets laid out according to the prefect's plans with an architectural face-lift: a modern Paris would be imposed on to the structure of the Second Empire city. This face-lift took the form of an intense concern with existing Parisian streets, or more precisely, with the *façade* of Parisian buildings. This aspect of the 'beauty' of Paris had long been subject to legislation (regulation of façades has been traced back to a royal edict of 1607).[20] The design of façades was the subject of a series of architectural competitions organised by the Municipality of Paris from the year 1897.[21] The competition was based on the idea that architectural *surface* was the solution to the 'monotony' of Haussmannised streets; façades were interpreted as manifestations of architectural 'individuality'. In the first years of the competition, prizes were awarded to well-known architects (such as Hector Guimard and Jules Lavirotte) practising in Art Nouveau styles. Prizewinners and their work were recorded in publications sponsored by the journal *La Construction Moderne* – *Les Concours de Façades de la Ville de Paris 1898–1905* (published in 1905) and *Les Concours de Façades de la Ville de Paris 1906–1912* (which appeared in 1912).

In 1902 a law granting greater artistic licence to the architect was enacted in order to facilitate a greater variety of approaches to the design of façades.[22] One consequence of the 1902 law (partly, it would

seem, as the result of increasing Parisian land values) was an increase
in the permissable height of the attic storey above the cornice. Ironic-
ally, this legislation which aimed at varying the monotony of the
Haussmannised street was frequently chastised for its failure to produce
an interesting architectural effect at street level. The 1902 law was
blamed for producing top-heavy architecture as well as excessive orna-
mentation.[23] A frequently cited example of the architectural response
to this legislation was the Hôtel Lutétia on the boulevard Raspail by
architects Louis-Charles Boileau and Henri-Alexis Tauzin. Built in 1910,
the Hôtel represented a dramatic instance of the attempt to relieve the
tedium of one of Haussmann's (posthumous) boulevards with an elab-
orately baroque attic storey and a richly articulated façade. Raymond
Escholier, a critic of the 1902 legislation, included a photograph of the
Lutétia in his book *Le Nouveau Paris* as an illustration of the horrors of
swollen and inappropriately grandiose architecture:

> Since 1900 we have become accustomed to receiving our guests in
> monstrous luxury hotels, conceived in the Exhibition style [...].
> Taste is absent from these colossal edifices, overloaded with mediocre
> sculpture. These façades are evidence of an insolent contempt for the
> rich foreigner whose gaze they aim to attract – or rather, to solicit.[24]

Escholier interpreted what others had claimed as greater freedom for
the architect as undesirable licence, a condoning of the bloated scale
and tawdry ornament of (1900) exhibition architecture, an architec-
ture which he considered totally unacceptable for the building of 'le
nouveau Paris'. The critical attention accorded the Hôtel Lutétia is
revealing. As a commercial building, the Hôtel clearly needed to attract
a *clientèle*. The attempt to solicit ('racoler') an urban gaze through rich
surface decoration was in many instances, however, deemed a monstrous
failure. Critics invoked the Hôtel Lutétia as evidence of the results of
the 1902 law as well as embodying everything that was undesirable
about *le style moderne* (Art Nouveau): 'with its decorative pastry, [the
Hôtel] resembles an enormous soft cheese with bizarre blisters'.[25]
 The problem seemed to be how to conceive of façades that
epitomised 'individuality' – differentiation – without lapsing into the
excesses of Art Nouveau historicism or overblown ostentation. A new
twist to the possible significance of 'individuality' appeared in 1923 with
a change to the regulations governing the municipal façades competi-
tion. An announcement in *La Construction Moderne* proclaimed that
boutique façades were now to be considered an important component

of the façade architecture category and that the next exhibition would consider such façades for the period 1914–22. Improvements to the appearance of the French capital, it was claimed, were due less to the imagination of individual architects than to the initiatives of Parisian commerce: 'Parisian commerce has made noticeable and very interesting efforts to give a more decorative aspect to shop fronts and these felicitous attempts have brought about a marked improvement in the decoration of the street.'[26] It was the processes of post-war commodification that were credited as the means of producing *la décoration de la rue*.

This change to the Concours de Façades regulations in 1923 was a significant acknowledgement of shop frontages (*devantures de boutiques*) as a means of urban renewal and modernisation. In the context of the Concours, 'decoration' of the street was construed in specific terms, that is, by contrast with an urbanistic preoccupation with housing. The October 1922 issue of *La Construction Moderne* reminded its readers: 'Now, let us not forget that this is a matter of judging only façades and not plans nor aspects of construction relating to hygiene and comfort.'[27] This statement was also in direct contradiction with the claims made for the improvement of the street in connection with the 1902 law, where tall attic storeys either as part of a new Parisian architecture or as extensions to existing buildings were justified in terms of enhanced hygiene, sun and fresh air (concerns more conventionally associated with urbanism).[28] With the municipal emphasis in 1923 on the boutique façade (as opposed to the elevated attic storey) the modern urban gaze was redefined as that into the shop-window as opposed to the panoramic look across the city. In this context, *décoration* clearly involved the quality of being eye-catching. The great virtue of the boutique was identified as its ability to attract the attention of the passerby on behalf of the commodity.[29] But again (as with Herbst's commentaries on the shop front) the boutique's overt identification with certain forms of looking seemed to arouse a sense of uncertainty. Even in the most favourable reporting on the Concours de façades it was often felt necessary to stress the need for better housing in Paris: 'A façades competition? What a charming idea and one can foresee the good results of French taste! But in a room next to this exhibition, wouldn't it be possible to organise an exhibition of flats?'[30] Despite such ambivalent statements concerning the validity of revamping the city in terms of façades, the façade – and in particular the *devanture de boutique* – was frequently cited as the most appropriate means of modernising Paris. The quality of surface was on occasion interpreted as particularly relevant to a 'new' age dominated by speed:

Admittedly it is not only in questions of townplanning that façades play an attractive role and subordinate everything else to themselves. Their importance has increased significantly in a frenetic society which no longer has the time to be profound! One judges by a person's face as one does by that of a building [...].[31]

With such claims that it was appearances which counted in a modern world, an older 'science'– that of physiognomy – was invoked in order to justify the boutique as a form of *urbanisme*.

The promotion of façade architecture as a means of modern urbanisation was to some extent the result of both the nature of build-ing in Paris and of certain economic realities. Such architecture could be deployed in order to enliven not only the Haussmannised street but also those streets dominated by *maisons de rapport* (buildings constructed with maximum rentable floor space for the purposes of profit), often cri-ticised for having produced a banal architecture.[32] In encouraging shop-keepers to refurbish their *devantures*, the municipality of Paris claimed that it was effecting aesthetic variety as well as modernising the street at minimum cost to the ratepayer. And all with the advantage that such rebuilding work could be carried out with minimal disruption to the boutique's immediate neighbours. Reporting on a *magasin de confections* in the boulevard Sébastopol, *La Construction Moderne* pronounced: 'it was necessary to modernise this shop without touching the floors above (which are let) and without ceasing to trade'.[33] Modernisation of the building and of the street via the boutique façade must involve, it was stressed, a certain discretion. Architects were encouraged to take into account the exact nature of the goods on sale in the boutique as well as the taste of the *clientèle* implied by these commodities. The *devanture de boutique* was expected to be modern without being in any way excessive, to modernise the street in ways tactful to the existing building. Above all, it was simplicity which characterised the modern boutique façade.[34] Rich building materials were to be deployed for the sake of identifying the commodity as luxurious – not for the purposes of drawing attention to the building itself.

Devantures de magasins et de boutiques made their first appearance at the 1924 Concours de Façades. Because the period under considera-tion for both façades and *devantures de boutiques* included the years 1914–22, boutiques indicated an ongoing commercial and architectural activity duing the war as well as a 'renaissance' of post-war Paris. Their intimate connection with luxury commodities meant that boutiques could be mobil-ised as proof of the health of certain French industries, particularly the Paris-based *arts décoratifs*. As a manifestation of post-war reconstruction

the boutique thus signified a determination to rebuild not only city streets, but also the national economy and prestige. Whereas 'exhibition architecture' regularly functioned as a term of disparagement at this period, the boutique (which was after all also concerned with the display of commodities) was enthusiastically promoted as an effective means of modernising the city. It is therefore worth considering in a bit more detail both the kinds of shop entered for the 1924 Concours and the nature of the critical writing and descriptive terminology associated with such entries.

Twenty-one boutiques were chosen from photographs of the sixty-eight entries in 1924 for an examination 'sur place'; of these, ten were designated as prizewinners.[35] The geographical location of the shop fronts is significant. Prizes were awarded to boutiques located in prestigious streets associated with the *ancien régime* (the rue Royale, the rue de Richelieu and the rue de la Paix), to shops in nineteenth-century Haussmann boulevards (the avenue de l'Opéra, boulevard Montmartre) and to a complex of four adjacent boutiques in the boulevard Haussmann. This selection of awards sustained claims that the boutique façade constituted a form of modernisation capable of harmonising earlier with later architectural styles. The boutique at 6 rue Royale, for example, was described as being designed in 'the lovely, pure style of the rue Royale, the most beautiful in Paris' and similarly, that at 3 rue de la Paix was praised for the 'lovely and pure style of the neighbouring place Vendôme'.[36] Equally, boutique façades were commended for enlivening an existing dull or undistinguished building, as in the case of a *confiserie* at 196 boulevard Saint-Germain: 'the aim is to distract attention away from the top part of an uninteresting old building. In a word, it is a boutique which attracts the eye through its simplicity and its originality.'[37] Architecturally, therefore, the boutique signified modernisation as a continuity (rather than a rupture) with great French traditions.

The nature of the goods on show in these boutiques was also crucial to the idea of the boutique as a means of modernising Paris. Many of the prizewinning boutiques sold luxury goods aimed at the female consumer: number 6 rue Royale housed the jeweller Fouquet and the four boutiques in the boulevard Haussmann sold furs and silks, jewellery, perfume and hats respectively. Number 38 rue d'Hauteville also sold perfumes. As we have already seen, journals such as *La Construction Moderne* were not the only means of documenting urban modernisation via the boutique. A 1927 publication by G. Henriot, *Nouvelles devantures*, consisting largely of photographs, illustrates a number of the prizewinners at the 1924 Concours (specifically Tailleur Ribby and the boutiques in

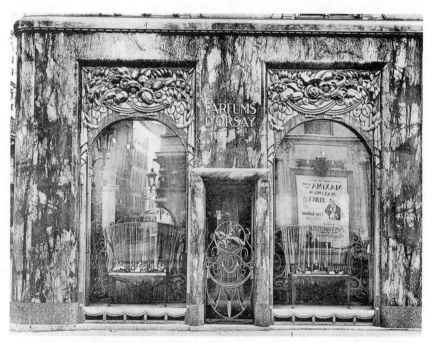

27 'Parfumerie d'Orsay, rue de la Paix', plate 11 in G. Henriot, *Nouvelles devantures: façades et agencements de magasins*, 1927

the boulevard Montmartre).[38] But in *Nouvelles devantures* one boutique façade receives more attention than any other: Sue et Mare's 'Parfumerie d'Orsay' (plate 27) in the rue de la Paix is represented by three photographs. Built earlier in the 1920s, the Parfumerie d'Orsay was often cited as typifying the modern boutique façade. The boutique was praised for the way it related to both its geographical site and to the products it sold. Sumptuously clad in rich materials (such as marble), the Parfumerie d'Orsay not only suitably 'framed' the perfume bottles on show but also shared something of perfume's purpose: 'through its sumptuousness, the decoration attracts attention without in any way detracting from the bottles'.[39] Just as perfume is intended to draw attention to the female body, so too the boutique façade was designed to distinguish itself from its neighbours in order to attract the eye of the viewer.

In the context of competitions and studies of boutique façades at this period, there seems to be a recurring preoccupation with perfume shops. Economically, French perfumes were a significant luxury industry. Indeed it could be said that with its stress on packing and marketing the perfume business constituted the paradigmatic luxury industry.[40] At a formal level, the elegant glass and crystal perfume bottles and the

glass *vitrine* of the boutique obviously shared certain characteristics – both partly transparent, partly opaque. The display of glass within glass created a tantalising effect of shimmering light and it was, in part, the quality of lightness as defined by the material of glass which was often advocated as a desirable modernity as opposed to the heaviness of earlier architecture (such as that of Napoleon III).[41] Given perfume's intimate association with the feminine toilette, it is not surprising to find the language of contemporary writing on the architecture of perfume shops peppered with references to femininity. Analogies between *parfumeries* and the female body abounded; such boutiques were described as presenting 'pleasing features' and being 'curvaceous'.[42] Irrespective of the goods it sold, however, in its insistence on attracting the attention of the passerby, the boutique signified a feminised form of architecture. 'Ribby' at the corner of the boulevard Montmartre and rue Vivienne sold expensive men's clothing: 'the shop of the famous tailor Ribby presents an alluring aspect'.[43] This description deploys a feminised vocabulary ('avec belle allure') despite the fact that Ribby was a shop devoted to men's tailoring. Very soon after its first year of publication in 1918, *La Renaissance de l'Art Français et des Industries de Luxe* began a series of articles on 'Parisian shop fronts'. Here we find a similar language used to describe the impact of new Parisian small shops: 'modernity is coquettishly placed amidst venerable stones'.[44] With the boutique, modernity was characterised as 'coquettish' – as a process of seduction ('it has to seduce a well-informed public', claimed a 1923 essay on boutique façades).[45]

Raymond Bouyer, the author of the 1919 *Renaissance* article on 'Les Devantures parisiennes', claimed that his topic constituted a kind of update to an existing preoccupation: 'these shop fronts add an unpublished chapter to Gustave Kahn's book *The Aesthetic of the Street*, which is now called 'urbanism': a brand new science [. . .]'.[46] *La Renaissance* produced its own version of a postscript to Kahn's book with two special issues devoted to Parisian luxury industries. In June 1923, the journal focused on the exclusive area of Paris around the rue de la Paix, the place Vendôme and the rue de Castiglione; a year later in June 1924, it was the Champs-Élysées, the faubourg Saint-Honoré, the rue la Boétie and rue Royale (plate 28). The luxury industries listed in these issues of the *Renaissance* were largely those catering to the female consumer (they included *haute couture*, millinery, lace, furs, silks, perfumes and jewellery). This was a cartography of the French capital in terms of its luxury shops, an *urbanisme* which defined a distinctively feminine city: 'the dream of elegant [women] is presented as in a film which unrolls the panorama of shop fronts on the rue de la Paix, a

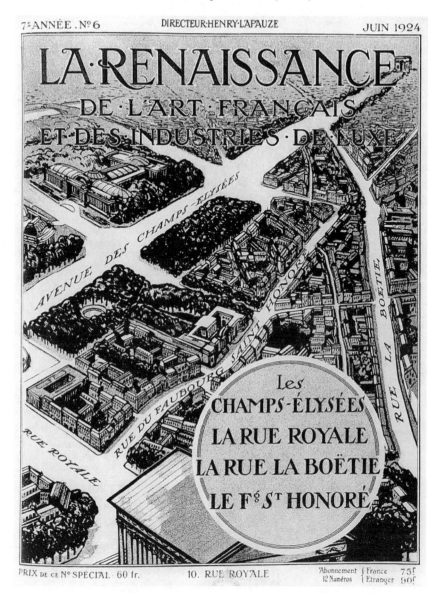

7ᵉANNÉE . Nº 6 DIRECTEUR·HENRY·LAFAUZE JUIN 1924

LA·RENAISSANCE
DE · L'ART · FRANÇAIS
ET · DES · INDUSTRIES · DE · LUXE

Les
CHAMPS-ÉLYSÉES
LA RUE ROYALE
LA RUE LA BOËTIE
LE Fᵍ Sᵀ HONORÉ

PRIX DE CE Nº SPÉCIAL · 60 fr. 10. RUE ROYALE Abonnement { France 75f
 12 Numéros { Etranger 90f

28 June 1924 cover of *La Renaissance de l'Art Français et des Industries de Luxe*

paradise paved with diamonds, with shimmering textiles [. . .]'.[47] The conceit was elaborated through photographs of the street's boutiques forming a continuous 'filmstrip' across the pages of the magazine (plate 29). The layout of these photographs suggested not only a kind of visual *flânerie* for the reader but also the serried boutique *vitrines* as panoramic view of Paris. Women's fashion was crucial to this version of 'urbanism':

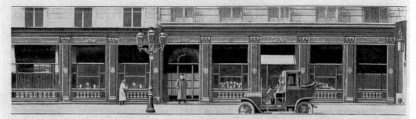

RUE DE LA PAIX.

Nᵒ 11. CARTIER,
Joaillier.

Nᵒ 13. CARTIER,
Joaillier.

qui prennent une importance savoureuse, une cravate ou la nuance distinguée d'une chaussette dépassant le soulier verni. Le miracle de leur toilette est dans les dessous, dans la souplesse du linge de soie, dans l'accord voulu des chaussettes et des caleçons, dans la symphonie des cravates dont chacune, comme disait Amiel des paysages, est un état d'âme, s'harmonisant avec la couleur des pensées. Et il y a le chapitre éblouissant des pyjamas, taillés dans des tissus des Mille et Une Nuits.

Doucet, au 21 de la rue de la Paix, a cravaté et caleçonné deux ou trois générations de dandys. Véritable poète de la cravate, il fait tisser pour ses clients des armures d'une distinction opulente et discrète, et il distribue sur ses chaussettes les broderies les plus suaves. *Franck et Braun*, au nᵒ 22, expose les écharpes les plus chatoyantes, les mouchoirs les mieux chiffrés.

Place Vendôme, au nᵒ 8 triomphe par la splendeur de ses pyjamas et l'éloquence de ses cravates, la maison *Charvet*, fondée dès 1838 rue de Richelieu par Christophe Charvet, elle appartient maintenant à *Ragon et Delostal*. *Edouard et Butler*, au nᵒ 10, satisfont les plus délicats par leur goût subtil ; *Muhlenkamp*, au 12, connaît le secret des tissus les plus seyants.

Rue de Castiglione, au nᵒ 10, *Boivin jeune* — transfuge de la rue de la Paix où ses gants avaient au siècle dernier la faveur des élégants de Tortoni et de la Maison

Dorée — excelle dans ses dessous et ses chemises, parfaits jusque dans les plus minces détails. A ses débuts, en 1827, la maison se bornait aux petits articles de dame. Les gants vinrent ensuite, puis la chemise de cour, avec jabot brodé pour les réceptions des Tuileries. Plus tard ce fut la grande extension de la chemise, l'innovation du pyjama, avec ses multiples transformations, et, dernière création, le costume de dame en crêpe pour les sports.

La Dentelle.

A ce laboratoire de la toilette élégante qu'est le quartier de la Paix, il fallait une réserve inépuisable de matières précieuses à transformer. La Parisienne s'habille d'un rien, c'est entendu. Encore ses fournisseurs habituels ont-ils besoin de dentelles, de fourrures et surtout de tissus de soie pour composer ses toilettes.

Aérienne, immatérielle, la dentelle se pose sur les chairs féminines comme le papillon sur la fleur. Une âme légère frissonne dans ses festons délicats, une grâce aristocratique respire à travers ses fins réseaux. La dentelle ajoute à l'élégance un je-ne-sais-quoi de pimpant, de rêveur, de poétique.

La maison *Lefébure*, au nᵒ 8 de la rue de Castiglione, d'une réputation si ancienne et si bien assise, confie à des ouvrières d'élite, respectueuses des traditions de cet art minutieux entre tous, le soin de parfaire ces

RUE DE LA PAIX.

Nᵒ 16. CAM-LAFONTAINE-HAZEBROUCQ,
Opticien.

Nᵒ 16. RIGAUD,
Parfumeur.

Nᵒ 16. BRANDT,
Couturier

Nᵒ 16. MELLERIO *dits* MELLER.
Bijoutiers, Joailliers, Orfèvres.

29 Photographs of boutiques in the rue de la Paix. Doublespread from the June 1923 issue of *La Renaissance de l'Art Français et des Industries de Luxe*, pp. 306–7

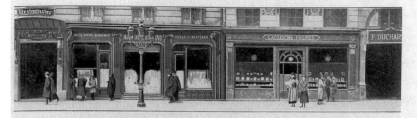

RUE DE LA PAIX.

Nº 13. Hôtel Nº 13. Martial et Armand, Nº 15. Lacloche frères,
Westminster. Couturiers. Joailliers.

points de France, ces points d'Alençon, ces points Colbert, ces Chantilly qui sont la gloire de la dentelle et qui vont garnir les corbeilles de mariage les plus riches ou parer les robes des mondaines d'une note de suprême élégance.

Les Fourrures.

Les fourrures que portaient nos grand'mères avaient pour raison d'être de les protéger du froid. Aujourd'hui, la fourrure est devenue avant tout un objet de luxe, un signe extérieur d'opulence comme une rivière de diamants ou un collier de perles, un artifice de coquetterie dont une élégante ne saurait se passer, à telles enseignes que la fourrure se porte maintenant aussi bien dans la belle saison qu'en hiver et qu'on a pu associer, dans cette expression toute moderne, deux mots qui semblent jurer d'être accouplés : les fourrures d'été.

Aussi bien, la fourrure enveloppe la femme chic d'une grâce à la fois altière et caressante et rien n'offre un charme plus fier qu'un beau buste qui émerge d'une cape de zibeline négligemment rejetée sur le fauteuil d'une loge. Ces pelages aux reflets chatoyants sont l'écrin rêvé de la grâce féminine.

Chez *Grunwaldt*, 6, rue de la Paix, les élégantes vont chercher les étoles aux douceurs de plumage, où luit l'agate, la topaze brûlée, l'opale ou la nacre, les man-

teaux somptueux qui donnent à l'espièglerie de nos Parisiennes une allure de petites reines.

Les Soieries.

Les soieries modernes, dans la chaude variété de leurs coloris, éparpillent des éblouissements de féerie. Splendeur, fantaisie, souplesse, légèreté, grâce novatrice et aérienne, elles conjuguent les plus séduisantes qualités pour parer les murs du boudoir, la sortie du bal, la robe de fête.

Coudurier, Fructus et Descher, au nº 17, de la rue de la Paix, demandent à nos meilleurs dessinateurs de composer les cartons de leurs étoffes d'un goût si raffiné et d'une opulence de si bon aloi.

Ducharne, au nº 20, confère à tout ce qui porte sa marque une élégance de grand style, à la recherche perpétuelle de la nouveauté.

Wilmart, au 25 de la place Vendôme, échantillonne pour ses clientes les plus beaux tissus de la fabrique lyonnaise, ceux des successeurs d'Albert Godde en toute première ligne.

Les Parfums.

Nous en aurions fini avec la catégorie des objets de première nécessité — toutes les jolies madames qui n'ont plus, cette saison, rien à se mettre, me comprendront —

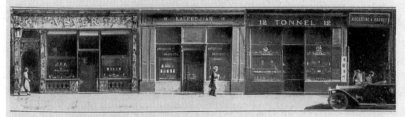

RUE DE LA PAIX.

Nº 14. Vever, Nº 12. Kalebdjian frères, Nº 12. Tonnel, Nº 12. Augustine et Andrée,
Joaillier. Antiquités. Maroquinerie. (Anc^{nes} M^{me} Virot), Modes.

it was precisely as a result of the affiliation with *la mode* that boutique façades effected an unceasing renewal of the best French architectural traditions.

This representation of a new urban modernity via the feminised boutique relied heavily (as we have seen) on the idea of tantalising surfaces, and in particular on appearances construed in terms of the human face. The architectural façade, the street, indeed the city as a whole, could all be described in terms of a 'physiognomy'. In a 1923 *Construction Moderne* essay 'A propos du Concours de Façades', for example, we read 'just like a living being, a city has a face'.[48] And in Bouyer's 'Les Devantures parisiennes', 'it is true that buildings have faces, their "physiognomies"'.[49] Similarly, *La Renaissance* discussed the 'wind of renovation' wrought by the modern boutique through reference to the female face: 'If the rue de la Paix of 1923 recalls that of 1869, it is in the way that a daughter resembles her mother. The details of her face are as different as those of her toilette.'[50] Just as the body – and in particular the face – had played a crucial role in nineteenth-century formulations of an urban modernity, so these texts on the boutique constitute a new kind of physiognomy of the modern.[51]

Seductive surfaces

Such references to the physiognomical proliferated in the critics' responses to the Place Publique project at the 1924 Salon d'Automne. Guillaume Janneau's review in the *Bulletin de la Vie Artistique* was entitled 'The face of the modern street'.[52] And in *La Renaissance* Henri Clouzot claimed that 'since the war, Parisian commerce has produced a lively and charming face'.[53] It is apparent that the fascination with the boutique in reviews of the Place Publique was specifically concerned with shop display; the emphasis was emphatically on 'the shop-window' ('l'étalage') and 'the show *vitrine*'. The Salon reviews seemed particularly preoccupied with justifying certain forms of display as modern. Paradoxically – given all the references to the physiognomical – modern forms of shop display were identified as those which produced a sense of the 'mysterious':

> Now it [the boutique] closes in on itself and absorbs the profusion of fabrics and food. It shrouds itself in mystery; all it offers to the layman's gaze is a blank facing, pierced by a small porthole behind which reposes a solitary jewel, a bibelot, a binding. In certain cases, there is no better mode of presentation: precious objects need to be isolated, and in any case, abundance is vulgar and repellent.[54]

This is, of course, very similar to Braddell's account of the 'discreet' displays found in 'little Paris shops'. The contrast between Parisian department stores and the Place Publique boutiques was made quite explicit: 'it is a new method which contrasts with department store displays, spreading out on to the pavement'.[55] In these reviews of the 1924 Salon d'Automne, it was not so much the scale of the *grand magasin* itself as the excessiveness of these stores' pavement displays which was designated old-fashioned. 'Yesterday's' boutiques were similarly characterised: 'it is the traditional mode of the boutique to disgorge its treasures on to the street'.[56] These narratives of past and present clearly implied different relationships between commodity and street. Whereas an 'old-fashioned' display (whether in *grand magasin* or boutique) took the form of a super-abundance of goods – a symbolic cornucopia suggesting an apparently unchecked outpouring of the shop's stock – the Place Publique boutiques defined the modern in their parsimonious display of the commodity, the presentation of a very few goods, perhaps only a single object. These boutiques did not rely on profusion to suggest luxury. Elegant and compact, they tantalisingly presented the commodity as precious object – as lure.

But whose is the implied look in these 1920s' texts? All this talk of a seduction through viewing is no simple thing, especially in relation to the representation of the boutique *vitrine* as a 'décor de la rue', the shop-window as component of the city street. On the one hand, given the frequent displays of artefacts for the feminine toilette, the boutique seemed to involve the enticement of the female consumer. At the same time, the terms in which the modern boutique was supposed to render the commodity desirable more often suggested a male viewer. Boutique number four in the Place Publique – Djo Bourgoies' design for a jewellery shop – was described in the arts magazine *Art et Décoration* as follows: 'It is both mysterious and secretive. It opens itself like the Egyptian temples of modern theatre, through a narrow door, in a vanishing perspective, and with two small glazed cavities between the jambs, the sanctuary of certain pleasures.'[57] Here, narrowness ('une porte étroite') can be read as metaphor for mystery; the boutique becomes enigmatic in order to arouse the desire of the consumer, to 'seduce'. And it is of course woman who most powerfully embodies seductive mystery; like the famous smile of the Mona Lisa, the boutique as 'sourire' fascinated precisely because it was suggestive rather than revealing. Such metaphors derived from the female body – the recurring 'visage' and 'sourire' – are, however, complex. They seem to follow a Freudian dynamic of 'upward displacement', whereby the imagery of the face is conflated with evocations of other parts of the anatomy. The *étalage* was repeatedly

referred to as some form of small (or tight) opening ('une étroite ouver-
ture' in the case of Clouzot) but also: 'a small porthole' ('un étroit hublot'
– Janneau) and 'a narrow doorway' ('une porte étroite' – *Art et Décoration*).
Similarly, the jeweller's shop in the Place Publique was described in terms
which evoke the female body, the jewels displayed in two *vitrines* ('deux
petites cavités') between 'les jambages'.[58]

During the nineteenth century, as in the novel *Au Bonheur des
dames*, the *grand magasin* had been represented as a temple to woman.[59]
A large part of Émile Zola's book is taken up with descriptions of the
woman shopper in the department store overcome with desire for the
goods on sale. What is striking in so much 1920s' writing, however, is
the way in which sales displays are characterised as feminine. Valmy-
Baysse, in a luxuriously produced book on department stores – *Tableau
des grands magasins* – included a chapter entitled 'Le Visage du magasin'
where he enthused: 'Shop-windows, lively and charming face of the
department store! After all, one says of an attractive woman endowed
with a generous bosom that she has a nice frontage.'[60] A similar sly
elision of *vitrine* and *poitrine* is effected visually by the illustration to the
'Boutique Floryse' in Pierre Mac Orlan's picture book *La Boutique*, like
Tableau des grands magasins published in 1925 (plate 30).[61] In his review
of the Place Publique Clouzot had rhapsodised: 'At each street corner,
flâneurs (if one can call them such) are surprised anew.'[62] Here it is not
woman but the 'feminised' spectacle constituted by the boutique which
is identified as the object of the flâneurial gaze.

In 'The Paris of the Second Empire in Baudelaire', Walter
Benjamin suggested that the spectacle of the shop-window had formed
part of Baudelaire's flâneurial discourse on the modern. Benjamin quoted
the poet's lament: 'No shop-windows. Strolling, something that nations
with imagination love, is not possible in Brussels. There is nothing to
see, and the streets are unusable.'[63] Although he deployed the imagery
of the shop to distinguish Paris from other cities, for Baudelaire it was
above all the Parisian prostitute who metaphorised modernity – as a
conjunction of male desire and commodification. Notions of modernity
construed as feminine enticement were still relevant in early twentieth-
century Paris but such ideas appeared in a revised and updated form.
Nowhere was this more apparent than in the theoretical and profes-
sional writing produced on the subject of *publicité*, a literature in large
part devoted to the business of making the streets 'usable'. The early
years of the twentieth century mark the institutionalisation of *publicité*
in France and its validation as a 'science'.[64] With their *Commerce et
industrie – les procédés modernes de vente – la publicité suggestive théorie et*

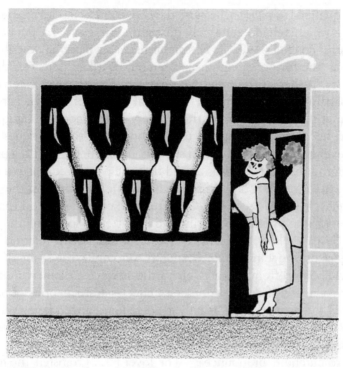

30 'Floryse', in Pierre Mac Orlan, *La Boutique*, 1925, n.p.

technique (often referred to by the shortened title of *La Publicité suggestive*) of 1911, Octave-Jacques Gérin and Charles Espinadel proposed what was to become a standard French definition of *publicité*: 'Advertising encompasses those sales devices and means of attracting the client which do not involve the intervention of the salesperson.'[65] In the early 1920s, the boutique was represented as an important form of advertising: 'the boutique and the poster are advertising devices', claimed Janneau in his essay on a competition for boutique façades at the 1923 Salon d'Automne.[66]

Analogies were often drawn between boutique and poster – both operated in the city street, and both were interpreted as manifestations of a vehement desire to be looked at: 'The boutique is a sign, a kind of poster, which attempts to solicit the attention of the passerby, it is assertive, occasionally indiscreet, but persuasive.'[67] Its relatively small scale (*vis-à-vis*, for example, the *grand magasin*) facilitated such characterisations of the boutique as in itself constituting a shop sign. And like the poster, the boutique as façade defined the city street in terms of a sequence of flat surfaces. More fundamentally, however, both boutique and

poster qualified as *publicité* because they operated as modes of attention-seeking which relied exclusively on sight. The essay 'La Publicité' in Georges d'Avenel's 1902 *Le Mécanisme de la vie moderne* described the poster as 'the towncrier who makes himself heard at 50 metres through the eyes'.[68] Whereas the *grand magasin* might be construed as relying (at least partly) on the sales patter – the oral skills – of its sales personnel in promoting its wares, part of the 'mystery' of the modern boutique was held to lie in its 'mute' appeal to the consumer: 'the boutiques of the past never had this secretive and silent countenance which is a product of modern urbanism'.[69] It was argued that the pace of contemporary life had resulted in forms of selling which relied exclusively on the visual. Boutiques, it would seem, were symptomatic of modernity in that they had transformed selling primarily into a matter of soliciting the gaze.

With *publicité* (as Henri Clouzot pointed out in relation to the boutiques on show in the 1924 Salon d'Automne), the scene of seduction had shifted from the boudoir to the street.[70] Commerce rendered the street a site of desire in order to effect sales. Theories of *publicité* depicted this seduction in heavily gendered and engendering terms. In the 1922 book by Paul Dermée and Eugène Courmont *Les Affaires et l'affiche*, for example, a chapter entitled 'How the poster can arouse the desire to purchase' pronounces: '"The lover [. . .] transfers the feelings aroused by the body of his mistress to her clothes, her furniture, her home." Similarly, our poster will favourably influence the public in favour of the brandname.'[71] In some instances, the poster constituted a virtual illustration of this ostensible transfer of desire from 'mistress' to object by representing the commodity in juxtaposition to a female figure thus effectively plastering the body of woman all along the city streets – another permutation of Paris as a 'woman's city'.

Seduction defined in terms of woman as object of a male gaze inevitably, however, involves anxiety as much as desire. In the 1920s' French theoretical writings on *publicité*, this anxiety was formulated as a problem: ostensibly, how to stop woman's body from stealing the show. *La Publicité suggestive* sternly warned that the female body all too easily distracted attention away from the commodity advertised.[72] And a chapter entitled 'Beware beautiful women' ('Méfions-nous des jolies femmes') in *Les Affaires et l'affiche* quoted an American criticism concerning the fact that images of enticing and scantily clad women were used in French advertising to sell anything from absinthe to biscuits. The authors of *Les Affaires et l'affiche* concluded that measures should be taken to ensure that the viewer's interest was concentrated on the commodity in such a way as to endow the object with 'an acute intensity' ('une vive intensité').[73]

Publicité advocated 'suspicion' and 'mistrust' of woman – an averting of the gaze away from the female body. Advertising theory thus legitimated the diversion of intense looking from female body to object. This legitimation of obsessive looking at the object was camouflaged in the guise of 'reason': in order to provide 'rational' explanations, *publicité* enlisted as its ally one of the most up-to-date sciences, that of the psyche. In his introduction to *La Publicité suggestive*, Walter D. Scott (identified as 'Directeur du Laboratoire de Psychologie de Chicago') asserted: 'the only scientific basis of advertising lies in psychology'.[74] And similarly, the preface to *Les Affaires et l'affiche* (by J.-M. Lahy, Chef des Travaux à l'École Pratique des Hautes Études et à l'Institut de Psychologie de l'Université de Paris) credited the United States as being the first to undertake a 'rational application of psychology to business affairs'.[75]

In its emphasis on the boutique and on sales display, the Place Publique boutiques at the 1924 Salon d'Automne associated (at least implicitly) not only architecture but also *publicité* with the concept of 'décoration urbaine'. *Publicité* – ostensibly as much a 'rational' discourse as *urbanisme* – was thus assigned a role in the national 'return to a rational order'. But the Salon d'Automne exhibited *publicité* and *urbanisme* (significantly identified as Art Urbain) in a specific context – that of the high and decorative arts. Equally, as we have seen, a preoccupation with the boutique façade as an agent of modernity occurred not only in architectural magazines or in books on advertising theory but also in arts magazines. Just as Braddell had recourse to notions of 'art' in order to validate the Parisian boutique as 'modern' architecture, so it would seem that there were means whereby references to the boutique functioned to underscore the modernity of Parisian art practice. Chapter 4 deals with 'the art of the shop-window' in an attempt to discover what motivated this fascination with the sphere of commerce on the part of art.

Notes

1 Henri Clouzot, 'Les Arts appliqués au Salon D'Automne', *La Renaissance de l'Art Français et des Industries de Luxe*, January 1925, no. 1, p. 16. Subsequent references to this publication will be to *La Renaissance*.

2 For a history of shops focusing on an earlier period and not specifically on France, see Alison Adburgham, *Shops and Shopping 1800–1914: Where and in What Manner, the Well-Dressed Englishwoman Bought her Clothes*, Allen & Unwin, London, 1964. On eighteenth-century Parisian boutiques see Jennifer Jones, 'Coquettes and grisettes: women buying and selling and Ancien Regime Paris', in De Grazia, *The Sex of Things*.

3 For a photograph of the 'Vieux Paris' exhibit at the 1900 Paris Exhibition, see Philippe Bouin and Christian-Philippe Chanut, '1900: l'inauguration du XXe

siècle', *Histoire française des foires et des expositions universelles*, Baudouin, Paris, 1980, p. 154. The 'Vieux Paris' exhibit needs to be considered in relation to the turn-of-the-century preoccupation with 'historic' Paris; for an account of this, see Molly Nesbit, *Atget's Seven Albums*, Yale University Press, New Haven and London, 1992, in particular pp. 16, 20, 21, 24–6, 62–73.

4 See the official catalogue *Salon d'Automne 1924 du 1er novembre au 14 décembre 71e Exposition*, Paris, 1924, pp. 363–7. The Art Urbain section of the Salon was organised by Marcel Temporal.

5 Catalogue *Salon d'Automne 1924*, p. 409.

6 Wilson, 'The stage setting', *Paris on Parade*, p. 27.

7 Raymond Bouyer, 'Les Devantures parisiennes', *La Renaissance*, December 1919, no. 12, p. 534.

8 Darcy Braddell, 'Little shops of Paris', *Architectural Review*, July 1926, vol. 60, p. 3 and p. 5.

9 Bonney, *A Shopping Guide to Paris*, pp. 115–16.

10 *Ibid.*, p. 116. On Parisian department stores of this period, see for example: M. B. Miller, *The Bon Marché: Bourgeois Culture and the Department Store, 1869–1920*, George Allen & Unwin, London, 1981; S. Tise, 'Les Grands Magasins', in C. Arminjon, *L'Art de Vivre: Decorative Arts and Design in France 1789–1989*, Thames & Hudson, London, 1989; and N. Troy, 'Reconstructing Art Deco: Purism, the department store and the Exposition of 1925', in *Modernism and the Decorative Arts in France*.

11 Braddell, 'Little shops of Paris', p. 5.

12 Luc Benoist, 'Les Arts de la rue', *Beaux-Arts: Revue d'Information Artistique*, 15.8.1925, p. 260.

13 *Modern French Shop-Fronts and their Interiors by René Herbst with a Foreword by James Burford (Associate Royal Institute of British Architects)*, John Tiranti & Co., London, 1927, n.p. On Herbst's career as a designer of boutiques, see 'Étalages et boutiques', in Solange Goguel, *René Herbst*, Éditions du Regard, Paris, 1990, pp. 143–90.

14 *Modern French Shop-Fronts.*

15 René Herbst, *Nouvelles devantures et agencements et magasins présentes par René Herbst*, 5e série, Éditions d'Art Charles Moreau, Paris, 1930, n.p.

16 For mention of the boulevards Raspail and Haussmann, see Evenson, *Paris*, p. 21. For the development of urbanism in France, see *ibid.*, p. 266 ff.; and Paul Rabinow, *French Modern: Norms and Forms of the Social Environment*, MIT Press, Cambridge, (Mass.) and London, 1989.

17 Charles Lortsch, *La Beauté de Paris et la loi*, 1913, p. 97, quoted in Evenson, *Paris*, p. 148, and E. Rumler, 'Concours de Façades de la ville de Paris', *La Construction Moderne*, 1.10.22, p. 1. On Haussmannisation, see also T. J. Clark, 'The view from Notre-Dame', *The Painting of Modern Life: Paris in the Art of Manet and his Followers*, Thames & Hudson, London, 1984, pp. 23–78, and Prendergast, 'Insurrection', *Paris and the Nineteenth Century*, p. 103.

18 On the debates concerning the rebuilding of the periphery of Paris, see Evenson, 'The wall surrounding Paris', *Paris*, pp. 272–6, and Jean-Louis Cohen and André Lortie, *Des fortifs au perif: Paris les seuils de la ville*, Picard Editeur, Édition du pavillon de l'Arsenal, Paris, 1991. See also the work on this subject by Molly Nesbit in *Atget's Seven Albums*, and Adrian Rifkin in *Street Noises: Parisian Pleasure 1900–1940*, Manchester University Press, Manchester and New York, 1993.

19 Evenson, *Paris*, p. 158.

20 *Ibid.*, p. 147.
21 *Ibid.*, pp. 143–4.
22 *Ibid.*, p. 150.
23 Lortsch, *La Beauté de Paris*, p. 89, quoted *ibid.*, p. 154.
24 Raymond Escholier, *Le Nouveau Paris: la vie artistique de la cité moderne*, Éditions Nilsson, Paris, n.d., p. 44.
25 Lortsch, *La Beauté de Paris*, p. 92, quoted in Evenson, *Paris*, p. 154.
26 'Concours – ville de Paris – Concours de Façades et des Boutiques', *La Construction Moderne*, 15.4.23, p. 342.
27 Rumler, 'Concours de Façades de la ville de Paris', *La Construction Moderne*, 1.10.22, p. 2.
28 See the 1909 report to the prefect in C. Lortsch, *La Beauté de Paris*, p. 51, quoted in Evenson, *Paris*, p. 155.
29 'Concours de Façades de la ville de Paris', *La Construction Moderne*, 14.9.24, p. 591.
30 'Revue de la presse – *Le Temps* 26.4.23 – à propos du Concours de Façades', *La Construction Moderne*, 13.5.23, p. 392. See also 'Maison primée, rue Alexandre-Dumas, à Paris', *La Construction Moderne*, 11.4.20, p. 218.
31 *Ibid.*, p. 392.
32 Evenson, *Paris*, p. 142.
33 'Un magasin de confections à Paris', *La Construction Moderne*, 5.2.22, p. 148.
34 See, for example, 'Concours de Façades de la ville de Paris', *La Construction Moderne*, 14.9.24, p. 591.
35 The ten prizewinning boutique façades for the 1924 Concours de Façades included: the *confiseur-glacier* 'A la Dame Blanche', 196 blvd. Saint-Germain; a shoe shop on the avenue d'Orléans; 'la Compagnie des Messageries Maritimes' at 8 rue Vignon; the jeweller 'Fouquet', rue Royale; 'Ribby' in the blvd. Montmartre and rue Vivienne; 'Au Jockey-Club', rue de Richelieu; four shops in the blvd. Haussmann; 3 rue de la Paix; 43 avenue de l'Opéra; and 'Roger Gallet' at 38 rue d'Hauteville.
36 *La Construction Moderne*, 14.9.24, p. 592 and p. 593.
37 *Ibid.*, p. 591.
38 G. Henriot, *Nouvelles devantures: façades et agencements de magasins*, 1ère série, Charles Moreau, Paris, 1927.
39 Jean Badovici, 'Parfumerie d'Orsay, par Sue et Mare', *Architecture Vivante*, Autumn and Winter 1923, pp. 19–20.
40 'Groupe de la parure', *Encyclopédie*, vol. 9, p. 16.
41 See, for example, 'Le Carnet d'un curieux – les devantures parisiennes', *La Renaissance*, February 1920, no. 2, p. 190.
42 For 'mines avenantes', see Paul-Sentenac, 'Nouvelles devantures parisiennes', *La Renaissance*, November 1923, no. 11, p. 607; for 'bien galbées', see 'Le carnet d'un curieux – les devantures parisiennes', *La Renaissance*, February 1920, no. 2, p. 190.
43 *La Construction Moderne*, 14.9.24, p. 592.
44 Bouyer, 'Les Devantures parisiennes', p. 536.
45 Guillaume Janneau, 'Boutiques modernes', *Bulletin de la Vie Artistique*, 15.11.23, p. 471.
46 Bouyer, 'Les Devantures parisiennes', p. 539.
47 Henri Clouzot, 'La rue de la Paix-la place Vendôme – la rue de Castiglione', *La Renaissance*, June 1923, no. 6, p. 300.
48 '*Le Temps*, 26.4.23', *La Construction Moderne*, 13.5.23, p. 391.

49 Bouyer, 'Les Devantures parisiennes', p. 538.

50 Clouzot, 'La rue de la Paix', p. 299.

51 See also Marcel Zahar, 'L'Architecture vivante: physionomies diverses des galeries de Paris', *L'Art Vivant*, 1928, pp. 853–7. In 'The new painting' (1876), Édmond Duranty had cited physiognomy as one means whereby the painter might study and depict modern life subjects: 'What we need are the special characteristics of the modern individual [. . .]. [. . .] the study of states of mind reflected by physiognomy and clothing' (Louis Émile Édmond Duranty, 'The new painting: concerning the group of artists exhibiting at the Durand-Ruel Galleries', *The New Painting: Impressionism 1874–1886*, Phaidon, Oxford, 1986, pp. 43–4). For discussions of nineteenth-century theories of physiognomy in relation to visual art practice, see Anthea Callen, *The Spectacular Body: Science, Method and Meaning in the Work of Degas*, New Haven and London, Yale University Press, 1995. See Prendergast, *Paris and the Nineteenth Century*, pp. 184–5 on physiognomies as an eighteenth- and nineteenth-century literary genre which constituted 'a form of urban anthropology'.

52 Guillaume Janneau, 'Le Visage de la rue moderne', *Bulletin de la Vie Artistique*, 5e année, 15 November 1924, no. 22, pp. 495–9.

53 Clouzot, 'Les Arts appliqués au Salon D'Automne', 1925, p. 16.

54 Janneau, 'Le Visage de la rue moderne', p. 497.

55 Clouzot, 'Les Arts appliqués au Salon D'Automne', pp. 15–16.

56 'L'Art urbain et l'art décoratif', *Art et Décoration*, 1924, vol. 45/46, p. 174. See also Janneau, 'Le Visage de la rue moderne', p. 497: 'hier [. . .] la boutique paraissait déborder dans la rue'.

57 *Art et Décoration*, p. 175.

58 For a discussion of the ways in which this contrast of display devices involved classed (as well as gendered) viewing positions, see Nesbit, *Atget's Seven Albums*, pp. 157–65.

59 Just as this book was going to press, I read Mica Nava's persuasive argument on feminine consumption and modernity, 'Modernity's disavowal: women, the city and the department store', in the collection *The Shopping Experience* edited by Pasi Falk and Colin Campbell, Sage Publications Ltd, London, 1997.

60 Jean Valmy-Baysse, *Tableau des grands magasins*, Nouvelle Revue Française, Paris, 1925, p. 55.

61 Pierre Mac Orlan, *La Boutique*, M. Seheur, Paris, 1925, n.p.

62 Clouzot, 'Les Arts appliqués au Salon D'Automne', p. 16.

63 Walter Benjamin, 'The Paris of the Second Empire in Baudelaire', *Charles Baudelaire: A Lyric Poet in the Era of High Capitalism*, New Left Books, London, 1973, p. 50.

64 For a history of advertising in France, see Marc Martin, *Trois siècles de publicité en France*, Éditions Odile Jacob, Paris, 1992.

65 Octave-Jacques Gérin and Charles Espinadel, *Commerce et industrie – les procédés modernes de vente – la publicité suggestive théorie et technique*, H. Dunod et E. Pinat, Paris, 1911 (reprinted 1927), p. 5.

66 Janneau, 'Boutiques modernes', p. 471.

67 *Ibid.*

68 Vicomte Georges d'Avenel, 'La Publicité', *Le Mécanisme de la vie moderne*, A. Colin, Paris, 1902, vol. 4, p. 160.

69 Janneau, 'Le Visage de la rue moderne', p. 498.

70 Clouzot, 'Les Arts appliqués au Salon D'Automne', p. 16.

71 Paul Dermée and Eugène Courmont, *Les Affaires et l'affiche*, Dunod Éditeur, Paris, 1922, p. 154. This is volume 8 of the nine-volume series 'La Technique des affaires'. For Paul Dermée, see Jean-Marie Roulin, 'Paul Dermée et L'Esprit Nouveau', *L'Esprit Nouveau*, 1987, pp. 152–9; and Albert Halter, 'Paul Dermée and the poster in France in the 1920s: Jean d'Ylen as "Maître de l'affiche moderne"', *Journal of Design History*, 1992, vol. 5, no. 1, pp. 39–51.

72 Gérin and Espinadel, *Commerce et industrie*, p. 180.

73 Dermée and Courmont, *Les Affaires et l'affiche*, p. 135.

74 Gérin and Espinadel, *Commerce et industrie*, p. viii.

75 Dermée and Courmont, *Les Affaires et l'affiche*, p. 11.

The art of the shop-window

> On the pont Alexandre, he began to rush along a street full of bou-
> tiques which revived his body and his mind through its profusion of
> sensual spectacles. Oh! the new mannequins at the milliner's, the hair-
> dresser's, the tailor's, the *couturières*! [...] those wax figures, those
> Sidonies with their outmoded airs and graces were no longer bearable,
> [...] we urgently need to let the sculptor's talent transform the volup-
> tuous nature of these life-size dolls, through stylisation. I observed to
> my friend that so-called 'cubist' sculpture [...] should also play an
> active role in the stripped-down architecture and furniture of tomor-
> row: those unfortunate artists, for want of better opportunities to flatter
> their pride, would have to accept those offered to them by Parisian
> commerce [...].[1]

Jacques-Émile Blanche's mock-rapturous account of the rue des Bou-
tiques on the pont Alexandre III appeared as part of a series of articles
for *Les Nouvelles Littéraires*, exhibition reviews which Blanche couched
in the form of *promenades*. It would be easy to dismiss such literary
flâneries as lightweight journalism penned by a reactionary critic – as
did Le Corbusier in his book of essays the *Almanach d'architecture
moderne*, where Blanche figures as a kind of uncomprehending fall-guy
who stumbles across the Pavillon de L'Esprit Nouveau quite by chance
('tout par hasard').[2] But this would be to miss the value of Blanche's
description as symptomatic of the ways in which exhibition boutiques
represented both modernity and Frenchness in terms of the street. His
ode to the modern mannequin is especially telling, revealing the extent

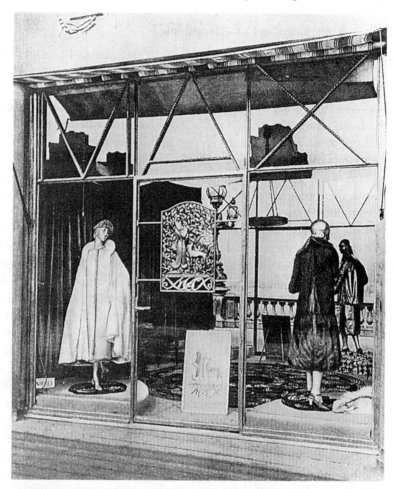

31 'Boutique des Fourrures Max', photograph from *Encyclopédie*, vol. 11, plate XXIII

to which certain aspects of the discourse of *publicité* had become common currency by the mid-1920s. More specifically, there is the implication (however facetious) that shop-windows had somehow become relevant to the practice of high art. Rather than discounting Blanche's review as snide commentary from a well-known opponent of the Parisian avant-garde, this chapter examines what might have been at stake in a conjunction of *publicité* and art as suggested by the 1920s' boutique *vitrine*. A good starting point for this exploration – following Blanche's lead – is the shop-window dummy (the *mannequin de l'étalage*) (plate 31).

A physiognomy of effacement

A fascination with mannequins was not particular to Blanche and pre-existed the 1925 Paris Exhibition.[3] In the critical response to the Place Publique at the 1924 Salon d'Automne it is possible to trace a recurring obsession with these inanimate stars of the shop-window. Of the ten boutiques in the Place Publique, two were devoted to the producers of shop-window mannequins (Siégel and Pierre Imans, two well-known Parisian manufacturers) and mannequins appeared as a display device in several of the other *vitrines*. Nearly all the critics took approving notice of the mannequins. Guillaume Janneau, for example, followed up his November review of the Salon for the *Bulletin de la Vie Artistique* two months later with an essay on 'Mannequins modernes' couched in the form of an interview with a representative of the firm Imans.[4] In many contexts throughout the 1920s the *mannequin de l'étalage* was fêted as the queen of *publicité*, the quintessential manifestation of a mute solicitation of the passerby's gaze. Mannequins, it has been argued more recently, mark a significant relationship between *la mode* and *publicité*. Writing on mannequins, Eugénie Lemoine-Luccioni claims that 'fashion generates *publicité*', initially taking the form of 'small "fashion dolls" which were toured around Europe since the seventeenth century'.[5] During the 1920s commentators such as Janneau also remarked on the fact that from a very early date the fashion industry had generated *publicité* in the form of simulacra of the female body. But Janneau was at pains to stress that these Ur-mannequins were a primitive thing.[6] It was indeed through contrast with such outdated models that the 'modern' mannequin was defined. If overflowing styles of window display were disparaged as old-fashioned, so too could the mannequin be credited with its *passé* formulations. Critics seemed in agreement as to what characterised the modern in this context. Mannequins were made of different materials and came in a variety of forms, but the identifying feature of the *mannequin moderne* was its *stylisation*. This notion of stylisation had to do with a transfer of attention from female body to inanimate object. A long article on mannequins in the advertising journal *Vendre* stressed: 'the aim is to arouse admiration for the "object" not the mannequin'.[7] Mannequins were defined as modern to the extent that they diverted desire from themselves to the commodity. In Janneau's interview with Imans, the producer of mannequins claimed: 'A mannequin, for example, is not simply a creation of the imagination [. . .] it must be constructed primarily in order to show the dress to advantage [*mettre en valeur*].'[8] According to theories of *publicité*, the mannequin both enhanced and duplicated the task of the *étalage* and hence of the boutique itself. In the case of the *mannequin*

de la mode, the mannequin ostensibly worked to arouse a female desire, that desire for the 'ever-new' constituted by woman's fashion. But at the same time, the *mannequin de l'étalage* was, like the poster, a component of the city street and therefore not solely the object of female looking. Of the mannequins at the 1924 Salon it was claimed: 'these, at any rate, are new attractions for the modern street'.[9]

'Stylisation' was not infrequently described in terms of art. The front cover of a 1928 issue of the advertising journal *Parade* featured the photograph of a 'female mannequin's head'. (The choice of a mannequin for the cover is not surprising given that V. N. Siégel is listed on the masthead of the magazine as a 'founder'.)[10] The mannequin is faceless and blank, a startling – even disconcerting – image of *publicité* as 'silent' selling. But this facelessness suggested more than silence. A Siégel publicity brochure entitled 'Modernism adapted to fashion' includes the photograph of a female mannequin positioned in front of a geometrical backdrop bearing the caption 'a dress shown to advantage: an unobtrusive [*effacé*] mannequin' (plate 32). And inside the brochure there is another caption reading 'no indication of facial features: an intense expression' (plate 33).[11] It was through this 'stylisation' – this abstraction of the female body – that the Siégel mannequin signified artistic modernism 'adapted' to the needs of fashion. The rhetoric of *publicité* invoked the non-figurative tendencies of avant-garde art in order to justify the erasure of the female face – to claim this eradication as modern. 'Stylisation' (that is, the emphasis on formal qualities of line and shape) was claimed as the means of shifting attention from female body to commodity. On the subject of the *étalage*, the magazine *Parade* quoted a theorist of *publicité* as follows:

> An effective shop display can be considered a salesman who speaks a special language that is necessary and accessible to everyone: the language of line and colour, the language of rhythm, of harmony and of light, the language of merchandise shown to advantage [*mise en valeur*].[12]

According to the Siégel advertisement for mannequins, effective display of *haute couture* was achieved via erasure of facial features, and it is the clothes worn by the mannequin which end up 'shown to advantage' ('mise en valeur'). Not woman (as represented by the mannequin) but rather the commodity was thus endowed with an 'intense expression'. With the *mannequin de l'étalage* therefore the discourse of *publicité* proposed yet another 'physiognomy' of the modern.

Significantly, the shop-window mannequin is a stand-in for the 'real' thing, the female body in the guise of the fashion model. But

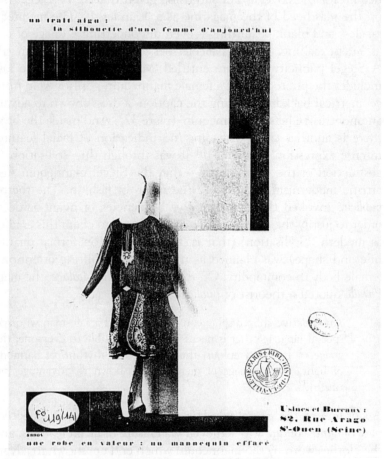

32 'Modernism adapted to fashion'. Page from Mannequins Siégel Paris advertising brochure, later 1920s

mannequins Siégel-Paris

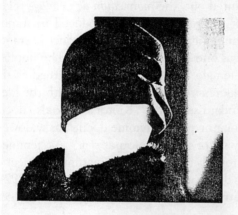

synthèse de
l'époque

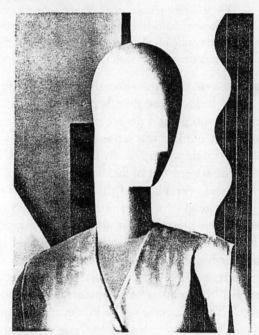

pas d'indication
de trait :
une expression
intense

Galeries d'Exposition et de Vente : 19, Rue Réaumur, Paris

33 'No indication of facial features: an intense expression'. Page from
Mannequins Siégel Paris advertising brochure, later 1920s

inanimate mannequins could be interpreted as substitutes in a number of different ways, as in Léon Riotor's 1900 book *Le Mannequin*. On the one hand, as Riotor pointed out, the *mannequin de l'étalage* related not directly to the body but to dress – clothing produced in standardised sizes.[13] Shop-window mannequins were thus the product of standardisation, 'madones en série' as one 1920s' writer put it.[14] The implied argument here *vis-à-vis* the female viewer might be construed as the shop mannequin's potential address to female narcissism, with the ideal body now redefined as the standardised body.[15] Riotor's book also documents, however, a role for the mannequin as 'femme docile', as widower's consolation or as the lonely sailor's companion at sea.[16] As 'femme docile' the mannequin overtly reveals its potential as inanimate object of male desire. The terms of this desire were quite specific. Janneau's 1924 Salon review contrasted 'modern' versions of the mannequin with older types:

> Yet another new art, that of mannequins; one tires of those frightful wax cadavers, disturbing facsimiles [. . .]. Certain gilded mannequins have been condemned. Why this restriction to the possibilities of stylisation? Aren't these [figures] all the more arresting for their lack of versimilitude?[17]

'Old-fashioned' mannequins, then, were interpreted as horrific ('affreux') precisely because the fake body of the mannequin was always undermined by too great a degree of verisimilitude. The wax mannequin all too vividly evoked the sense of a disturbingly 'real' female body. With Siégel's *mannequin stylisé* on the other hand, the violence of obliteration – the wiping out of facial features (one of the most important signs of identity) – emphasised the mannequin as object. And not just any object: instead of a head articulated in terms of a face these stylised mannequins presented an almost phallic aspect. In this sense, 1920s' *publicité* (the 'science' of selling) did indeed speak 'un langage spécial, mais nécessaire' – that of fetishism. In his *Traité pratique de publicité commerciale et industrielle* Louis Angé claimed that the twentieth century was 'the century of advertising – of scientific and rational advertising'.[18] The discourse of the modern mannequin, however, reveals the dynamics of this modernity as those of the unconscious.

At the 1924 Salon d'Automne, one boutique in particular – the Boutique Simultanée with its *vitrine* of moving textiles – provided a dramatic contrast to the frozen stillness of the *mannequins de l'étalage* on show in the Place Publique (plate 34). In this boutique, electricity was deployed not only as a means of illumination but also to set in motion a sequence of four lengths of abstract-patterned textiles stretched flat and rotated by a roller device.[19] (The display mechanism, a roller device, had been invented and patented by Robert Delaunay.) As we

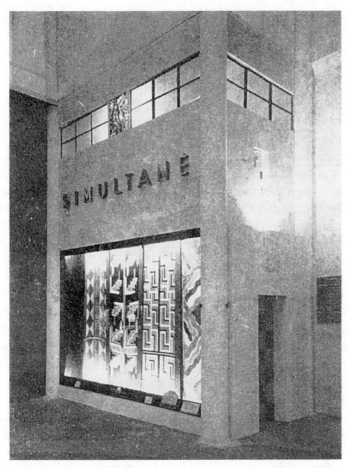

34 The Boutique Simultanée at the 1924 Salon d'Automne, Paris

have seen, in claiming its mannequins as the product of 'modernism adapted to fashion' the Siégel advertisement juxtaposed a geometrically patterned backdrop with the figure of a shop-window mannequin. The intended analogy was with non-figurative abstraction. Siégel mannequins were 'modern', it is implied, precisely because of their lack of figuration, the absence of legible human features. Such references to the realm of high art were deployed in order to legitimate the transfer of intense looking from face to commodity, from female body to object. But of course the 'tissus Simultanés' on show at the 1924 Salon d'Automne – textiles designed by the painter Sonia Delaunay – also represented an 'adaptation' of artistic modernism to fashion. If Siégel's *mannequin stylisé* involved a *mannequin effacé* in the sense of 'no indication of facial features', the kinetic display of the Boutique Simultanée would seem to

have obliterated not only the face but also the body of woman. How should we interpret this obliteration? Did these spotlit textiles in movement refuse or compete with the strategies of *publicité* embodied by the 'modern' mannequin?

In relation to techniques of catching the eye, manuals of *publicité* constantly reiterated the need for vivid presentation of the commodity; Paul Dermée wrote of 'the need to represent the commodity, the advertised merchandise, with the maximum possible realism. [. . .] Isn't it the commodity itself that must appear on the wall?'[20] According to theorists of *publicité*, the shop-window was one means of achieving this 'realism'.[21] Even more than the poster, it was claimed, the *étalage* rendered the commodity visible 'on the wall' of the city's streets: 'here, the displayed object – jewellery, ceramics, fashion – is encrusted into the [surrounding] architecture'.[22] With the modern boutique, the commodity became a constituent part of the street – 'encrusted' into the architecture of the façade. In presenting lengths of textiles full-frontally (the surface of the textiles parallel to the glass pane of the shop *vitrine*) the Boutique Simultanée was a particularly vivid instance of displaying the commodity 'on the wall'. And showing the commodity in motion fulfilled a fundamental premise of *publicité*, according to which movement constituted one of the most successful ways to attract the attention of the viewer. (Louis Angé, in writing about an early form of moving advertisement – the *homme sandwich*, in effect a walking poster – cited psychological research which 'proved' that viewers paid more attention to moving than to static objects.)[23] Displays in shop-windows might also involve movement, and in this connection the human body could make an appearance.[24] But clearly the idea of putting 'real' people on show in the shop-window generated some unease. For one thing, as we saw above, it was claimed that the body (and in particular, the female body) always threatened to divert attention away from the commodity. Even more alarmingly perhaps, such displays risked defining the human body itself as commodity. *La Publicité suggestive* rather nervously cautioned: 'this method requires great delicacy of treatment'.[25] A less problematic solution was to deploy a mechanical means of showing the commodity in motion – a wind machine to blow silk ribbons in streams running parallel with the plane of the *étalage*, for example.[26]

The screen constituted by the glass pane of the shop-window suggested a specifically modern technology – that of cinema. The analogy was evident to one critic (Henri Clouzot) who described the *étalages* at the 1924 Place Publique as 'luminous like a cinematographic image'.[27] As cinema at this period was a silent medium – largely a matter of the

luminous moving image – it is not surprising that the 1920s' advertising industry should have sought to harness cinematic techniques to the processes of 'silent' selling. A rather literal instance appears in a 1925 issue of the magazine *Vendre* which featured a prominent advertisement for a device called 'Écran-Stop!', described as 'a cinema in the shop-window' (plate 35).[28] The accompanying illustration graphically makes its point:

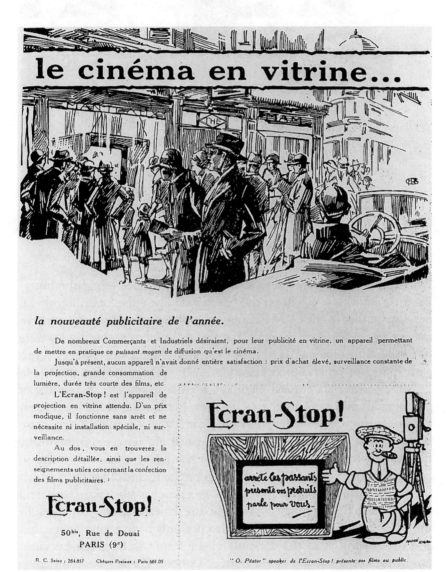

35 Advertisement for 'cinema in the shop-window' in *Vendre: Tout ce qui Concerne la Vente et la Publicité*, Dec. 1925, opp. p. 548

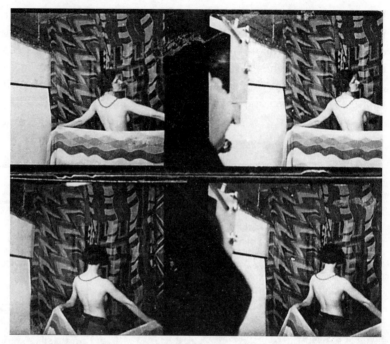

36 Photographs of a model demonstrating Sonia Delaunay textiles in movement, dated 1924

turning the shop-window into a cinematic experience brings the hurrying urban crowds to a halt on the pavement. The effect of brilliantly lit, moving textiles in the 1924 Boutique Simultanée constituted a particularly vivid evocation of cinema.[29] But the associations of this display were not only with cinema. The 1924 Boutique Simultanée project forms part of a more general preoccupation on the part of Robert and Sonia Delaunay to display Sonia Delaunay's textiles in motion. A number of photographs taken during the 1920s show her textiles draped and stretched over the body of female models in such a way as to convey a sense of movement; here the inanimate (textiles) are rendered animate by the moving female body (plate 36). Such imagery relates of course to Sonia Delaunay's drawings and paintings on the theme of dance in which the body of the dancer is represented as a series of abstract shapes and disk patterns.[30] One might argue that the kinetic display on show in the 1924 Boutique Simultanée implied not only a cinematic image, but also the apparition of the dancing female form. As Lemoine-Luccioni has written of the seven-metre train of Princess Diana's wedding dress: 'It looked like the traces left by the body of the princess, like the milky way. It is the line of a moving body: the halo of an apparition.'[31] The

Simultaneous fabrics were luxury textiles, silks produced for the purpose of making women's dresses.[32] And in the 1920s' writing on fashion textiles, fabrics were often described as 'modern' precisely because they were lightweight and flowed with the wearer's movements.[33]

Staging the commodity: transformation scenes

The claim for the 1924 Boutique Simultanée as a form of spectacle was (as we have already seen in Chapter 3) quite commonly applied to the boutique shop-window in general: 'In order to attract the crowds, commerce has created the boutique, marvellous sorceress who presents onlookers with a mirage: the shop-window, where objects are composed as performances for the purposes of shop display.'[34] Here the phantasmagoria of the commodity ('ce mirage') is represented in terms of theatrical performance ('les sketches') staged in the shop *vitrine*. The comparison of shop with theatre appeared again in a 1924 issue of *La Construction Moderne* where an article on shop-windows argued that electric lighting was vitally necessary for successful *publicité*. Electric lighting was here promoted as an effective means of distinguishing one shop display from another by showing off the commodity to best advantage: 'presenting objects in their most favourable aspect'. Spotlighting the commodity was identified as an important means of achieving the aim of *publicité* to effect sales without the intervention of sales staff.[35] In rendering the commodity spectacular, it was claimed, electricity put the commodity to work by night as well as by day – the work of making itself noticed and desired.

Studies of shop display were frequently given titles which emphasised the nature of *publicité* as spectacle – as with the advertising journal *Parade*, whose full title was *Revue du Décor de la Rue – Journal de l'Étalage & de ses Industries*. *Publicité* involved a spectacle motivated by the need to sell, a spectacle often staged in the street. The language of *publicité*, however, alluded more often to the theatre than to the street parade. An essay on billboard advertising, for example, claimed that 'yet again the street is a theatre auditorium'.[36] Robert Delaunay's account of his textile display device for the 1924 Boutique Simultanée accorded with this idea of *publicité* as inherently theatrical; he claimed that the revolving roller system could also be used as 'a moving backdrop for actors'.[37] Despite the cinematic effects of this Boutique therefore, it was the theatrical associations which prevailed. Something more concerning what might be at stake in the characterisation of *publicité* as theatre is suggested by Georges d'Avenel's description of the poster in *Le Mécanisme de la vie moderne*. This involved an extended theatrical metaphor:

> The poster which descends to the pavement must be 'made up', like an actress's face, who before treading the boards of the stage, exaggerates the features and details of her face, substituting a skilful boldness for the natural harmony of her features.[38]

D'Avenel's evocation of woman 'on stage' emphasises woman's need to be looked at, a need indicated by the artifice of exaggerated stage make-up. Like the prostitute, the *femme de théâtre* signified a woman who made a show of herself in public. With the image of the female stage performer (and the implication of her passionate desire to be looked at) the discourse of *publicité* rationalised – or rather masked – a *male* need to look at artificial substitutes for the real (and all too frightening) female body. But this metaphor of the woman on stage suggests not only a (male) anxiety motivating the obsessive gaze directed at the commodity, it also signals a conflict of desires.

In order to elucidate this claim, let us return to what I have described as the absent presence of woman's (dancing) body evoked by the moving textiles of the 1924 Boutique Simultanée. In the context of dance at this period, one of the most dramatic instances of dance effecting a displacement of movement from female body to textiles was the work of Loie Fuller, whose dances were referred to as 'nothing but a display of coloured textiles' (plate 37).[39] Fuller's performances involved metres and metres of lightweight material suspended on wooden rods attached to the dancer's arms. The dances were electrically lit (often with complex sequences of coloured lights) and usually climaxed in a cloud of swirling textiles which totally enveloped the dancer's body. During her own lifetime, Fuller was a cult figure in France, and images of the dancer (frequently taking the form of a cloud of textiles) proliferated in a variety of media.[40] Contemporary responses attributed an almost hypnotic effect to Fuller's animated textiles: her body dramatically lit from below (she often performed standing on top of an electric light), the fabric of her swirling dress produced hallucinatory images of tumescence and detumescence. Fuller's dances were a vivid demonstration of textiles' double role in simultaneously veiling and revealing the female body. In some of Fuller's more 'abstract' dances, however, the performers remained completely hidden. This was the case with 'La Mer' performed at the 1925 Paris Exhibition to the music of Debussy in which a number of dancers animated a shimmering ocean of blue silk.[41]

Although Fuller performed at the 1925 Exhibition, her dances were – even by this date – very much associated with the Belle Époque (she had also danced at the 1900 Exhibition).[42] By the mid-1920s,

'modern' dance was more often defined through reference to the vogue for 'American' dances such as the tango and the Charleston. The New World was credited as the birthplace of innovative dance and these 'American' dances were represented not only as modern but also as highly erotically charged.[43] Writing in the 1920s, Havelock Ellis cited dance as evidence that woman had appropriated man's role in the ritual of mating.[44] Change in contemporary women's fashion was often attributed to this post-war mania for dance.[45] However different from

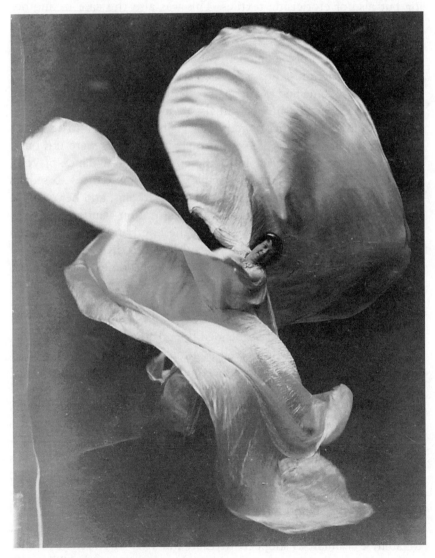

37 Loie Fuller dancing, c. 1914

Fuller's stage performances, these dances could also suggest a displacement of movement from body to dress. For example, one etymological explanation proposed for the name of the then popular dance – the shimmy – was 'shake my chemise'.[46] And revealingly, Blaise Cendrars opened his 1914 poem 'The Simultaneous Dress' (dedicated to a dress designed by Sonia Delaunay for wear at the Bal Bullier, a popular venue for dancing the tango) with the line 'on her dress she wears a body'.[47]

Cendrars' poem implied dance as the means not only of animating but also of eroticising textiles. This was also the case in another dance context, that of the ballet, and in particular, certain performances of the Ballets Russes. If America (both North and South) represented an exoticism of the 'modern', then the Ballets Russes staged the dream of an Orientalised past. Russian dancers such as Ida Rubinstein performed as Salomé and as Cleopatra – both characters through whom the erotic is enacted through rituals of unveiling.[48] In 1918, Sonia Delaunay designed a series of veils for Diaghilev's 'Cleopatra'. Fokine's choreography involved a dance in which twelve veils were unwound from Cleopatra's body, each in a different way.[49] The dance of veils, however, involves a significant complexity: Salomé dances to seduce Herod, but this is a performance desired by Herodias, and her desire is represented as threatening, castrating – a castration symbolised by the decapitation of John the Baptist. If on the one hand dance implies a displacement of movement from woman's body to dress, and therefore an eroticisation of textiles for the male viewer, Salomé's dance of veils also suggests the presence of a female desire. 'Whether professional or not, all women wanted to be Salomé, at least for a night,' claimed Jean d'Udine, author of the 1921 book *Qu'est-ce que la danse?*[50]

Commerce and *publicité* defined the urban street as site of desire, but this involved a female as well as a male gaze, woman's as well as man's desire. Indeed, since the nineteenth century, it had been apparent that it was above all the female consumer to whom the strategies of selling must be addressed.[51] However, much like the figure of Salomé, the woman shopper – the woman who 'wants' – was inevitably described as deviant, asocial and out-of-control. The obsessive nineteenth-century preoccupation with female kleptomania in department stores is but one measure of the threat embodied by the woman shopper. Although acknowledged as necessary to the processes of modern production and consumption, woman's desire was represented as in need of constant policing.[52] Early twentieth-century psychoanalysis set out to 'analyse' woman as shopper. In 1908 and 1910 the French psychoanalyst Gaëtan de Clérambault published two essays entitled 'Women's

erotic desire for textiles' ('Passion érotique des étoffes chez la femme').[53]
Clérambault engaged with the discourse of the female kleptomaniac in
order to represent her as doubly deviant, sexual pervert as well as thief.
He formulated a theory which harnessed notions of female kleptomania
to those of fetishism, proposing a female fetishism defined specifically in
terms of a textiles fetish. Unlike the male fetishist who was reverently
attached to his fetish, argued Clérambault, the female fetishist, having
been overcome by a desire so powerful that it became uncontrollable
(usually for the most luxurious textiles, particularly silk) stole a piece of
the fabric, masturbated with it, and threw it away. Clérambault's essays
posited the existence of a specifically female fetishism in order to ensure
that in the realm of perversion (as elsewhere) femininity was valued as
inferior to masculinity.[54] Men too, Clérambault was quick to point out,
might fixate on textiles as fetish. Women, however, he claimed, desired
only new textiles, they disdained those traces (both visual and olfactory)
of the body so prized by the male fetishist. This fetishistic desire for the
'ever-new' thus reasserted the notion of woman as victim of fashion, and
it is thus that woman emerges in Clérambault's theory as the paradigm
consumer: ravenous, capable of only momentary (but repeated) *jouissance*,
complicit with capitalism's ceaseless rhythms of consumption and waste.
Even more significantly, whereas male masturbation with the fetish in-
volved a mobilising of the imagination (the conjuring up of an absent
other), female fetishism was defined by Clérambault as a mindless activity,
simply a further manifestation of woman's inherent narcissism.[55]

Clérambault's psychoanalytic theory of female fetishism can be
read as one attempt to counter the threat posed by woman's desire. The
realm of commerce, characterised in terms of the boutique window as
'théâtre de présentation', engendered a choreographer responsible for
directing not only what appeared in the shop *vitrine* but also the per-
formance of shopping itself: the desiring gaze of the woman shopper
was subsumed by that of the *étalagiste*, the window-dresser. This figure
was charged with orchestrating female desire on behalf of capitalism as
well as in the interest of producing and reproducing a dominant male
subjectivity.[56] In this sense, the *étalagiste* was the necessary counter-
point to the female shopper. Woman's gaze, necessary but threatening,
was structured and directed according to the skills of the *étalagiste*.
(Window-dressers, as 1920s' articles on the profession of *étalagiste* re-
veal, might be either male or female; it is the significance of the male
étalagiste as a means of articulating fantasies of masculinity and author-
ship that forms the focus of my concern here).[57] An earlier, nineteenth-
century formulation is revealing: Zola's character Octave Mouret, a great

womaniser and the director of the ironically named Bonheur des Dames *grand magasin*, represents the *étalagiste par excellence*. It was his talent for window-dressing and shop display which enabled Mouret to transform the Bonheur des Dames into a gigantic snare for woman, to turn woman's desire against herself, to the shop's and (man's) advantage. Mouret's professional abilities are represented as an extension of his sexual prowess and his successes as an irresponsible seducer. When Mouret is depicted as surveying the scene of one of his most enormous and profitable sales from the top of the shop's staircase, he forms the dramatic embodiment of the fantasy of a panoptic and all-powerful male gaze.[58]

The artist and the shop-window

During the 1920s, references to *publicité* constituted one means of reconceptualising the status of art in the modern city. Art and *publicité*, it was suggested, formed congenial allies. On the one hand, there was the claim that since beauty was a necessary component in the 'seduction' of the consumer which was the aim of *publicité*, art (like psychology) must be recruited to the work of selling.[59] Paul Dermée's contribution to *Les Affaires et l'affiche* was in part an argument on the potential for art offered by advertising. One of the painters interviewed for this book concluded: 'Industrialisation permits the artist to use the walls of the city, the façades of buildings, for the expression of innovation and one can say that the possibilities thus opened and put at his disposal are prodigious.'[60] Here commerce was interpreted as the means of expanding the sphere of artistic activity; indeed, it was precisely the artist's engagement with *publicité* which was deemed symptomatic of modernity. This line of argument provides one context through which to assess the significance of the Delaunays' participation in the 1924 Salon d'Automne: two painters, one exhibiting textiles, the other window display and a poster in the Place Publique central *kiosque*. In an essay entitled 'The art of movement', Robert Delaunay credited the boutique format at the 1924 Salon as one of the 'new signs' through which the painter was able to establish a mass audience for art. The boutique thus provided the opportunity for avant-garde art to compete with – but also through – *publicité* for the attention of the crowds on the city streets.

Great claims were made for the boutique as a disseminator of modern art. An article in *La Renaissance* entitled 'The modern movement – art in the boutique' asserted that advertising was an important means of spreading art throughout the nation: 'Regional schools could be among the first to introduce them. The museum *en plein air*

constituted by posters can play a part. The boutique will complete the work.'[61] Like the commodity, it was argued, art must seek the 'frame' of the shop-window in order to be rendered visible on the street of the modern city. It was often contended that the *étalage* constituted the ultimate in modern display techniques not only for the shop but also indoors for exhibitions.[62] Taking the argument one stage further, Robert Delaunay claimed that the Boutique Simultanée was more modern than any of the canvases on show at the 1924 Salon d'Automne; he charac-terised these paintings as 'corpselike' by comparison with the vitality of the Simultaneous display.[63]

For Fernand Léger – like Robert Delaunay – the pictures exhib-ited at the Salon were a thing of the past. According to Léger's 1924 essay 'The machine aesthetic' (which first appeared in the *Bulletin de l'Effort Moderne*), Salon easel painting had been rendered redundant by the modern craftsman and artisan. A key sequence in Léger's argument is his recollection of one year in which the Salon d'Automne had been shown alongside the Aviation show, a juxtaposition which revealed to him the inferiority of art ('dismal and gray, pretentious') by comparison with the products of technology ('metallic objects, hard, permanent and useful'). Even more vivid a contrast, however, is set up by this narrative through the confrontation of a mechanic and the paintings on show at the Salon:

> I will always see a sixteen-year-old with fiery red hair, a new blue canvas coat, orange pants, and a hand spattered with Prussian blue blissfully contemplating the nude women in gold frames; without the slightest doubt, he – in his clothes of a modern worker, blazing with color – killed the whole exhibition.

In Léger's formulation, modernity involved averting the gaze from female to male body (the mechanic was referred to by Léger as 'the dazzling kid'). The female nude is thus defunct (reduced to 'vaporous shadows in old frames') whereas the mechanic unselfconsciously displayed that body which was 'the symbol of the life of tomorrow'.[64]

This passage is evidence of a desire to reformulate the identity of the modern artist, a reformulation which necessitated 'jumping over the barrier' not only between two exhibitions but also (figuratively speaking) between professions. Along with the figure of the mechanic, that of the *étalagiste* also featured prominently in Léger's essay:

> We should deeply admire this worthy craftsman, forging his own work with difficulty and conscientiousness, which is more valuable than those expensive canvases [. . .]. Men like this, such artisans, incontestably

have a concept of art – one closedly tied to commercial purposes, but one that is a plastic achievement of a new order and the equivalent of existing artistic manifestations, whatever they may be.[65]

Working away behind the barrier of the boutique window the *étalagiste* formed another artisanal model for the modern artist. Of the 'display-window spectacle', Léger wrote: 'Frantic competition reigns there: to be looked at more than the neighbouring store is the violent desire that animates our streets.' This reference to 'a desire to be looked at' would seem to relate to contemporary theories of *publicité*, but why should Léger have appropriated the language of advertising?

An answer is suggested by another reminiscence, yet again on the subject of male looking. Léger recounts the occasion when he and his friend Maurice Raynal paused in front of a haberdasher's to observe a window-dresser at work:

> This man, this artisan, had seventeen waistcoats to arrange in his window, with as many sets of cufflinks and neckties surrounding them. He spent about eleven minutes on each; we timed him. We left, tired out, after the sixth item. We had been there for one hour in front of that man, who would come out to see the effect after having adjusted these things one millimeter.

There is (significantly) another artistic persona present in this text, one based on an older model than that of the artisan-*étalagiste* – that of the *flâneur*. A notable feature of Léger's anecdote is the determined dis-avowal of any male desire for the commodity: the *flâneur* may desire woman (avidly seek her out as preferred object of the gaze indeed) but the defining characteristic of the *flâneur* is his aimless wandering about town. The *flâneur* may, in other words, gaze into shop-windows but he is emphatically not a shopper.[66] André Warnod in his 1920 book *Les Plaisirs de la* rue claimed that the *flâneur* neither seeks nor desires, 'il flâne'.[67] The occupation of shopping ostensibly legitimated the presence of desiring woman on the urban streets, but the figure of the female shopper (as we have seen) all too easily merged with the spectre of the out-of-control woman. Or as Léger put it in another essay of 1924, 'The spectacle: light, color, moving image, object-spectacle':

> A woman who goes into the store is half won over; she must buy, she will buy because her defenses are destroyed by the 'shopkeeper's bril-liant trick'.
>
> It's a spell, a fascination, knowingly manipulated. The stores want a victim; they often have one.[68]

The two flâneurial figures in Léger's account are represented as entirely caught up in their admiration for the *étalagiste*, but this admiration does not take the form of uncontrollable desire – Léger claimed to have timed the work of the window-dresser and the whole scenario is depicted as a kind of precision performance.[69]

An updated definition of artistic authorship is produced through identification with figures on both sides of the shop-window. Glass – simultaneously means of communication and barrier, both transparent and opaque – provides the appropriate imagery for this process. On the one hand, the thin, transparent sheet of glass which allows such a clear view into the shop *vitrine* serves as a reminder of the difference (in status) between artist and artisan. At the same time, the glass pane operates less as a 'barrier' than as a looking-glass. In this narcissistic fantasy, *flâneur* confronts *étalagiste* as mirror image. And it is significant that the body on both sides of this 'glass' is reassuringly male – even the goods arranged by the window-dresser are identified as ordinary men's clothing. We might thus read this 1920s' reformulation of author as *étalagiste* (notions of a 'new' art based on the staging of the commodity) as representing male fantasies of appropriating not only woman's gaze, but also her enticing powers of adornment and display. Just as it was sometimes useful to invoke the visual language of avant-garde art in the cause of *publicité* (as with the Siégel advertisement for *mannequins stylisés*), so the practices of high art did not exist in a sphere detached from and unaffected by the commercial and economic developments which had engendered the institutions of *publicité*. At certain levels, the idea of Paris as 'one large boutique' may have been an effective promotional strategy. But this depiction of Paris as a woman's city – mecca of shopping – also aggravated anxieties and posed threats which art (as much as contemporary psychoanalysis or sociology) attempted to allay in redefining (male) identity through reference to the 'modern' language of *publicité*.

These fantasies of male authorship formed the defence against the threat implied by woman's gaze – not only that of woman as shopper, but also that of woman as author. And in connection with authorship the identity of the dancer is particularly revealing. In a certain sense, the woman dancer was (like the woman shopper) an ambivalent figure. Books on dance of the 1920s often dwell on the idea that in performance the dancer was simultaneously subject and object.[70] Up to a point then, the woman dancer remained reassuringly the object of the gaze, the embodiment of male desire. But the woman dancer always threatened to return that gaze, a moment dramatically enacted in Loie Fuller's 'Fire Dance' (performed to Wagner's 'Ride of the Valkyries').[71]

Here the dancer's dress was activated in order to cover her entire body, conjuring up metaphors of consuming passion. At a climactic moment Fuller opened a slit in the 'flaming' veils and Medusalike revealed her eyes to the audience. Loie Fuller not only choreographed her own dances (and those performed by her school) but also directed the complex system of coloured lights that were beamed on to her flowing veils. (These special effects were carefully worked out in her 'laboratory'.) Fuller the 'electrician' (as she was sometimes called) represents a rejoinder to the image of the helpless woman shopper bedazzled and hypnotised by the electrically lit commodity. With Fuller it was woman herself who directed and controlled the gaze of the audience. Fuller's account of having exhausted her large team of male lighting technicians by the end of her performances suggestively conflates images of authorship and desire.[72]

The woman dancer thus represented a much more unstable and volatile figure than that other performer, the fashion model. Sisley Huddleston, waxing lyrical about models in *In and about Paris*, pronounced:

> The *mannequin* [. . .] conveys something mythical, the eternal woman – Lilith, Cleopatra, the Queen of Sheba – draped in silk and colour and light. She neither speaks nor dances – her movements are meaningless; yet she says more than she could say in words or in music or in dance.[73]

A prerequisite for this profession was extreme slenderness, the erasure of physical signs of femininity – models, Sisley claimed, were 'without what is euphemistically called a "figure"'. The best models were also devoid of personality. Their bodies functioned to demonstrate another's creativity: 'on their slender frames the fantasy and the audacity of the designer are revealed'. Much the same was true of that other fashion body – the (inanimate) mannequin. Magazines of the 1920s abound with articles about the men who produced shop-window mannequins – a genre often elevated to the status of popular 'sculpture'.[74] These 'stylised' mannequins, it was claimed, evoked the quintessential modern *Parisienne*.[75] A bit like the Pygmalion myth, such narratives inverted the natural order of procreation to represent man producing woman. The point about these 'madones en série', however, was precisely that they were 'madonnas': the *Parisienne* as shopper was recast as nondesiring woman. Like the dancer the shopper remained perpetually – terrifyingly – potential subject. The presence of the *mannequin stylisé* reassured the male viewer that it was not woman who returned his gaze from the boutique *vitrine*. The gaze 'reflected' back from behind the

looking-glass of the shop-window was not that of urban woman but rather that of the *étalagiste* in his guise as author.

Mannequins at the 1925 Exhibition

For Jacques-Émile Blanche writing in 1925, it was above all the *mannequin de l'étalage* which characterised the modernity of the rue des Boutiques on the pont Alexandre III. As we have seen, an admiration for 'modern' mannequins was well established by the time Blanche took his stroll along the shop-lined street. Similarly, the terms of that admiration – the invocations of 'stylisation' and the references to 'art' – conformed to certain recurring patterns. For Blanche as for others, the modernity of these mannequins in 1925 was defined through contrast with the 'insupportable' wax figures of the past. The new mannequins achieved a desirable sensuality he claimed through the intervention of art – the art of the sculptor. Janneau, like Blanche, referred to sculpture in describing the mannequins on show in 1925 as 'monumental sculpture in the service of fashion'.[76] This conceit of the mannequin as monumental sculpture suggests a kind of modern-day caryatid: a representation of the female body conceived as a support and hence as a fundamental component of the urban architectural ensemble. In the case of the shop-window mannequin, however, this supporting role involved display of the commodity as opposed to loadbearing.

The idea of the modern mannequin as art – as life-size sculpture – was based on notions of stylisation that involved qualities of surface as much as simplification of form. An enthusiastic reviewer writing for the *Architectural Review* pronounced thus on the mannequins which appeared at the 1925 Exhibition:

> Sometimes all naturalisation is cast aside, decoratively cut feature, cut out in place, is gilt or silvered over, to add to its strangeness. Sometimes face and figure become a mere cubistic chaos of intersecting surfaces; sometimes face and hands are reduced to a decorative hieroglyphic traced in space.[77]

The art of 'stylising', as we now know, involved an eradication of the signs of the 'natural' female body, its translation (as this writer put it) into 'cubistic chaos' or 'hieroglyphic'. Woman's body, in other words, qualified as 'decorative' only when it had been rendered illegible. This defamiliarisation of woman involved not only a reconfiguring of expressive parts of the body (such as face and hands) but also a transformation of surface; the modern mannequin might have, for example, 'skin' that was 'gilt or silvered over'. With the mannequin as much as the boutique

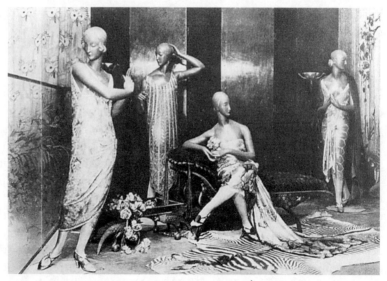

38 Mannequins Siégel in the 1925 Pavillon de l'Élégance. 'Robes du soir par Callot Sœurs', photograph from *Encyclopédie*, vol. 9, plate XIV

itself therefore, surface was ascribed an important role in defining the commodity on display as luxurious.

The firm Siégel & Stockmann (who had also exhibited in the Place Publique at the 1924 Salon d'Automne) was awarded a gold medal at the 1925 Exhibition. Their mannequins were prominently displayed in numerous locations throughout the Exhibition, in the Pavillon de l'Élégance as well as on the pont Alexandre III. The Pavillon de l'Élégance was devoted to the display of lavish fashions by some of the most famous Parisian *couturiers* (plate 38). It is clear, however, that reviewers of this pavilion were impressed as much by the mannequins as by the clothes:

> At the Pavillon de l'Élégance, through their originality, the mannequins display the latest developments in this new genre. Their richness, their sumptuous skin [le luxe de leur épiderme], their pared-down contours, far from distracting from the materials in which they are clad, render these precious [. . .].[78]

The 'luxe de leur épiderme' was here interpreted as the result of a rejection of more *trompe-l'œil* materials such as wax and hair. As opposed to fake skin (*fausses chairs*), 'modern' mannequins presented gleaming, obviously inanimate surfaces. And this richness of 'skin' was juxtaposed with luxurious clothing: the mannequins were dressed in gowns adorned with lamé, pearls and velvet.

The exhibits in the Pavillon de l'Élégance involved a series of naturalistic *mises-en-scène*. The four mannequins dressed in evening dresses by Callot Sœurs, for example, were surrounded by wall hangings with floral patterns, bird tables designed by Albert Rateau and zebra skin carpets. These props all clearly signalled 'nature' and their function was to act as a foil to the modern female bodies of the mannequins. If the zebra floorcoverings connoted luxury through being 'real' skin, it was as a consequence of their metallic *épidermes* that the mannequins identified the commodities they displayed as precious. By contrast with the zebra skin, it was through its display of artificial skin that the modern mannequin defined the tantalisingly exotic. Through a 'stylisation' of skin and body Siégel mannequins represented Parisian woman as simultaneously modern and 'barbaric':

> this is an evocation of the Parisienne through small, long and narrow heads, almost as though it were necessary to be brainless in order to be 'chic'. What a profusion of Egyptian profiles, narrow eyes, Javanese contorsions! Most of these figures are coloured grey, light ochre when indeed they are not veritable statues in gold or silver. In short, a host of obliging barbaric idols clad [in fashions from] the rue de la Paix or the department stores.[79]

The well-worn conflation of femininity with the primitive is deployed in order to defuse the threat of an all too modern woman. These mannequins substitute not merely for the Parisienne in general but for the female consumer in particular, a 'légion d'idoles' standing in for the crowds of women shoppers on the urban street. The circumscribed and demure gaze of non-Western woman is thus fantasised as a (reassuring) alternative to the active and desiring look of the woman shopper. These pinhead mannequins defined a feminised *visage de la rue moderne* less in terms of physiognomy ('face' being reduced to a minimum) than as mindlessness.

During the 1920s, a fascination with 'modern' mannequins extended across a range of discursive sites – magazines of art and architecture as well as fashion journals and trade journals for the advertising profession. But this discourse on mannequins as agents of modernity was not limited to only these. The comic book volume *Bécassine, her Uncle and their Friends* appeared in 1926. Largely devoted to the subject of the 1925 Exhibition it was in effect a parody of that genre of review based (as in the case of Blanche) on the notion of a 'walk' around the Exhibition. The narrative involves a young girl's adventures in taking her country relatives and friends around the Exhibition. Although the *bande*

39 'Les Mannequins', in Caumery, *Bécassine, son oncle, et leurs amis*, illustrations by J.-P. Pinchon, Gautier et Languereau, Paris, 1926, p. 45

dessinée format of *Bécassine, son oncle, et leurs amis* might suggest a children's book, the knowing presentation of the gormless country bumpkin up for a special visit to the city also afforded laughs for the adult reader.

The joke mainly revolves around the country visitors' inability to negotiate the manifestations of urban modernity as displayed at the Exhibition. And this 'confusion' is played up to the hilt in a confrontation with the *mannequin moderne* (plate 39). Bécassine attempts to

explain its significance to her audience by recounting a short history.[80] Although she perfectly well understands that it is 'stylised' mannequins that qualify as truly modern, she confesses to preferring wax manne-quins, the rather friendlier-looking figures that smile out of hairdressers' windows. The fact that Bécassine, a little girl, preferred the old-fashioned, more naturalistic mannequins to the *mannequin moderne* may have been mildly amusing to the reader. The real fun, however, concerned the events which had prompted Bécassine's potted lecture – a rustic mis-understanding of the mannequin and its attendant rituals of urban consumption. One of the male visitors, fascinated by the mannequin's gold coating, takes out a pocket-knife in order to test whether it is real. He has to be restrained from cutting into the gold 'skin' of the manne-quin, reminded that the cardinal rule of exhibitions is 'do not touch the objects on display' ('défense de toucher les objets exposés'). The joke here, however, operates at more than one level. On the one hand, there is the character's inability to read the codes of *publicité*, the failure to identify a 'luxe de leur épiderme' with the fashionable clothes worn by the mannequins. Unlike the sophisticated urban consumer, he is incapable of understanding the transfer of value from the figure's surface to the garments on exhibit. But the scenario is also funny in its incomprehension of what I have referred to as the modern man-nequin's role as fetish – such figures were of value, in other words, precisely in so far as they were obviously fake and reassuringly not the 'real' thing.

The *mannequins stylisés* displayed in large glass *vitrines* along the pont Alexandre III reinforced the role of the boutique in defining the modern street – and hence too the urban environment more generally – in terms of one vast façade or surface. In the case of the new manne-quins, however, this quality of surface was not confined to a metallic finish. Siégel also offered another special effect: 'silver skin applied to peachskin' (plate 40). This version of the 'stylised' mannequin suggests something more of what was at stake in notions of preciousness based on a 'luxe de leur épiderme'. The sinister implication was of female skin ('peau de pêche') coated in silver. The *épiderme* which supposedly rendered textiles and dress luxurious (and therefore desirable to the viewer) was not construed simply as 'skin', nor even as silver substituting for skin, but as 'real' skin smothered in a precious metal. It would seem therefore that the 'sensualité' so lauded by Blanche was not without a sadistic com-ponent. As with Siégel's *mannequin effacé* and pinhead Parisienne, this rhetoric of surface luxury involved a disturbing suggestion of violence, the transformation of woman into gleaming object of desire.

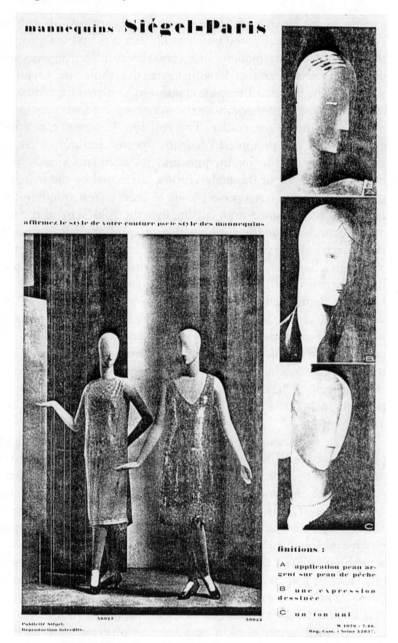

40 'Application of silver skin on peachskin'. Page from Mannequins Siégel Paris advertising brochure, later 1920s

It is evident that in fixating on mannequins in order to define the street as a site of desire, Blanche participated in a wider (cultural and psychic) fantasy. But the fantasies of a 'légion d'idoles' or of 'madones en série' – of endlessly repeated simulacra of the female body – are not symptomatic of woman (nor even of the female shopper run amok). They speak rather of modern man's anxiety and hysterical need of reassurance. For the negative critics of the pont Alexandre III (as of the Place Publique in 1924) an urban space composed entirely of luxury shops failed to qualify as effective urbanism.[81] The *Architectural Review*, for example, invoked the excesses of the music hall in order to condemn Dufrène's rue des Boutiques:

> In place of efforts towards an architecture contemporaneous and applicable to the needs of life, one meets with cardboard and gilding of tasteless temporary erections aiming for the most part at the ideal of the pantomime transformation scenes of our youth.[82]

As is now apparent, however, urban configurations depicted solely in terms of the boutique involved a very particular representation of the city, an attempt to effect a return to 'order' (an 'esprit de corps') that was related to unconscious (male) anxieties as much as to 'logic'. This was an *art urbain* which involved topographies that were not only spatial and temporal but also psychic. The Place Publique and the rue des Boutiques both constituted a 'woman's city' which catered to man's narcissism as much as to women. It is perhaps as a symptom of the extent of that narcissistic anxiety (as opposed to the functional needs addressed by urbanism) that the fascination exerted by the repeated – and exclusive – appearance of the boutique can be explained. Considered in this light, ostensibly contradictory assessments of the boutique in 1925 – as 'pantomime' (a performance involving fake women) and as 'tabernacle' (the means of venerating the object) – prove equally apt.

Notes

1 J. É. Blanche, 'Promenade à l'Exposition', *Les Nouvelles Littéraires*, 4.7.25, no. 142, pp. 1–2.

2 Le Corbusier, 'Inauguration du Pavillon de L'Esprit Nouveau', *Almanach*, p. 137.

3 For other studies of the obsessive concern with mannequins, see Hal Foster, *Compulsive Beauty*, MIT Press, Cambridge (Mass.) and London, 1993 (especially chapter 5, 'Exquisite corpses'); and Sara K. Schneider, *Vital Mummies: Performance Design for the Show-Window Mannequin*, Yale University Press, New Haven and London, 1995.

4 G. Janneau, 'Mannequins modernes', *Bulletin de la Vie Artistique*, 1.1.25, no. 25, pp. 6–11, reprinted in G. Janneau, 'VI. – Un métier d'art: LES MANNEQUINS MODERNES', *L'Art décoratif moderne: formes nouvelles et programmes nouveaux*, Les Enquêtes du Bulletin de la Vie Artistique, Paris, 1925, pp. 112–15.

5 Eugénie Lemoine-Luccioni, 'Le nu', *La Robe: essai psychanalytic sur le vêtement*, Éditions du Seuil, Paris, 1983, p. 35.

6 G. Janneau, 'Le Visage de la rue moderne', *Bulletin de la Vie Artistique*, 15 November 1924, no. 22, p. 498.

7 Victor de Mendez, 'L'Évolution du mannequin', *Vendre: Tout ce qui Concerne la Vente et la Publicité*, December 1924, no. 14, p. 1225.

8 Janneau, 'Mannequins modernes', p. 10.

9 Janneau, 'Le Visage de la rue moderne', p. 498.

10 *Parade: Revue du Décor de la Rue. Journal de l'Étalage & de ses Industries*, 15 June 1928, no. 18, p. 9.

11 *Mannequins Siégel – Paris*, advertising brochure; see the section 'Iconographie' at the Bibliothèque de la Ville de Paris, number Fo 119(14).

12 *Parade*, 15 June 1928, no. 18, p. 9. The theorist is Louis Angé (see note 18 below).

13 Léon Riotor, *Le Mannequin*, Bibliothèque Artistique et Littéraire, Paris, 1900, p. 28 and p. 77.

14 Marcel Zahar, 'Les Grands Magasins', *L'Art Vivant*, 1928, p. 922.

15 See Briony Fer, 'The hat, the hoax, the body,' *The Body Imaged: The Human Form and Visual Culture since the Renaissance*, edited by Kathleen Adler and Marcia Pointon, Cambridge University Press, Cambridge, New York and Victoria, 1993, especially p. 166.

16 Octave Uzanne, 'Préface' in Riotor, *Le Mannequin*. See 'Le Mannequin, son histoire anecdotique – les femmes dociles', p. x ff.

17 Janneau, 'Le Visage de la rue moderne', p. 498.

18 Louis Angé, *Traité pratique de publicité commerciale et industrielle*, 2 vols, Éditions Pratique de Publicité Commerciale et Industrielle, Paris, 1922 (first published 1912), vol. 1, p. 209. Angé is here identified as 'Professeur de Publicité à l'École Supérieure Pratique de Commerce et d'Industrie de Paris et à l'Institut d'Enseignement Commercial Supérieur de Strasbourg, Directeur des Cours Techniques par Correspondance de la Revue *La Publicité*.

19 A fascination with electrical light can be seen as one aspect of the Delaunays' interest in light and colour; Sonia Delaunay, for example, had undertaken the series of studies of nocturnal lighting effects on the boulevard Saint-Michel in 1912–13 and the painting *Electric prisms* (Musée National d'Art Moderne, Paris) was executed in 1914. Later, in the 1930s, the Delaunays collaborated on the design of an electric neon light advertisement. Electricity (and in particular lighting) as an index of modernity was also a subject of interest to the Italian Futurists.

20 P. Dermée, 'L'Art et l'affiche', in Dermeé and Courmont: *Les Affaires et l'affiche*, pp. 183–184.

21 Gérin and Espinadel, 'L'Étalage', *Commerce et industrie*, p. 348.

22 Clouzot, 'Les Arts appliqués au Salon D'Automne', *La Renaissance de l'Art Français et des Industries de Luxe*, January 1925, no. 1, p. 16.

23 L. Angé, 'Les Moyens de publicité – Hommes-sandwiches', *Traité pratique*, vol. 2, p. 11.

24 Gérin and Espinadel, 'L'Étalage', p. 348 and p. 351. And according to P. Dermée in 'Comment l'affiche peut attirer le regard': 'L'objet en mouvement est donc un moyen des plus puissants d'attirer le regard', *L'Affaire et l'affiche*, p. 81.

25 Gérin and Espinadel, 'L'Étalage', p. 351.

26 *Ibid.*

27 Clouzot, 'Les Arts appliqués au Salon D'Automne', p. 16.

28 *Vendre*, vol. 3, no. 26, December 1925, opposite p. 548.

29 See caption to photograph of the Boutique Simultanée at the 1924 Paris Salon d'Automne, from *Psyche*, January 1925. Paris, Bibliothèque Nationale, Département des Estampes, M221411.

30 See the paintings and drawings on the theme of the tango executed in the pre-war and First World War period of Sonia Delaunay's work; *Le Bal Bullier ou Tango Bal Bullier* (1913) and *Tango* (1914), for example, are illustrated on pp. 200–1 and p. 206 of *Le Centenaire Robert et Sonia Delaunay*, Musée d'Art Moderne de la Ville de Paris, 1985. Much later paintings based on the disk are identified with dance, such as 'Rythme sans fin, danse (1964), illustrated on p. 277. (An earlier version of this composition exists as a drawing entitled *Robe, rythme sans fin*, dated 1923; see p. 167 of Buckberrough, *Sonia Delaunay*.) Robert Delaunay also designed a number of costumes for dance performances using abstract disk patterns; see the 1923 design for a 'Projet de costume pour la danseuse aux disques', Bibliothèque Nationale, *Sonia & Robert Delaunay*, Paris, 1977, p. 78. In 1924, Delaunay designed scarves and costumes to be paraded by models during a recitation of Delteil's poem 'La Mode qui vient' at the Hotel Claridge. Delaunay said of her costumes: 'Je voulais, en m'amusant, montrer la richesse multiple des lignes de la femme et des mouvements du corps. [. . .] ses vêtements font partie de son corps' (Sonia Delaunay, *Nous irons jusqu'au soleil* avec la collaboration de Jacques Damase et de Patrick Raynaud, Éditions Robert Lafont, Paris, 1978, p. 93). The relationship of dance to abstraction is investigated in the context of De Stijl by Nancy J. Troy in 'Figures of the dance in De Stijl', *The Art Bulletin*, 1984, vol. 12, pp. 645–56,

31 Lemoine-Luccioni, 'La Coupe et la coupure', *La Robe*, p. 18.

32 'Tissus Simultanés' Emphasize the Present Tendency for Modern Geometrical Dispositions in Fashion. The Patterns are Block Printed on Chiffon or Crepe. [. . .] Silks from Godau, Guillaume, Arnault. From the Paris Bureau of Women's Wear.
 (Advertisement in *Women's Wear*, dated 1925. M221415.)

33 See, for example, 'Préface – Parure', *Encyclopédie*, vol. 1, p. 67.

34 M. Zahar, 'Physionomies diverses', *L'Art Vivant*, 1928, p. 853.

35 H. Maisonneuve, 'L'Éclairage des vitrines de magasins', *La Construction Moderne*, 19 October 1924, p. 26.

36 Louis Cheronnet, 'La Publicité moderne: la gloire du panneau', *L'Art Vivant*, 2e année, 15 August 1926, no. 40, p. 618.

37 R. Delaunay, 'The art of movement' (1938) in Arthur A. Cohen (ed.), *The New Art of Color: The Writings of Robert and Sonia Delaunay*, The Viking Press, New York, 1978, p. 140.

38 G. d'Avenel, 'Les Affiches', *Le Mécanisme de la vie moderne*, A. Colin, Paris, 1902, p. 162.

39 See Fernand Divoire, *Découvertes sur la danse*, avec dessins de Bourdelle, G. Crès et Cie., Paris, 1924, p. 111. On Loie Fuller, see Hélène Pinet, *Ornement de*

la durée: Loie Fuller, Isadora Duncan, Ruth St. Denis, Adorée Villany, Musée Rodin, Paris, 1987; Gabriele Brandstetter and Brygida Maria Ochaim, *Loie Fuller: Tanz, Licht-Spiel, Art Nouveau*, Verlag Rombach Freiburg, Freiburg im Breisgau, 1989; and Giovanni Lista, *Loie Fuller: danseuse de la Belle Époque*, Stock-Éditions d'Art Somogy, Paris, 1994.

40 See the sources on Fuller cited in note 39 above for illustrations of these.

41 Deborah Jowitt, 'The allure of metamorphosis', *Time and the Dancing Image*, University of California Press, Los Angeles and Berkeley, 1988, p. 348.

42 At the 1900 Paris Exhibition, Fuller performed in a theatre designed by Henri Sauvage; the design of the theatre was based on the swirling textiles of her dance. See pp. 40–3 of Brandstetter and Ochaim, *Loie Fuller*.

43 See, for example, André Warnod, 'Les Danses nouvelles – le tango', *Les Bals de Paris*, G. Crès, Paris, 1922, pp. 277–9; and Divoire, *Découvertes sur la danse*, pp. 193–4.

44 Havelock Ellis, *The Dance of Life*, Constable & Co., London, 1923, p. 44.

45 See 'Préface – Parure', *Encyclopédie*, vol. 1, pp. 65 and 66.

46 A. Warnod, 'Le Shimmy', *Les Bals de Paris*, p. 282.

47 On Cendrars' poem, see the note on the original manuscript in 'Sonia Delaunay. La Mode et les poètes', Bibliothèque Nationale, *Sonia & Robert Delaunay*, p. 65. Lemoine-Luccioni reiterates the idea: 'on peut dire qu'un vêtement a du corps'. (*La Robe*, p. 18). This is probably a conscious reference to Cendrars' poem; the front of *La robe* illustrates Sonia Delaunay's drawing *Danse de la robe* of 1922.

48 See D. Jowitt, 'Sphinxes, slaves and goddesses', *Time and the Dancing Image*, 1988, pp. 108–23. According to Jowitt, women dancers showed a preference for dancing the part of the *femme fatale*.

49 Sonia Delaunay's designs for Cleopatra's shawls appear as catalogue number 210 (p. 227) of *Le Centenaire Robert et Sonia Delaunay*; on the choreography of the ballet, see Wollen, *Raiding the Icebox*, p. 9.

50 Jean d'Udine, *Qu'est-ce que la danse?*, H. Laurens, Paris, 1921, p. 14.

51 See, for example, 'Selling consumption', pp. 165–89 in Miller, *The Bon Marché*; and Rachel Bowlby, 'Commerce and femininity', in *Just Looking: Consumer Culture in Dreiser, Gissing and Zola*, Methuen, New York and London, 1985, pp. 18–34.

52 M. B. Miller discusses the nineteenth-century preoccupation with female kleptomania in department stores in 'Selling the store', *The Bon Marché*, pp. 197–206. See also Elaine Abelson, *When Ladies go A-Thieving: Middle-Class Shoplifters in the Victorian Department Store*, Oxford University Press, New York, 1989.

53 See Gaëtan Gatian de Clérambault, *Passion érotique des étoffes chez la femme*, Collection Les Empêcheurs de Penser en Rond, Paris, 1991.

54 Clérambault concluded that this version of female fetishism did not qualify as the real thing (*ibid.*, p. 97). For other discussions of Clérambault's theories, see Elisabeth Roudinesco, *Jacques Lacan & Co.: A History of Psychoanalysis in France 1925–1985*, Free Association Books, London, 1990; Emily Apter, 'Splitting hairs: female fetishism and postpartum sentimentality in fin-de-siècle France', *Eroticism and the Body Politic*, edited by Lynn Hunt, The Johns Hopkins University Press, Baltimore and London, 1991, pp. 164–90; and Jann Matlock, 'Masquerading women, pathologized men: cross-dressing, fetishism, and the theory of perversion, 1882–1935', in Apter and Pietz, *Fetishism as Cultural Discourse*, pp. 31–61. Miller cites the work of Roger Dupouy ('De la kleptomanie',

Journal de Psychologie Normale et Pathologique, 1905): 'others saw in kleptomaniacs the same perverted behavior of fetishistic collectors' (*The Bon Marché*, p. 204).

55 Similar characterisations of female desire pre-existed Clérambault's psychoanalytic formulation. Zola's *Au Bonheur des dames* repeatedly evokes images of women's hands trembling with lust as they finger (and indeed steal) expensive textiles; and in the silk department of the *grand magasin*, we find a scene of mass narcissism: 'women pale with desire leaning over [the fabrics] as if to see their reflections' (Emile Zola, *Ladies' Delight*, Bestseller Library/Paul Elek Ltd, London, 1960, p. 110). See Rachel Bowlby's discussion of *Au Bonheur des dames* in *Just Looking*, pp. 66–82.

These ideas were still current in a 1925 book on department stores which claimed that 'le voleur à l'étalage est, dans la proportion de 90 pour cent, une femme [...]' (J. Valmy-Baysse, 'Parasites-kleptomanes', *Tableau des grands magasins*, p. 155.

56 For a parallel exploration of 'the sexual politics of selling' in an Australian context, see Gail Reekie, *Temptations: Sex, Selling and the Department Store*, Allen & Unwin, Australia, 1993, which deals with a number of the issues pertinent to this and the previous chapter.

57 See, for example, the three photographs (two of men, one of women students) of the Concours de Fin d'Année at the École des Vendeurs-Étalagistes located at 47 rue Montmartre, Paris, in the *Revue de l'Étalage: Revue de la Confection et de la Nouveauté*, 1ère année, August 1925, no. 8, pp. 6–7.

58 Zola, *Ladies' Delight*, p. 104.

59 For example: 'Préface – Rue et jardin', *Encyclopédie*, vol. 1, p. 81.

60 Dermée and Courmont, *Les Affaires et l'affiche*, p. 339.

61 Guillaume Janneau, 'Le Mouvement moderne – l'art dans la boutique', *La Renaissance*, Novermber 1920, no. 11, p. 478.

62 See, for example, H. Clouzot, 'Les Arts appliqués au Salon D'Automne', p. 15.

63 Delaunay, 'The art of movement', p. 139.

64 Fernand Léger, 'The machine aesthetic: the manufactured object, the artisan, and the artist', *Functions of Painting by Fernand Léger*, Thames & Hudson, London, 1973, pp. 60–1. The essay was first published in the *Bulletin de l'Effort Moderne*, Paris, 1924. Léger delivered a lecture of the same title in the spring of 1923 at the Sorbonne for Dr René Allendy; see Green, *Léger and the Avant-Garde*, p. 147.

65 Léger, *Functions of Painting*, p. 56.

66 The literature on the significance of the *flâneur* is now too large to rehearse here. I would like, however, to cite the work of Janet Wolff, Rozsika Parker and Griselda Pollock (see Select bibliography) as well as that of Kathy Adler in 'The suburban, the modern and "une dame de Passy"', *Oxford Art Journal*, 1989 vol. 12, no. 1. For a different argument on twentieth-century male artistic identity *vis-à-vis* 'feminine' consumption, see Amelia Jones, *Postmodernism and the En-gendering of Marcel Duchamp*, Cambridge University Press, Cambridge, 1994.

67 André Warnod, 'L'Art de flâner', *Les Plaisirs de la rue*, L'Édition Française Illustrée, Paris, 1920, p. 10.

68 F. Léger, 'The spectacle: light, color, moving image, object-spectacle', *Functions of Painting*, p. 36 (originally published in the *Bulletin de l'Effort Moderne*, in 1924).

69 Braddell employed a similar device (an assertion of professional interest) in order to distance himself from the activity of shopping (and any desire for the

commodity) in his account of researching Parisian small shops (D. Braddell, 'Little shops of Paris', *Architectural Review*, July 1926, vol. 60, p. 9):

> On explaining his errand, and when it was discovered that 'Monsieur' did not wish to expend a halfpenny on scent, or shoes, or whatever it might be, but was merely a foreign architect interested only in the setting and not the goods themselves, he was everywhere received by the assistants with the utmost courtesy, shown with the greatest of pride everything he wanted to see, given every facility to photography, and in fact had his mission looked upon as the most natural proceeding in the world.

70 See, for example, J. d'Udine, 'Le Danseur', *Qu'est-ce que la danse?*, p. 23, and p. 110 in a later chapter entitled 'L'Amour de la danse et l'amour dans la danse'.

71 According to Jowitt ('The allure of metamorphosis', p. 345 and p. 348), Fuller's 'Fire Dance' involved:

> a small army of sweaty electricians [...] each lamp required its own handles, fourteen men were necessary to create the eerie interplay of red and light for her *Fire Dance*. [...] she crosses her wands, opens a slit in the flaming veils and shows her eyes to the audience.

72 As a finale I intended to dance with illumination from beneath, the light coming through a square of glass over which I hovered, and this was to be the climax of my dances. After the fourth number my electricians, who were exhausted, left me there unceremoniously.

(Loie Fuller, *Fifteen Years of a Dancer's Life with Some Account of her Distinguished Friends*, with an introduction by Anatole France, Herbert & Jenkins, London, 1913, p. 57.) For a recent account of women's artistic authorship at this period, see Gill Perry, *Women Artists and the Parisian Avant-Garde: Modernism and 'Feminine' Art, 1900 to the late 1920s*, Manchester University Press, Manchester and New York, 1995.

73 Huddleston, 'Around the Champs-Élysées', *In and about Paris*, p. 181.

74 I have already cited, for example, G. Janneau's interview with Pierre Imans (note 4 above); this essay concludes: 'la statuaire monumentale à l'usage de la mode' (p. 11).

75 An account of 'stylised' Siégel mannequins claimed: 'c'est une évocation de la Parisienne'. Th. Harlor, 'La Parure, ses accessoires et quelques bibelots', *L'Amour de l'Art*, 1925, p. 335. And the Siégel promotional material already cited included the caption 'un trait aigu: la silhouette d'une femme d'aujourd'hui'.

76 Janneau, 'Un métier d'art: LES MANNEQUINS MODERNES', p. 115.
The association between the *mannequin de l'étalage* and the 1925 Exhibition was also made by the Parisian Surrealists; a Man Ray photograph of a mannequin at the Exhibition (with the caption 'et guerre au travail') appeared on the front cover of *La Revolution surréaliste*, 15 July 1925. The photograph had apparently been commissioned by (and previously appeared in) French *Vogue*. See Merry Foresta and Willis Hartshorn, *Man Ray in Fashion*, International Center of Photography, New York, 1990, p. 17.

77 Vernon Blake, 'Modern decorative art', *Architectural Review*, July–December 1925, vol. 58, p. 31.

78 Albert Flament, 'Le Pavillon de l'Élégance', *La Renaissance*, July 1925, no. 7, p. 317.

79 Harlor, 'La Parure', p. 335.

80 Caumery, *Bécassine, son oncle, et leurs amis*, illustrations by J.-P. Pinchon, Gautier et Languereau, Paris, 1926, p. 45.

81 See, for example, Janneau, 'Le Visage de la rue moderne', p. 498: 'L'erreur serait d'appliquer à toutes les destinations une formule uniquement convenable aux commerces de luxe. [. . .] Mais il y a, par la ville, plus de boucheries que de librairies, voire de joailleries.'

82 Blake, 'Modern decorative art', pp. 27–9.

Cars and jars: L'Esprit Nouveau and a geometry of the city

[. . .] row after row of shops foist on us countless industrially produced objects, all characterised by strict precision which is the inevitable consequence of mechanisation: objects of all kinds are presented in an impeccable order: it is in this way that geometry brings all its powers of attraction to commerce.[1]

Dufrène's project for the pont Alexandre III in 1925 emphasised the artifice of that spectacle staged by the boutique in the city street. Unlike 'real' boutiques, those along the bridge existed in isolation, divorced from the context of any larger building. Even more significantly, most of these boutiques had two façades: one facing the Seine, the other the central avenue of the bridge itself. Glass-fronted on two sides, these exhibition shops constituted a dramatic confirmation of claims that the modern boutique had metamorphosed into a 'little glass house' – a mechanism for showcasing the commodity.[2] Here France was able to demonstrate its pre-eminence in both fashion and the skills of presentation. In the words of one critic: 'where we are truly superior is in [. . .] the display of luxury, of dress [. . .]'.[3] As a manifestation of publicité, the boutique was central to the 1925 Exhibition, not only geographically, but also (as we have seen in previous chapters) as a means of defining both modernity and Frenchness in terms of the 'seductive'. The inclusion of advertising at the 1925 Exhibition was hailed as a first and publicité identified as a crucial index of modernity: 'the art of advertising must be modern or cease to exist'.[4] The importance of publicité in defining France as modern was vividly underscored

by Citroën's appropriation (timed to coincide with the Exhibition) of the Eiffel Tower as a giant billboard. By night the Tower – wired up with electric lightbulbs – was transformed into a kind of giant firework. Citroën's logo appeared along with a stream of shooting stars against the city's skyline – yet another manifestation of Paris *ville lumière*.[5]

But the Exhibition's representation of the modern city street through Classe 26 'The arts of the street' ('Les arts de la rue') included not only 'art publicitaire' but also 'plans de villes et aménagements urbains'. 'Les arts de la rue', not in itself a new rubric or category, was updated through its identification with the modern 'sciences' of *publicité* and *urbanisme*.[6] As an exponent of *arts urbain* or of *urbanisme* the boutique proved somewhat contentious. Although frequently cited in commentaries on the 1925 Exhibition as an aspect of town-planning, the boutique occupied an ambivalent status in contemporary literature on *urbanisme*. In his book *Urbanisme* (first published in 1924) Le Corbusier had argued forcefully that urbanism involved the large-scale replanning of the city, not 'a sort of street art'. He complained about 'one of the popular theories of modern town planning and a practice widely spread; *i.e.* rearranging, tinkering'.[7] Le Corbusier repeatedly described his notion of *urbanisme* as 'surgery'. By contrast, 'tinkering' town planners he disparaged as mere 'decorators': 'And our decorative town planners, the lovers of beautiful detail and of highly individual shop-fronts and so on, thrust us still deeper into error.'[8] He stressed the collective nature of urbanism, defining *urbanisme* as the opposite of *décoration* and individuality.

By 1925, Le Corbusier's formulation of urbanism was well established as (and through) opposition to certain other notions of revamping the city. There is an anecdote, for example, about Le Corbusier being invited to participate in the 1922 Salon d'Automne:

> 'What do you mean by urbanism?' Le Corbusier asked the salon's director. 'Well, it's a sort of street art,' the man replied, 'for stores, signs, and the like; it includes such things as the ornamental glass knobs on railings.' 'Fine', said Le Corbusier, 'I shall design a great fountain and behind it place a city for three million people'.[9]

As in 1922, so in 1925, an oppositional stance was crucial to Le Corbusier's presentation of his practice and theory. He saw the 1925 Exposition des Arts Décoratifs as a high-profile opportunity to design an exhibit which would define his version of *urbanisme* via a critique of the Exhibition as a whole. 'The difference of opinion was complete,' he claimed, 'the Pavillon was as it were smuggled in [. . .] and we had no

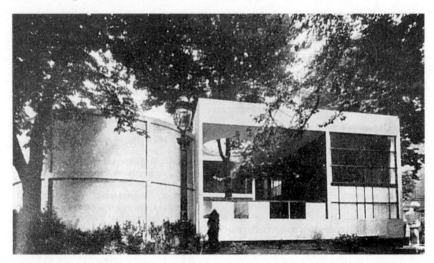

41 'Pavillon de L'Esprit Nouveau', from Le Corbusier's 1926 *Almanach d'architecture moderne*, p. 139

grant towards building it. What difficulties we experienced!' Whereas the boutiques on the pont Alexandre III were signed by their respective architects and showed expensive goods by named designers, with his Pavillon de L'Esprit Nouveau project Le Corbusier set out to prove that a truly modern decorative art was the product of industry and not of the individual designer. The Pavillon, he claimed, was 'a document of standardization'. It represented a modular unit in terms of an individual living space all of whose 'furnishings were the product of industry and not of the decorators' (plate 41).[10]

For Le Corbusier it was above all the home which constituted the vital component of town-planning: 'houses make the street and the street makes the town' he proclaimed.[11] A notion of the street as spectacle was nevertheless important to Le Corbusier's argument, as indeed was an idea of the shop-window as manifestation of modernity. Only in the serried ranks of shops and in the department stores, he claimed, was it possible to view the evidence of machine production – the full range of mass-produced commodities. Commercial display put such products on view in the street; the domestic interior by contrast lagged far behind:

> These people have their eyes fixed on the display of goods in the great shops that man has made for himself. The modern age is spread before them, sparkling and radiant ... on the far side of the barrier! In their own homes, where they live in a precarious ease [...] they find their uncleanly old snail-shell [...]. These people, too, claim their rights to a machine for living in, which shall be in all simplicity a *human* thing.[12]

The Pavillon de L'Esprit Nouveau was presented as the remedy to this situation, as a prototype home equipped with the 'sparkling and radiant' products previously encountered only in shop *vitrines*.

For Le Corbusier therefore sales displays were important as a kind of transitional phase of visual education rather than as an end in themselves. Not only the products on show but also the means of presentation were considered to play a vital role: 'it is in this way that geometry brings all its powers of attraction to commerce'.[13] This reference to geometry signals a different interpretation of commercial display as somehow sacred (a contrast to what we have seen, for example, in characterisations of the boutique *vitrine* as 'tabernacle'). In *The Decorative Art of Today* (published in book form to coincide with the 1925 Exhibition) geometry is represented as a kind of divine aspect of the machine and its products:

> The machine brings before us shining disks, spheres, and cylinders of polished steel, shaped with a theoretical precision and exactitude which can never be seen in nature itself. Our senses are moved, and at the same time our heart recalls from its stock of memories the disks and spheres of the gods of Egypt and the Congo. Geometry and gods sit side by side![14]

Here light is a property of geometry and geometry is identified as the means of imposing order on the irregularity of nature. Similarly in shop displays of food, argued Le Corbusier, it was the precise and orderly geometric arrangements of fruit or of meat that excited the appetite of the viewer. Geometry achieved order, transforming the products of the slaughter house – 'the power of geometry!'[15] More than merely the butcher's or grocer's sales device, however, 'divine' geometry is credited as the means of warding off the horror of death and decay:

> These monumental urban still lives, at odds with the picturesque still lives of artists, prompt us to reject Rembrandt's perishable beef and take us directly back not only to the Egyptian friezes depicting food and trophies but also to the monumental and timeless works of the Nile and the Euphrates.[16]

Like previous exemplars of the *nature morte* genre, these monumental (commercial) still lives taught a lesson – in this case, that only geometry offered hope of physical transcendence.

This talk of geometrically ordered shop displays is to some extent reminiscent of the descriptions of the *mannequin stylisé*, but in Le Corbusier's language the shop-window mannequin could not embody

modernity, only the outdated. In a lecture (subsequently published as an essay in *Précisions* entitled 'Architecture in everything, city planning in everything'), Le Corbusier pronounced on historicising 'styles':

> Firmly, I write: *This is not architecture. These are styles.* So that my words should not be misused, so that I am not made to say what I don't think, I write again:
> *alive and magnificent originally*
> *today they are only dead bodies,*
> or women in wax![17]

Unlike contemporary writing on *publicité*, no updated version of the mannequin appears here to figure the modern. Similarly, Le Corbusier disallowed any notion of an architectural *visage de la rue moderne*:

> A plan is not a pretty thing to be drawn like a Madonna face; it is an austere abstraction; it is nothing more than an algebrization and a dry-looking thing. The work of the mathematician remains none the less one of the highest activities of the human spirit.[18]

Whereas *publicité* defined modernity in terms of an enticing female body (or face), Le Corbusier posited that body as either repugnant ('dead bodies') or as trivial ('a pretty thing'), proposing instead the desirability of mathematics on the basis that 'our eyes are ready for ordered delights'. Le Corbusier insisted on a connection between looking and the intellect: 'Behind the eye is that agile and generous, fecund, imaginative, logical and noble thing: the mind.'[19] Fecundity, it is emphasised, is as an attribute of the *mind*. This chapter explores in more detail what was at stake in the Esprit Nouveau refutation of those terms through which *publicité* – as manifested in Classe 26 'Les Arts de la rue' – represented the urban street at the 1925 Exhibition.

Cars: an 'optique moderne'

Although Le Corbusier accorded such significance to the mind, the discourse of L'Esprit Nouveau represented architecture and *urbanisme* by means of a range of metaphors based on an imagery of the body. One of these metaphors involved, as we have already seen, a non-human body – that of the snail. In *Vers une architecture*, Le Corbusier described the home of man in 'earlier ages' as follows: 'he lived like a snail in its shell, in a lodging made exactly to his measure'.[20] If (as Le Corbusier claimed) by 1925 the snail was 'putting together the pieces of its shell' (evidence that 'the real question at issue is the house'), then the snail had perhaps learned a lesson from the motor car:

VOISIN. SPORTS TORPEDO, 1921

It is a simpler matter to form a judgment on the clothes of a well-dressed man than on those of a well-dressed woman, since masculine costume is standardized. It is certain that Phidias was at the side of Ictinos and Kallicrates in building the Parthenon, and that he dominated them, since all the temples of the time were of the same type, and the Parthenon surpasses them all beyond measure.

42 From Le Corbusier, 'Eyes which do not see: automobiles', *Towards a New Architecture*, p. 145

If the problem of the dwelling or the flat were studied in the same way that a chassis is, a speedy transformation and improvement would be seen in our houses. If houses were constructed by industrial mass-production, like chassis, unexpected but sane and defensible forms would soon appear, and a new aesthetic would be formulated with astonishing precision.[21]

Le Corbusier advocated that the modern house be industrially mass-produced as opposed to 'made to measure'. This call for mass-produced housing occurs in the chapter on 'Automobiles' in *Vers une architecture*; here (following Adolf Loos) it is argued that men's dress offered valuable lessons for the architect.[22] The caption to a photograph of a 'Voisin Sports Torpedo, 1921' reads: 'It is a simpler matter to form a judgment on the clothes of a well-dressed man than on those of a well-dressed woman, since masculine costume is standardized.' (plate 42)[23] This conjunction of cars and male dress is illustrated visually in the same chapter of the book by two photographs which show male drivers seated in Hispano-Suiza and Bignan-Sport cars (plate 43). Indeed all the drivers shown in these photographs are men. As I shall argue below, this interweaving of metaphors (that of the motor car with that of men's clothing) reveals the importance of the (male) body not only for Le Corbusier's arguments on the production of architecture but also for the manufacture of masculine identity.

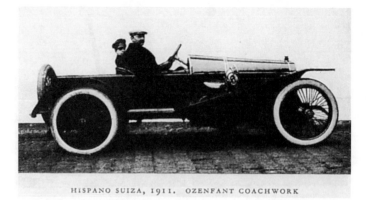

HISPANO SUIZA, 1911. OZENFANT COACHWORK

43 From Le Corbusier, 'Eyes which do not see: automobiles',
Towards a New Architecture, pp. 136–7

Earlier in the decade, Le Corbusier had drawn on the imagery of
the car in naming his proposal for a mass-production house 'Citrohan'.
As he put it '"Citrohan" (not to say Citroën). That is to say, a house
like a motor-car.'[24] As part of his Pavillon de L'Esprit Nouveau at the
1925 Exhibition, Le Corbusier exhibited his scheme for the rebuilding
of Paris, a design (again) named after a car: the Plan Voisin (plate 44).
Here the reference to the automobile functioned not only as a meta-
phor for mass-production housing, but also as an indication of the kind
of financial sponsors sought by Le Corbusier both for his 1925 exhibit
and his projected future work (Le Corbusier had also approached the
Michelin Company for money, intending to call the plan 'Plan Michelin
et Voisin du Centre de Paris').[25] Speaking of his plans for the centre
of Paris in the eighth edition of *Urbanisme*, Le Corbusier announced:
'"The motor has killed the great city. The motor must save the great
city.'[26] There were therefore two prominent displays of this symbolic
conjuncture of car and city (Paris) at the 1925 Exhibition: in the form
of *urbanisme* with the Voisin plan (exhibited as a dramatically lit dio-
rama at the Pavillon de L'Esprit Nouveau) and as *publicité* with the
Citroën illuminations on the Eiffel Tower (plate 45). This is not to
suggest, of course, that in the case of L'Esprit Nouveau *urbanisme* and
publicité were separate or discrete entities. With the Pavillon de L'Esprit
Nouveau project Le Corbusier had produced not only a polemic on
urbanisme but also (in effect) an advertisement for his own practice as
an architect. And as Beatriz Colomina has argued, Le Corbusier often
deployed advertising techniques of promotion in order to enhance the
power of polemic.[27] Similarly, as indicated by his praise of shop-window

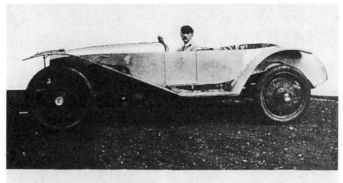

BIGNAN-SPORT 1921

44 'Le Plan Voisin de Paris', photograph from Le Corbusier, *Almanach d'architecture moderne*, 1926, p. 175

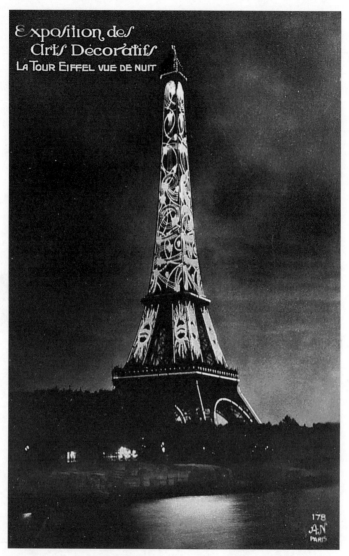

45 The illuminated Eiffel Tower in 1925

displays, references to contemporary manifestations of *publicité* played an important role in the Esprit Nouveau formulation of *urbanisme*.

Take for example the case of a photograph accompanying the chapter title 'Mass-production houses' in *Vers une Architecture* which juxtaposes a background of classicising architecture with posters for cars: Ford and Citroën (plate 46).[28] It is just possible to glimpse the rubric of another sign – 'travaux publics' – advertising the services of

MASS-PRODUCTION
HOUSES

46 'Mass-production houses', photograph from Le Corbusier, *Towards a New Architecture*, p. 209

Dufayel. This montage of advertisements for building work and motor cars functions as part of Le Corbusier's argument for mass-production housing – produce houses in the same way that cars are produced. In the now famous extended metaphor of house as automobile which appears in the chapter on 'Automobiles' he asserted that the motor car would eventually achieve the same perfection as the great masterpieces

47 and **48** Drivers at the Concours d'Élégance. Photographs from
La Femme, le Sport, la Mode, July 1927, p. 10 and p. 15

of classical architecture. But as Tim Benton has pointed out, despite all
Le Corbusier's eulogising of the car as product of the processes of stand-
ardisation and mechanical selection, he did not use illustrations of
cheap mass-produced cars as part of his arguments in *L'Esprit Nouveau.*[29]
In *Vers une architecture* the Delage Grand-Sport, 1921 is paired with
the Parthenon, a 1907 Humber with the temple at Paestum; the photo-
graph of the 1921 Voisin Sports Torpedo appears above the claim that
'Phidias would have loved to have lived in this standardised age'.[30] The
appearance of the glamorous sports-car as opposed to the modest family
saloon might be read either as inconsistency on the part of Le Corbusier
or as evidence of Le Corbusier's claims that (unlike the Greek temple)
the car had still not reached its maximum development. In juxtaposing
motor cars and temples Le Corbusier was advocating a developmental
mode for the automobile applicable to modern architecture: the car, he
confidently predicted, would *evolve* into a 'tool', no longer fulfilling a
role as ostentatious luxury.

But there is another way to read this apparent inconsistency
in picturing the more upmarket products of the automobile industry.
Whereas Le Corbusier reproduced illustrations of cars as part of his
campaign for standardised, mass-production housing, there existed a
contemporary but quite different discourse which celebrated the motor
car as luxurious and stylish. It could be argued, indeed, that *Vers une
architecture* mobilised images of the automobile and automobiliste pre-
cisely in order to suppress certain aspects of that other discourse. Fash-
ion identified the motor car as a component of woman's toilette and
this involved rather different notions of beauty from those Le Corbusier
would have attributed to the automobile. At the various Concours

d'Élégance of the 1920s, to take but one instance, motor cars were par-
aded in a form of mechanical beauty show. Photographs of the winners
at such events show expensive cars driven not only by elegant men but
also by glamorously dressed women – film stars and inhabitants of high
society (plate 47). What is striking in the journalistic coverage of such
shows is the emphasis on the automobile as fashionable accessory for
the up-to-date Parisienne.

This specifically twentieth-century form of 'elegance' was often
defined (as in Le Corbusier's argument) in terms of an evolution of the
car's body. The most advanced cars are described as small, lightweight
and powerful, according well with contemporary accounts of the 'mod-
ern' female body as fit and strong, slimmed down by exercise.[31] The
Concours d'Automobile provided the context for endless comparisons
and elisions between these two 'bodies' – a veritable feminising of the
car (already gendered feminine in the case of both *automobile* and *voiture*).
A reviewer at the Élégance Automobile held at the Bois de Boulogne,
for example, referred admiringly to the 'shapely curves of these limous-
ines and the elegance of their women drivers' and quoted the judge's
prize-winning address which had praised 'the grace of your smile' as well
as the 'your sumptuous car'.[32] By contrast with the rather dour-looking
male drivers who appear in *Vers une architecture*, the photographs of
women participants in the Concours d'Élégance constituted yet another
version of a feminised *visage de la rue moderne*. A photograph of 'the
graceful and mischievous Rahna, after her victory in the competition'
shows the victorious driver with a beaming smile, lying stretched out
on the bonnet of her car in a way which establishes visual rhymes
between the curves of female body and automobile (plate 48).

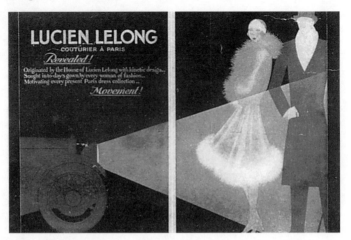

49 Advertisement for Lucien Lelong's 'kinetic design' in M. Kingsland, 'Advertising psychology of the Paris dressmaker', *Foreign Trade*, Feb. 1929

In the context of these *concours*, analogies were produced not only between the body of the female driver and the body of the car but also with the 'elegance' of the driver's clothes. Reports of women participants often involved detailed accounts of the appearance of both car and clothes. Terms such as *grâce*, *superbe* and *somptuosité* could apply equally to the driver's dress or to the automobile; both were presented as fashionable and luxurious. This conjunction of motor car and *la mode* was not invented with (or confined to) the Concours d'Élégance. The imagery of cars was used to define of-the-moment *haute couture* as in the case of Lucien Lelong's 'kinetic fashions' of the 1920s – one of the advertising images for Lelong shows a woman in 'kinetic' dress spotlit by the headlights of a car (plate 49).[33] And the November 1924 issue of *Art – Goût – Beauté* used the Paris motor show (with its prominent signs for Delage, Michelin and Voisin) as the setting for a display of the season's fashions (plate 50). Women's magazines of the period regularly included coverage of cars and of the Concours d'Élégance alongside (or as part of) the fashion reporting. The front cover of the May 1927 issue of *La Femme, le Sport, la Mode*, for example, (in which the above accounts of the Concours appeared – car-driving qualified as *sport mécanique*), took the form of an illustration of a cloche-hatted woman at the wheel of her car. When, immediately below the photograph of two men in a Hispano-Suiza illustrated in the chapter on 'Automobiles' in *Vers une architecture*, it is proclaimed that 'a standard is established on sure bases, not capriciously but with the surety of something intentional and of a logic controlled by analysis and experiment', Le Corbusier was in effect

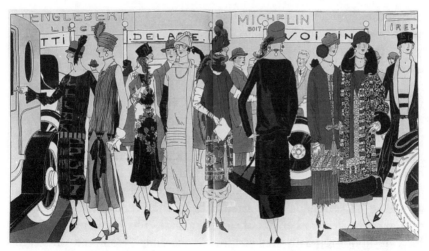

50 Paris Motor Show. Fashion illustration from *Art – Goût – Beauté*, Nov. 1924

formulating his definition of standardisation through subverting that
discourse which posited a kind of symbiotic relationship between the
motor car and the 'caprice' of women's fashion.[34]

The reviews of the Concours d'Élégance often attributed inno-
vations in the fitting out of car interiors to *haute couture*. At the sixth
Concours, for example, the modernity of certain cars was vouchsafed
by reference to one of the most recent developments in fashion design
– the use of snake-skin: 'numerous female drivers presented us with
rattlesnake outfits [*ensembles*]'.[35] Such assessments make clear the status
of the motor-car as fashion accessory. These two ways of representing
the car involved very different conceptions of the urban street and of
the city itself. For Le Corbusier, the automobile was (at one level) a
symptom of the speed characteristic of the modern city. In its guise as
fashionable luxury, however, the car appeared in the city as both com-
modity and spectacle – as part of the experience of shopping in Paris.
In the *Renaissance* feature on Parisian luxury trades and their shops,
many of the strip photographs of the rue de la Paix show a car as
part of that street's elegant *ambiance*. And in the magazine's extensive
section on the Champs-Élysées, we find the Alfa Romeo showrooms
included along with the area's numerous *haute couture* houses, photo-
graphs of Renault's 'magasin d'exportation' juxtaposed with an article
on Madeleine Vionnet.[36] For Le Corbusier, on the other hand, the signi-
ficance of the Champs-Élysées did not lie in its shops. In *Urbanisme* he
praised the boulevard as 'the glory of Paris to-day and the only avenue
which renders real services to motor traffic'.[37] According to Le Corbusier,

one of the main functions of the city street was as a 'machine for traffic' and a 'sort of factory for producing speed traffic'.[38]

But the Champs-Élysées was not only the site for traffic, nor even of shopping. If on the Champs-Élysées the motor car constituted the spectacle of the commodity it was also here that the car showed off its driver as fashionably turned out. The Champs-Élysées (like the Bois de Boulogne) was one of the places in Paris where *le beau monde* went to admire its collective self. It was perhaps this aspect of the *automobiliste* as urban display that the deadpan expressions of the drivers in *Vers une architecture* work so hard to deny – with these men there is no smile to acknowledge the gaze of the onlooker. Accounts of the 'elegant' car as woman's fashionable accoutrement, on the other hand, render the notion of the driver as object of a desiring gaze quite explicit. The vogue for cars upholstered in snake-skin, for example, prompted one commentator to wax lyrical in his description of women drivers in terms of 'the seductive power of a modern Eve'.[39] Considered as fashion accessory, the automobile both enhanced and shared the feminine attribute of seductiveness. This was a 'power' construed not in terms of a mechanical engine's horsepower (or even as the 'power of geometry') but rather – as with the *mannequin moderne* – as allure. With this emphasis on seductiveness, the car took on something of the role of *publicité* – like the boutique and the poster, the car was an eyecatching manifestation of the modern street.

At the 1925 Exhibition, notions of the car as forming part of an elegant *ensemble* were perhaps most vividly manifested in the photograph of a car decorated by Sonia Delaunay (plate 51). The car and two models fashionably clad in Simultaneous outfits are posed outside Mallet-Stevens' 'Pavillon de Tourisme', a setting which enhanced the status of the car as fashionable and chic. Like travel, the car was identified as ostentatious and luxurious. During the mid-1920s tourism carried connotations of elitist leisure: 'Money is now in different hands. [. . .] As for the *nouveaux riches* they have different desires: a love of travel, cars, holidays by the sea [. . .]. Luxury, which is as dazzling as in previous centuries, now takes more ephemeral and fugitive forms.'[40] Photographs of the Exhibition as much as the physical fabric of the Exhibition itself played a key part in establishing the context through which exhibits (such as Delaunay's Simultaneous designs) signified. Here, the presence of the two models emphasises the ephemeral nature of luxury, which was – like women's fashion – fugitive. This geometrically decorated car constitutes the antithesis to Le Corbusier's argument in *L'Esprit Nouveau*, where the motor car is predicated as the modern version of standardised

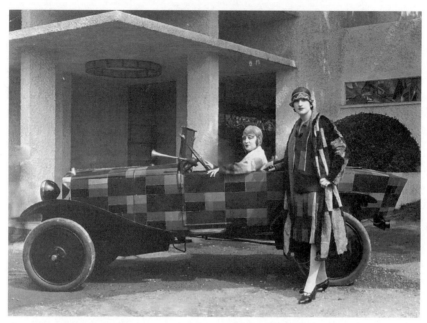

51 Sonia Delaunay's decorated car at the 1925 Paris Exhibition

perfection. At the same time, it functions almost as a textbook illustration for Le Corbusier's Loosian disparagement (in *The Decorative Art of Today*) of 'tawdry' ornament as feminine – the lure to a gullible female consumer. The inappropriateness of the decorated car, in other words, is explained by the presence of the fashionably dressed mannequins.

These two photographic representations of the car – those in *Vers une architecture* as well as the photograph of Sonia Delaunay's co-ordinated *ensemble* – establish a relationship of human body to commodity which in turn defines different modes of urban looking. Delaunay's decorated car – along with the Simultaneous clothing – is clearly an adornment of the female driver. The commodity (like woman's body) appears as object of a desiring gaze and it is this display of desirable 'objects' which makes up the spectacle of the city. With Le Corbusier's *urbanisme*, on the other hand, the car is presented (like men's clothing) as an extension of the male body. In *The Decorative Art of Today*, Le Corbusier referred to mechanical extensions of the body as 'tool-objects':

> We are born naked and with insufficient armour. [. . .]
> In speaking of decorative art, we have the right to insist on the type-quality of our needs since our concern is with the mechanical system that surrounds us, which is no more than an extension of our

limbs; its elements, in fact *artificial limbs*. Decorative art becomes orthopaedic [. . .].[41]

Defined as 'tool-object' (or more often, as 'human-limb object'), the commodity is described as 'discreet', a 'servant' which liberates its master, freeing him from utilitarian tasks in order that man can 'think' and engage with art – 'that disinterested passion that exalts us'.[42] Far from provoking a desiring gaze, in Le Corbusier's formulation the commodity is 'self-effacing' in order to facilitate contemplative thought and a 'disinterested' looking at art. When, therefore, in *Urbanisme* Le Corbusier claimed 'a town is a tool', this involved not only the idea of the city as an efficiently functioning machine but also the kinds of looking appropriate to the modern city: the uplifting contemplation of art as well as the cerebral pleasures afforded by the 'geometric delights' afforded by those standardised goods on view in the urban street.[43]

Pots: the contours of desire[44]

With the Pavillon de L'Esprit Nouveau Le Corbusier claimed to have brought these 'geometric delights' into the interior of the home. The purpose of exhibiting such commodities in the Pavillon was not, however, described primarily in terms of display. On the one hand, the 'standardised' objects on show in the Pavillon were claimed to stand in metonymic relation to the project as a whole – as with Le Corbusier's invocation of the motor car, an assertion of the industrially produced, standardised object as a model for mass-produced housing. At the same time, as indicated by their plain, undecorated surfaces, such commodities shared the status of furniture as 'equipment' of the home.[45] It was only 'art' (painting and sculpture) which was presented as the object of prolonged looking and meditation. Le Corbusier claimed that this conjunction of 'human-limb object' and art produced a home which would function as a retreat from the stresses of urban life, a space for mental and spiritual recuperation as well as physical rest.

'Human-limb' objects and art appear together in the carefully composed photographs of the Pavillon's interior published in the *Almanach d'architecture moderne*. Such photographs function not only as documentation of a temporary exhibit, but also (like the photographs in other *L'Esprit Nouveau* publications) as an important part of Le Corbusier's polemic. Indeed photographs afforded more opportunities for guiding the viewer's gaze than would have been possible in the case of the Exhibition itself. Take for example the two photographs in the *Almanach* labelled 'Verrerie

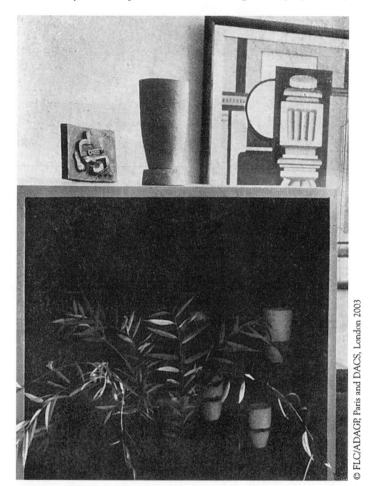

52 Laboratory pots ('Ustensiles de laboratoires (Creusets)') in the Pavillon de L'Esprit Nouveau. Photograph from Le Corbusier, 'Des pots . . .', *Almanach d'architecture moderne*, 1926, p. 169

(appareils de laboratoires)' and 'Ustensiles de laboratoires (Creusets)' (plate 52).[46] The identification of these implements as deriving from the laboratory reinforced the scientific rationality attributed by Le Corbusier to the standard. As he had written in his essay on 'Automobiles': 'A standard is established on sure bases, not capriciously but with the surety of something intentional and of a logic controlled by analysis and experiment.'[47] In both *Almanach* photographs, utilitarian objects (glasses and laboratory pots) are juxtaposed with the works of art on display in the Pavillon. By implication, it was unobtrusive 'servants' such as these which enabled the inhabitant of this modern home to derive maximum

53 'Des pots . . .', photograph from Le Corbusier, *Almanach d'architecture moderne*, 1926, p. 167

benefit from the presence of art. The photographs of laboratory utensils thus functioned both as guarantors of the rationality of Le Corbusier's *urbanisme* as well as the means of establishing particular circuits of look-ing. And although the photographs are of an interior, such trajectories of looking are clearly identified with the modern city. In the *Almanach*, the essay on 'Des pots . . .' is positioned between the lengthy chapter devoted to the Pavillon and the two sections dealing with Le Corbusier's urbanistic displays in 1925: 'Une ville contemporaine de trois millions d'habitants' (originally shown at the Salon d'Automne of 1922) and the 'Plan Voisin de Paris' (plate 53).

Similarly, the photograph accompanying the section on 'Des tapis décoratifs' (which appears immediately after 'Des pots . . .') makes explicit

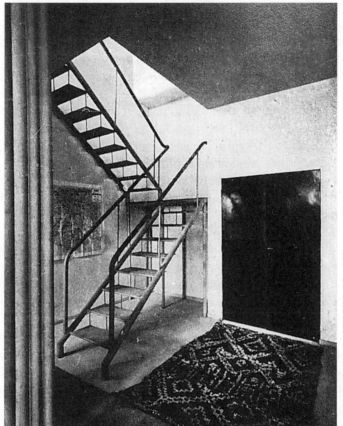

© FLC/ADAGP, Paris and DACS, London 2003

54 'Pavillon de L'Esprit Nouveau – l'antichambre: un tapis berbère', photograph from Le Corbusier, 'Des tapis décoratifs', *Almanach d'architecture moderne*, 1926, p. 170

a relationship between interior and exterior – between home and city – through the presence of a map of Paris on the left-hand wall (plate 54).[48] A short accompanying text draws attention to the geometry of the carpet.[49] The carpet plays a crucial role, leading the viewer's eye into the photograph up to the metal Ronéo doors and to the metallic staircase with its tubular steel handrail. The geometric patterning of the rug relates visually both to these mass-produced features of the Pavillon as well as to the Paris map on the wall, thus emphasising the connection between the Pavillon's interior and its display of *urbanisme*. In addition to orchestrating circuits of looking, the *Almanach* Pavillon photographs are contrived in order to reinforce the narratives of past and present as established by the discourse of L'Esprit Nouveau. For Le Corbusier, an important aspect

of these rugs was their status as 'folklore'. And the great achievement of folk culture was, according to Le Corbusier, anonymous production and 'unanimous' meaning. *The Decorative Art of Today* proclaimed that folk culture was 'an achievement purified by time and number' but also 'a creation of the distant past'.[50] The modern version of folk culture was now brought about not by the revival of earlier forms but through the products of 'anonymous industry'. In relation to handmade artefacts, 'folk culture no longer exists'.[51] Strategically positioned (and photographed) in the Pavillon de L'Esprit Nouveau, the 'tapis berbère' signalled not only Le Corbusier's admiration for the distillation of forms achieved by the folk culture of the past but also his argument about a future 'purification' of form which would be ensured by the processes of industrial mass-production.

A similarly didactic point is made by the photo-essay concerning pots in the chapter on folk culture in *The Decorative Art of Today*. Two pots are illustrated: a heavily ornamented Serbian pot ('an outstanding artefact') and a plainer Spanish jar 'similar to the Adrianople jars which themselves resembled Greek amphoras'.[52] Both pots, according to Le Corbusier, had been relegated to the past as the result of an 'inexorable and irresistible' economic revolution. The Serbian pot of about 1900 was consigned to the potter's attic owing to the fact that his house was 'filled with commercial pottery decorated in a vulgar way by machine'. The Spanish water jug had also been replaced by an industrialised product. Le Corbusier recounted an observation from his own travels around the Aegean coast:

> Tin petrol cans from Batum were proving very convenient containers, being besides unbreakable. [...] With a can in each hand one was balanced and did twice the work. What about the immortal pose of Ruth at Jacob's well and the really beautiful industry of the potter which seems to have been the companion of civilisation since time began? *Finished!* Replaced by a tin can.[53]

In the case of the water jar, folklore has ostensibly been superseded by a product of that industry which, for Le Corbusier, constituted the paradigm of modern mass-production. This textual juxtaposition of classical amphorae with petrol can involves expressions of regret and nostalgia, but it functions primarily as a narrative delineating a relationship of present to past which promises a happy ending sometime in the future: 'regret is useless; poetry which seemed immortal is dead; everything begins again; that is what is fine and promises the joys of tomorrow'.[54] The little anecdote about the petrol can, however, concerns

more than one historical 'past', not only the classical past (or turn-of-the-century Balkan culture) but also (as revealed by the use of the anecdote form) that of Le Corbusier as exponent of L'Esprit Nouveau.

Indeed, references to Le Corbusier's own past are strategically inscribed into both the Esprit Nouveau publications specifically related to the 1925 Exhibition. *The Decorative Art of Today* closes with a chapter entitled 'Confession'. This claims to chart the development of Le Corbusier's anti-decorative stance by recording a sequence of *Bildungsreisen*, an odyssey over a period of time which coincides not only with Le Corbusier's youth but also with the first decades of the twentieth century. Early in the second decade of the century, Le Corbusier recounted, he had undertaken a 'great journey, which was to be decisive', a journey in search of origins. The itinerary is traced in his 'Confession':

> From Prague I went down the Danube, I saw the Serbian Balkans, then Rumania, then the Bulgarian Balkans, Adrianope, the Sea of Marmora, Istanbul (and Byzantium), Bursa in Asia.
> Then Athos.
> Then Greece.
> Then the south of Italy and Pompeii.
> Rome.
> I saw the grand and eternal monuments, glories of the human spirit.[55]

This trip is also recollected in the *Almanach d'architecture moderne* in a chapter entitled 'Carnet de route 1910. *Les Mosquées; sur l'Acropole; en Occident'*. The references in the mid-1920s' Esprit Nouveau publications to the 'tapis berbère' and the Serbian pot, along with the *souvenirs* of Jeanneret's 'decisive' journey (subsequently known as the 'Voyage d'Orient') reveal the extent to which Orientalism as much as the classical world of the Parthenon was crucial to the discourse of L'Esprit Nouveau.

In his 'Confession', Le Corbusier claimed that it was this voyage which had revealed to him the true nature of art and architecture. Here again, the Serbian pot (mentioned previously in the chapter on folk culture) plays a prominent role; it is equated with 'art' – the classical sculpture of Phidias. The pot, it would seem, could be categorised either as 'art' ('a beautiful poem') or as folk culture ('a good tool'), as a precursor of the modern standardised object. The chapter on 'Des pots . . .' in the *Almanach* (which opens with the photograph of a Greek vase) ascribes a similarly high status to the pot on the basis of its affinity with pure geometrical form. Such Greek vases were, pronounced Le Corbusier, 'architectural', their profiles evoking cornices.[56] Taken together therefore, *The Decorative Art of Today* and the *Almanach d'architecture moderne*

offer a complex framework through which to read the photograph of
the laboratory pot on show in the Pavillon de L'Esprit Nouveau. At
one level, the laboratory pot was 'evidence' of the replacement of the
Serbian pot (as folk culture) by the modern utensil. The identification
of the pot as deriving from the laboratory is again significant because
for Le Corbusier the laboratory unequivocally signified the present: 'On
one side lies the economics of the past, and on the other, that of the
present; it is founded on a major science, on experimentation (often
dramatic: aircraft), on the work of the laboratories.'[57] In the context of
1925, the laboratory pot was assigned an important polemic role *vis-à-vis*
the ostentatiously ornamented objects which Le Corbusier claimed char-
acterised the rest of the Exhibition. The lab pots appear as tool-objects
or human-limb objects, discreet and banal as opposed to showy.

At the same time, the repeated affiliation with art and architec-
ture meant that pots were attributed with a superior hierarchical status
to that of the standardised 'tool'. In 'Des pots . . .', the phrase 'Archi-
tecture, sculpture, peinture et des vases' appears immediately above the
photograph of the laboratory pot. The composition of this photograph
reiterates the point, with the pot neatly framed on the left by Lipchitz's
relief sculpture and on the right by Léger's painting of *Le Balustre*. It is
perhaps this identification of the pot as the equivalent of art (or indeed
of architecture) which explains the fact that far from deflecting the
viewer's gaze from itself to the contemplation of art, the laboratory pot
constitutes the dominating presence in this photograph of the Pavil-
lon's interior. Prominently positioned on top of a cabinet, the pot
towers above the sculpture. Dramatically lit, it easily upstages the easel
painting hung on the wall behind it. This photographic gaze, how-
ever, involves fixation as much as meditation. Indeed, the laboratory
pot appears repeatedly in the *Almanach's* photographs of the Pavillon
(plate 55). As luminous presence or alternately as mysterious silhouette,
it seems to haunt this modern interior – an intimation of the uncanny as
much as of the homely. The laboratory pot can be characterised as 'heimlich'
(in the sense of 'agreeable restfulness and security as in one within the
four walls of his house') but its recurring presence also suggests some-
thing less reassuring, something 'concealed' or 'withheld from others'.[58]

Despite autobiographical sections like the 'Confession', the Pavil-
lon de L'Esprit Nouveau project effectively abolished certain *souvenirs*.
In the essay on 'A coat of whitewash – the law of Ripolin' in *The Decorat-
ive Art of Today* Le Corbusier defined a relationship between the interior
of the home and memory, advocating the eradication of 'the cult of the
souvenir' by whitewash in order that 'you will be master of yourself'
and 'want to be precise, to be accurate, to think clearly'.[59] Although

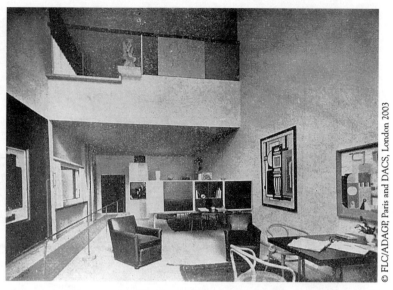

© FLC/ADAGP, Paris and DACS, London 2003

55 Interior of the Pavillon de L'Esprit Nouveau with laboratory pot in the distance, photograph from Le Corbusier, 'Le Pavillon de L'Esprit Nouveau', *Almanach d'architecture moderne*, 1926, p. 155

ostensibly about remembering, the recollections of the 'Voyage d'Orient' in *The Decorative Art of Today* and the *Almanach d'architecture moderne* also constitute a forgetting – a kind of whitewashing of the 'past'. A photograph dated 1920 shows Le Corbusier along with Amédée Ozenfant and Albert Jeanneret in the offices of *L'Esprit Nouveau* (plate 56). Whereas Jeanneret is holding a newspaper, Le Corbusier uses both hands to balance a pot on his head – the Serbian pot illustrated in *The Decorative Art of Today*. This somewhat incongruous image might be read as a visual pun on the concept of 'souvenir', the pot appearing like a cartoon thought-bubble – the concrete manifestation of Le Corbusier's 'memory' of the Orient. The pot is positioned as an attribute of the (rational) mind – indicative perhaps of Purism's appropriation of the Oriental pot as 'folklore' in order to define it as antecedent of modern standardisation. It was, however, in so far as the pot signified another aspect of the mind that it proved necessary to forget the Orient. In the context of the 'Voyage d'Orient' the Serbian pot was associated with a quite different kind of relationship of object to body from that defined by the 'human-limb object', those 'reassuring articles' which (Le Corbusier claimed) enable us to 'quit the anguished realms of fantasy'.[60]

 With the references to the 'Voyage d'Orient' in *The Decorative Art of Today* and the *Almanach d'architecture moderne*, Le Corbusier was ostensibly extracting both texts and sketches written during the course

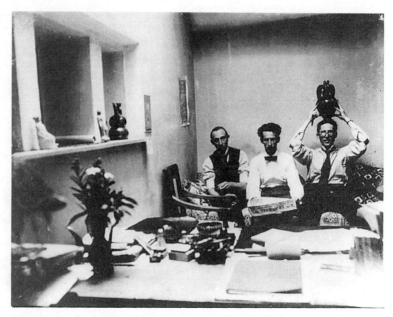

56 Amédée Ozenfant, Albert Jeanneret and Le Corbusier in the offices of *L'Esprit Nouveau*, Paris 1920 (with Le Corbusier holding the 'Serbian' pot on his head)

of that journey.[61] But extracts or paraphrases are, like memory, highly selective. And in the processes of selection, it is often that which is omitted (in this case, the excised portions of the earlier 'Voyage d'Orient' text concerning pots) which is most telling. There is a certain sense in which the Pavillon de L'Esprit Nouveau project – like the Serbian potter relegating the traditional pot to his attic – achieves the 'modern' precisely through this process of forgetting. In one of his 1911 letters home from the Voyage d'Orient, Jeanneret described Serbian pots, extolling a beauty based on the geometry of the sphere. In this Orientalist discourse, however, beauty is not an aspect of the rational (the intellectual appreciation of beauty as manifested through the pure forms of geometry) but of 'ecstasies'. Through a metaphoric play on vase and body – 'generous belly', 'graceful neck', and subtle curves – the letter produces an analogy between pot and female body. But this is not an attribution of ideal form to the body of woman. Rather, the Orientalist *mise-en-scène* is deployed in order to sustain a fantasy in which attributes of male and female body are conflated: 'To thrust your hands into the deepest parts of your pockets and, with your eyes half-closed, to give way slowly to the intoxication [. . .]. The vases about which I am going to tell you will be there, bulging mightily.'[62] Jeanneret's onanistic

'ceramicological epistle' produces a tactile identification of 'female' pot with the male body of the onlooker (hands plunged deep in pockets) – by implication, both are 'bulging'. It is this hallucinatory elision of 'female' and phallic forms which constitutes a beauty experienced as consoling: 'their beauty was comforting'.[63] And it is through the denial of such 'Orientalist' self-abandon to the object – the obliteration of narratives in which the object is so overtly fantasised as 'comforting' – that Purism articulates the modern. The discourse of L'Esprit Nouveau proposed a different, more determined masculinity as appropriate to the modern age ('men of vigour').[64]

The substitution of the laboratory utensil for the Serbian pot is thus symptomatic of the attempt to 'forget' not the Serbian vase itself, but rather the blatant fetishisation of the object evident in the 'letters home'. The Pavillon de L'Esprit Nouveau project involved a vociferous refutation of the identifying traits (compulsive looking, artifice) of fetishism. The Pavillon's exhibits were insistently identified as undecorated 'tools' and 'utensils', not ornamented objects of display with their implicit invitation to intense looking. Similarly, the Pavillon represented genuine as opposed to fake architecture. Materials such as reinforced concrete signified the 'real' as opposed to the obvious artifice of plaster, a confrontation with social problems (such as housing and transport) rather than a preoccupation with theatrical display. Although the Pavillon did not leave behind the kind of book of ornament or style which Le Corbusier referred to as the 1925 'Yearbooks', it did involve (as with the *Almanach*) extensive photographic 'documentation'. As suggested by the dominating presence of the laboratory pot, such photographs constitute both the means and the traces of a fetishing gaze. Christian Metz has pointed out that photography is both dependent on and enabling of this 'lingering look', a lingering look legitimated in the case of the pot, by the status ascribed to the vase as both art and architecture.[65]

Photographs of vases on display in museums (at Pompeii) (plate 57) and at the Musée de Saint-Germain-en-Laye, illustrations to the essay 'Other icons – the museums' in *The Decorative Art of Today*) precede the chapter's concluding statement:

> The naked man does not wear an embroidered waistcoat; he wishes to think. The naked man is a normally constituted being, who has no need of trinkets. His mechanism is founded on logic. He likes to understand the reasons for things. It is the reasons that bring light to the mind. He has no prejudices. He does not worship fetishes. He is not a collector. He is not the keeper of a museum.[66]

57 'Museum at Pompeii', photograph from Le Corbusier, *The Decorative Art of Today*, p. 21

Significantly, it is precisely those terms which the psychoanalyst Wilhelm Stekel used to theorise the dynamics of fetishism – what he claimed as the fetishistic tendency to fixate on objects and organise them as 'collection', 'museum' and 'harem' – which the Pavillon de L'Esprit Nouveau project makes such a show of rejecting.[67] The Pavillon offered the promise of escape from the orientalised, hallucinatory 'den' in order to 'seat ourselves in a cell'.[68] Le Corbusier's praise for the 'tapis berbère' on show in the Pavillon, for example, involved no sensuous surrender to texture and colour but rather an intellectual appreciation of its geometry. In *The Decorative Art of Today* he had asserted: 'luxury no longer resides in the Aubusson carpet but has moved up to the brain'.[69] Similarly, his reformulation of decorative art as 'the totality of *human-limb objects*' was presented as the means of forsaking 'the anguished realms of fantasy'. But the designation of 'human-limb object' – the redefinition of *l'art décoratif* as 'orthopaedic' – reveals as much as it conceals. The orthopaedic device, artificial substitute for a missing part of the body, seems cut out for the role of fetish object (indeed, in his great catalogue of fetishism Stekel included a chapter on 'orthopaedic fetishism').

Le Corbusier's proclamation concerning 'naked man' implies that the male body does not require the 'camouflage' of ornament (the 'embroidered waistcoat'). Man, confident of being 'normally constituted', does not need to assuage his anxiety by fantasising the object as supplement to an inadequate (female) body. The proximity of this statement to images of vases is far from fortuitous since the pot is in certain ways particularly suited to the role of fetish object. Janine Chasseguet-Smirgel has argued for the 'overdetermined character of the fetish' in that 'pre-

cursors of castration anxiety coincide with different forms of separation anxiety'. One such separation anxiety involves 'the inability to renounce primary identification with the mother'. In this sense, the fetish object represents not only the mother's missing phallus but also, the mother's body as a whole. The rhapsodising on Serbian vases in the *Voyage d'Orient* – where the bulging pot is clearly evocative of the maternal body – might thus be read not merely as idiosyncratic purple prose, but as relating to a wider psychic and cultural symbolism. In relation to pre-genital separation conflicts, the pot can function as a particularly apposite fetish object. As Chasseguet-Smirgel contends: 'the fetish is both content and container. Thus the link between the object and erotogenic zone is re-established (the nipple in the mouth, the stool in the rectum) [. . .].'[70] In *Précisions*, Le Corbusier emphasised the containing quality of architecture through reference to the vase: 'architecture is the function by which useful vases are built to contain different human under-takings'.[71] At the same time, the 'female' form of the pot also relates to a later anxiety than those involved with pre-genital separation; as Freud wrote in his essay on 'The uncanny':

> Men declare that they feel something uncanny [*unheimlich*] about the female genital organs. This [*unheimlich*] place, however, is the entrance to the former Heim [home] of all human beings, [. . .] the place where each one of us lived once upon a time and in the beginning. [. . .] The prefix 'un' is the token of repression.[72]

It was such *souvenirs* which it was necessary to eradicate from (or rather, through) the Pavillon de L'Esprit Nouveau project.

Unlike the boutique (so identified with its *mannequins de l'étalage* and its displays of female adornment) or contemporary theories of *publicité*, the discourse of L'Esprit Nouveau involves a range of fetishistic imagery in which representations of the female body are emphatically occluded. Something of this occlusion is signalled in the statement concerning folklore: 'What about the immortal pose of Ruth [. . .]? *Finished!* Replaced by a tin can.' With the Pavillon de L'Esprit Nouveau project, it is not only the industry of the potter but also woman's body which is rendered redundant by the 'modern' object. Just as the essay on 'Automobiles' in *Vers une architecture* unequivocally identifies the motor car with men's dress and hence the male body, so in *The Decorative Art of Today* containing vessels are associated with man's rather than woman's body. A recurring image throughout this book, for example, is that of Diogenes. Diogenes represents the archetypal 'naked man', embodying the sentiment that it is necessary 'to identify the superfluous and throw it away'.[73] A Diogenean austerity signifies

self-sufficiency and wisdom as opposed to the susceptibility of 'shop-girls' for abundantly decorated 'trash'.[74] Most importantly, however, the Diogenean barrel 'already a notable improvement on our natural protective organs (our skin and scalp), gave us the primordial cell of the house'.[75] If for Le Corbusier both the male suit and the motor car constituted metaphors of standardisation in order to establish a model for the future mass-production of houses, it was Diogenes' barrel which was cited as the 'primordial cell of the house'. The vessel form (and according to some accounts, Diogenes' barrel was in fact a large pot) was now associated solely with the male body. Diogenes' barrel is thus symptomatic of the extent to which the Pavillon de L'Esprit Nouveau project ensured that 'the city [...] built to capture men's dream, finally only inscribes woman's absence'.[76]

Notes

1 A. Ozenfant and C.-É. Jeanneret, 'Formation de l'optique moderne', *La Peinture moderne*, Éditions Georges Crès et Cie., Paris, 1925, pp. 64–5.

2 The expression 'petites maisons de verre' appears in 'Le Décor de la rue', *Présentation*, 1ère série, Édition Parade, 1927, p. 7. Here it is argued that in the case of the modern boutique, the attention of the viewer is drawn not by a hanging shop sign but by the dramatic presentation of the commodity behind glass.

3 Elie Richard, 'Exposition Internationale des Arts Décoratifs – les arts de la rue', *L'Art Vivant*, 1.11.25, pp. 24–5; reprinted in *Exposition Internationale des Arts Décoratifs Édité par L'Art Vivant*, Paris, 1925.

4 'Art publicitaire – Section française', *Encyclopédie*, vol. 11, p. 48.

5 See my comments on the different modes of *publicité* constituted by the modern mannequin and the Eiffel Tower at the 1925 Exhibition in 'Beware beautiful women: the 1920s shopwindow mannequin and a physiognomy of effacement', *Art History*, September 1997, vol. 20, no. 3, pp. 375–96.

6 See, for example, Gustave Kahn, *L'Esthétique de la rue*, Bibliothèque-Charpentier, Paris, 1901.

7 Le Corbusier, 'Surgery – physic or surgery', *The City of Tomorrow* (a facsimile of the 1929 edition, translated by Frederick Etchells), The Architectural Press, London, 1971, p. 168. This book was first published in Paris in 1925 by Éditions Georges Crès et Cie. as *Urbanisme*. Unless otherwise stated, all further references will be to the English edition. For an account of the development of Le Corbusier's ideas on town-planning, see H. A. Brooks, 'Jeanneret and Sitte: Le Corbusier's earliest ideas on urban design', *In Search of Modern Architecture: A Tribute to Henry-Russell Hitchcock*, edited by Helen Searing, MIT Press, Cambridge (Mass.), 1982.

8 Le Corbusier, 'Classification and choice (timely decisions)', *The City of Tomorrow*, p. 74.

9 Robert Fishman, 'The contemporary city', *Urban Utopias in the Twentieth Century: Ebenezer Howard, Frank Lloyd Wright, and Le Corbusier*, Basic Books, Inc., New York, 1977, p. 188.

10 Le Corbusier, 'The hours of repose – on repetition or mass production', *The City of Tomorrow*, footnote 2, p. 231.

11 Le Corbusier, 'The engineer's aesthetic and architecture', *Towards a New Architecture*, p. 19.
12 Le Corbusier, 'Architecture or revolution', *Towards a New Architecture*, p. 259.
13 See note 1 of this chapter.
14 Le Corbusier, 'Argument – the lesson of the machine', *The Decorative Art of Today*, p. xxiv.
15 Ozenfant and Jeanneret 'La Formation de l'optique moderne', *La Peinture moderne*, p. 65.
16 *Ibid*. This passage forms part of Rosalind Krauss's exploration of 'the optical unconscious'; see chapter 4, p. 161, in *The Optical Unconscious*, MIT Press (October Book), Cambridge, (Mass.) and London, 1993.
17 Le Corbusier, 'Architecture in everything, city planning in everything', *Précisions: On the Present State of Architecture and City Planning*, MIT Press, Cambridge (Mass.), 1991, p. 68. (The book was originally published by Éditions Crès et Cie. in Paris in 1930.) Unless otherwise stated, all further references are to the 1991 edition.
18 Le Corbusier, 'Three reminders to architects', *Towards a New Architecture*, pp. 46–7.
19 Le Corbusier, 'Classification and choice', *The City of Tomorrow*, p. 66.
20 Le Corbusier, 'Architecture or revolution', *Towards a New Architecture*, p. 253.
21 Le Corbusier, 'Eyes which do not see: automobiles', *ibid*., p. 123.
22 For further, extended arguments on architectural theory and male dress, see M. McLeod, 'Undressing architecture', in D. Fausch *et al.* (eds), *Architecture: In Fashion*, Princeton Architectural Press, New York, 1994, pp. 38–123; and Wigley, *White Walls, Designer Dresses*.
23 Le Corbusier, 'Eyes which do not see: automobiles', *Towards a New Architecture*, p. 135.
24 Le Corbusier, 'Mass-production houses', *ibid*., p. 222.
25 Beatriz Colomina, '*L'Esprit Nouveau*: architecture and *publicité*', *Revisions 2: Architecture and Reproduction*, Princeton Architectural Press, New York, 1988, p. 87. Le Corbusier displayed the names of *collaborateurs* at the Pavillon; see the photograph in the *Almanach d'architecture moderne*, p. 141.
26 Le Corbusier, 'The centre of Paris', *The City of Tomorrow*, pp. 275–6.
27 See Colomina, '*L'Esprit Nouveau*: architecture and *publicité*', and 'Introduction' ('On architecture, production and reproduction') in this issue of *Revisions: Papers on Architectural Theory and Criticism* guest-edited by her. Also, Colomina's *Privacy and Publicity: Modern Architecture as Mass Media*, MIT Press, Cambridge (Mass.) and London, 1994.
28 Le Corbusier, 'Mass-production houses', *Towards a New Architecture*, p. 209.
29 Tim Benton, 'Dreams of machines: futurism and l'Esprit Nouveau', *Journal of Design History*, 1990, vol. 3, no. 1, pp. 31–2.
30 Le Corbusier, 'Eyes which do not see: automobiles', *Towards a New Architecture*, pp. 124–5, 135.
31 As implied in the descriptions of a streamlined *mannequin moderne* discussed in Chapter 4.
32 R. H., 'Sports mécaniques – L'Élégance automobile au Bois', *La Femme, le Sport, la Mode*, July 1927, p. 11.
33 Martha Kingsland, 'Advertising psychology of the Paris dressmaker', *Foreign Trade*, February 1929. Paris, Bibliothèque Nationale, M222098. See also the reference to Lelong's *Ligne kynétique* 'for the modern active woman' in M. Ginsburg, *Paris Fashions*, p. 33.

34 Le Corbusier, 'Eyes which do not see: automobiles', p. 126.
35 R. H., 'Sixième Concours d'Élégance Automobile', *La Femme, le Sport, la Mode*, July 1927, pp. 10–11.
36 'Notices sur les industries de luxe par les collaborateurs de *La Renaissance*', *La Renaissance*, June 1924, no. 6, n.p. See Chapter 3, pp. 66–70.
37 Le Corbusier, 'Physic or surgery', *The City of Tomorrow*, p. 259.
38 Le Corbusier, 'Statistics', p. 123 and 'Newspaper cuttings and catchwords', p. 131, both in *The City of Tomorrow*.
39 'Championnat automobile des artistes', *La Femme, le Sport, la Mode*, July 1927, p. 14.
40 'Parcs et jardins – arbres et arbustes, plantes et fleurs – Section Française', *Encyclopédie*, vol. 11, p. 70.
41 Le Corbusier, 'Type-needs', *The Decorative Art of Today*, p. 72.
42 Le Corbusier, 'Argument', *ibid.*, p. xxiii.
43 Le Corbusier, 'Foreword', *The City of Tomorrow*, p. 1.
44 The following arguments were first rehearsed in T. Gronberg, 'Speaking volumes: the Pavillon de l'Esprit Nouveau', *The Oxford Art Journal*, 1992, vol. 15, no. 2, pp. 58–69. For a subsequent discussion of Le Corbusier's 'Voyage d'Orient', see M. Wigley, 'Delirious white', *White Walls, Designer Dresses*, pp. 206–13.
45 As Le Corbusier himself indicated, some of the furniture on show in the Pavillon had been especially made to order for the occasion; Le Corbusier, 'Le Pavillon de L'Esprit Nouveau', *Almanach*, p. 162.
 For further information on the furniture in the Pavillon, see Arthur Ruegg, 'Le Pavillon de L'Esprit Nouveau en tant que Musée Imaginaire', *L'Esprit Nouveau*, 1987, pp. 134–51.
46 Le Corbusier, 'Des pots . . .', *Almanach*, pp. 168–9.
47 Le Corbusier, 'Eyes which do not see: automobiles', p. 126.
48 Le Corbusier, 'Des tapis décoratifs', *Almanach*, p. 170.
49 *Ibid.*, p. 171.
50 Le Corbusier, 'Plagiarism – folk culture', *The Decorative Art of Today*, p. 36 and p. 25.
51 Le Corbusier, 'A hurricane', *ibid.*, p. 57.
52 Le Corbusier, 'Plagiarism – folk culture', *ibid.*, p. 34. See Jacques Gubler's essay 'Cari vasi', *Casabella*, January–February 1987, p. 104 (English translation p. 120).
53 Le Corbusier, 'Plagiarism', *ibid.*, pp. 34–5.
54 Le Corbusier, *ibid.*, p. 34.
55 Le Corbusier, 'Confession', *ibid.*, p. 206.
56 Le Corbusier, 'Des pots . . .', *Almanach*, pp. 169–9. See Annemarie Bucher, 'Vases,' *L'Esprit Nouveau*, 1987, pp. 220–1.
57 Le Corbusier, 'Consequences of the crisis', *The Decorative Art of Today*, p. 47.
58 Sigmund Freud, 'The uncanny' (1919), *Art and Literature*, The Pelican Freud Library, vol. 14, Penguin Books, Harmondsworth, 1985, p. 342 and p. 344.
59 Le Corbusier, 'A coat of whitewash – the law of Ripolin', *The Decorative Art of Today*, pp. 188–9. The significance of concepts of white walls and whitewashing *vis-à-vis* architectural theory forms a major focus of Mark Wigley's *White Walls, Designer Dresses*.
60 Le Corbusier, 'Type-needs', *ibid.*, p. 69.
61 Le Corbusier (Charles-Édouard Jeanneret), *Le Voyage d'Orient*, Les Éditions Forces Vives, Meaux, 1966; *Journey to the East* translated by Ivan Žaknić in collaboration with Nicole Pertuiset, The MIT Press, Cambridge (Mass.) and

London, 1989. All subsequent translations are taken from the 1989 edition. See also Giuliano Gresleri, *Le Corbusier Viaggio in Oriente*, Marsilio Editori, Venice, and Fondation Le Corbusier, Paris, 1984; Giuliano Gresleri, 'Home ties – adrift abroad: the Oriental journey of Ch.E. Jeanneret', *DAIDALOS: Berlin Architectural Journal*, 15.3.86, no. 19, pp. 102–11; and Adolf Max Vogt, 'Remarks on the "reversed" Grand Tour of Le Corbusier and Auguste Klipstein', *Assemblage*, 4, October 1987, pp. 39–51.

62 Jeanneret/Le Corbusier, 'Lettre aux amis des "Ateliers d'Art" de La-Chaux-de-Fonds', *Le Voyage d'Orient* (English translation, 'A letter to Friends at the Ateliers d'Art in La-Chaux-de-Fonds', pp. 14–15).

63 *Ibid.*, p. 15.

64 Le Corbusier, 'A coat of whitewash', *The Decorative Art of Today*, p. 192.

65 Christian Metz, 'Photography and fetish', *The Critical Image: Essays on Contemporary Photography*, edited by Carol Squiers, Lawrence & Wishart, London, 1991, p. 155.
 For discussion of photographs of Le Corbusier's architecture, see Beatriz Colomina, 'Le Corbusier et la photographie', *L'Esprit Nouveau*, 1987, pp. 32–43 (also published as 'Le Corbusier and photography', *Assemblage*, 4, October 1987, pp. 6–23); Beatriz Colomina, 'The split wall: domestic voyeurism', *Sexuality & Space*, Princeton Papers on Architecture, Princeton Architectural Press, Princeton, New Jersey, 1992, pp. 98–128.

66 Le Corbusier, 'Other icons – the museums', *The Decorative Art of Today*, p. 23.

67 For example: 'I recall the well-known case of Moll, who exhibited a case of rose fetishism [. . .]. He finally collected quite a museum of roses with a deal of industry. I wish also to point out that this is a characteristic which we will observe time and again. This collecting of symbolic objects is what I have called the harem cult of the fetishist. It is never absent in any case of genuine fetishism' Wilhelm Stekel, *Sexual Aberrations: The Phenomena of Fetishism in Relation to Sex*, John Lane, The Bodley Head Ltd., London, 1934, p. 21.

68 Le Corbusier, 'The decorative art of today', *The Decorative Art of Today*, p. 98.

69 Le Corbusier, 'Consequences of the crisis', *ibid.*, p. 42.

70 Janine Chasseguet-Smirgel, 'Reflections on fetishism', *Creativity and Perversion*, Free Association Books, London, 1985, pp. 78–88, p. 87.

71 Le Corbusier, 'The world city', *Précisions*, p. 230. On vases and pots as metaphor in architectural discourse, see Adrian Forty, 'Of cars, clothes and carpets: design metaphors in architectural thought', *Journal of Design History*, 1989, vol. 2, no. 1, pp. 1–14.

72 Freud, 'The uncanny', p. 368.

73 Le Corbusier, 'The sense of truth', *The Decorative Art of Today*, p. 166. For an earlier and slightly extended discussion of these references to Diogenes, see my 1992 essay 'Speaking volumes', p. 64 and note 41, p. 69. See also M. McLeod, 'Undressing architecture', pp. 75–6 and M. Wigley, *White Walls, Designer Dresses*, pp. 18–19, 21, 115.

74 Le Corbusier, 'The decorative art of today', *The Decorative Art of Today*, p. 87.

75 Le Corbusier, 'Type-needs', *ibid.*, p. 72.

76 Teresa de Lauretis, *Alice Doesn't: Feminism, Semiotics, Cinema*, Macmillan, London and Basingstoke, 1984, p. 13. The statement is made in connection with a discussion of Italo Calvino's *Invisible Cities*.

Conclusion

> Just a few more weeks and the Exhibition of Decorative Arts will be a
> thing of the past. Demolition teams are already checking the state of
> their pickaxes, ready to hurl themselves at the white city in order to
> reduce it to dust.[1]

> A few months after the closure of the Exhibition, even the ruins of
> pavilions [. . .] had disappeared without leaving the slightest trace and
> the passerby, finding the esplanade des Invalides, the quays and the
> Cours-la-Reine looking the same as ever, may well ask whether it
> wasn't all a dream.[2]

The 1925 Exhibition was an intrinsically ephemeral event; it bequeathed
the French capital neither permanent buildings nor a new *quartier*.
Long before its closure plans were being made for demolition. It could
be said indeed that given the restrictions imposed by the central Paris
site the Exhibition was designed with a view to complete eradication.
Commentators remarked on how quickly the Exhibition disappeared,
vanishing without trace – almost as if it had been a dream. Certain
aspects of this dream, however, have been retained more vividly than
others in the collective, historical memory. Le Corbusier's 1925 exhibi-
tion pavilion was, like the rue des Boutiques, a temporary structure. But
through the various L'Esprit Nouveau publications he succeeded in
establishing a permanent (and highly influential) monument to his
ideas on the relationship of *art décoratif* to architecture and *urbanisme*.
In the face of Le Corbusier's forceful polemic, it has proved all too easy
to 'forget' that modern city conjured up by the luxury displays along the
pont Alexandre III. Recollection is possible, however, albeit by reference
to rather different kinds of publication than those of L'Esprit Nouveau.

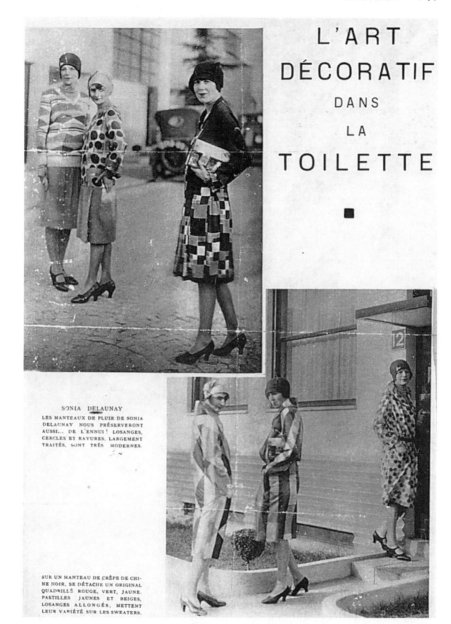

58 Sonia Delaunay fashions modelled in the rue Mallet-Stevens in 'L'Art décoratif dans la toilette', *La Revue de la Femme*, 1.5.28, p. 29

A May 1928 issue of the women's magazine *La Revue de la Femme* includes two fashion photographs labelled 'L'Art décoratif dans la toilette' (plate 58). It is perhaps no coincidence that the setting for these displays of elegant dress should be the rue Mallet-Stevens in Auteuil,

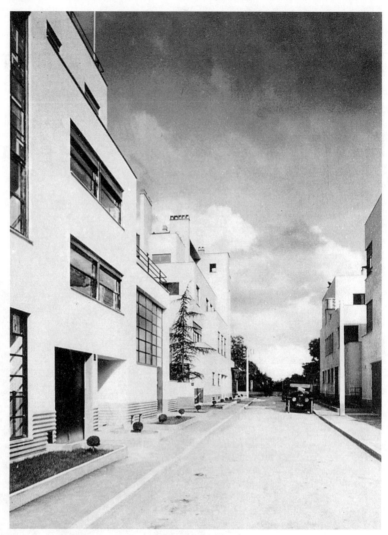

59 The rue Mallet-Stevens, Paris, 1927

the affluent sixteenth *arrondissement* (plate 59). This new Parisian street (completed in 1927 and named after the architect whose work had appeared so prominently at the Exhibition) was cited by the *Encyclopédie* as tangible legacy of 1925.[3] The photographs in *La Revue de la Femme* show three models wearing Sonia Delaunay's fashions (a similar juxtaposition of *mode Simultanée* with Mallet-Stevens' architecture to that in the photograph of Delaunay's decorated car parked outside the Pavillon de Tourisme). Here a three-graces configuration proves useful for the

purposes of fashion photography, enabling different views of the female body. In these photographs the recently built architecture of the rue Mallet-Stevens functions as décor in order to show off the well-dressed women; indeed the conjunction of mannequins and architecture reinforces the glamour of each.

La Revue de la Femme identifies 'l'art décoratif' as a component of woman's toilette, as a proliferation of geometric surface ornamentation extending from the textiles of the mannequins' outfits to the architecture of the city street. Here geometry signifies the city as stylish as opposed to ordered. What identifies this city as modern is the presence of women in Simultaneous fashion outdoors in the street and yet again it is woman who appears not only as the manifestation but also as the agent of *les arts de la rue*. As is made clear by the pairing of *l'art décoratif* and *la toilette*, art is not the object of a 'disinterested' contemplation but the means of producing the female body as public spectacle – a 'spectacle très sensuel'. When Mallet-Stevens proclaimed that 'modern architecture is intrinsically photogenic', he was referring to the use of architectural sets in the film studio.[4] But this remark has wider implications. Unlike Le Corbusier's photographic preoccupation with the Pavillon de L'Esprit Nouveau, this is a conception in which architecture (and indeed the city itself) is acknowledged as a means of arousing and orchestrating a desiring look. It was against such representations of the city – and in particular of Paris as a woman's city – that the Pavillon de L'Esprit Nouveau project so vociferously protested.

In the context of the 1925 Exhibition, the classical figures of Diana and Diogenes constituted two versions of the 'pared down' ('dépouillé' or 'épuré') body through which the modern was defined.[5] Both Diana and Diogenes signified the refutation of excess. In her guise as modern woman, Diana goddess of the hunt appeared as devotee of sport – as a lithe and exercised body (plate 60). A reviewer at the Pavillon de l'Élégance was moved to describe the inanimate fashion mannequins on show there as 'dianas enamoured of fresh air and sport'. How different from 'the voluptuous beauties of the eighteenth century, created exclusively for the divan'.[6] Diana thus represented not only the goddess of light, but also the fashionably light-weight. In the case of Diogenes on the other hand excess was a matter of 'unnecessary' (ostentatious) surface ornamentation as opposed to superfluous flesh. It was as 'naked man' that Diogenes exemplified the modern body. In 1925 Diogenes challenged the 'dianas' of the shop *vitrines* (along with those actually strolling through the Exhibition) as manifestation of the modern city street.

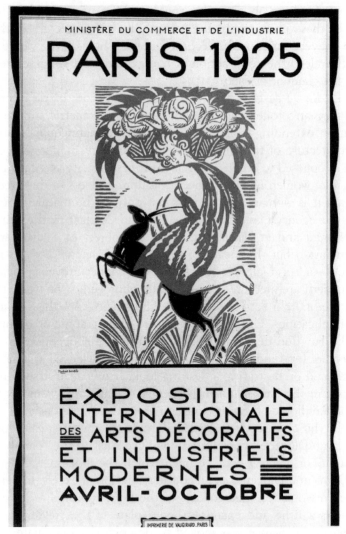

60 Poster for the 1925 Paris Exposition Internationale des Arts Décoratifs et Industriels Modernes

As at the Exhibition so in *La Revue de la Femme* the personification of the urban street took a female form. Here surface ornamentation (geometrically patterned textiles) complements the modern body of the fashion models, a body exercised and stripped of its excessive 'voluptuousness'. The commentary accompanying these photographs proclaims that the value of the garments (made up of expensive materials such as crêpe de chine) lies less in their functional attributes than

61 Illustration to 'L'Age du losange' in the April 1925 issue of *L'Art et la Mode*

in their status as up-to-date fashion, as manifestations of the 'ever-new': 'raincoats by Sonia Delaunay protect us also from boredom! Lozenges, circles and stripes, boldly treated, are very modern.'[7] The geometry of the circle and of the *losange* (motif *par excellence* of what was later to be called Art Deco) is explicitly identified with luxury.

This was, moreover, a luxury specifically associated with the female body. Here geometry signified visual as opposed to intellectual pleasures. A 1925 article entitled 'The age of the lozenge' in *L'Art et la Mode* referred to 'so many little chiseled lozenges adorned with precious stones hanging from the ears of beautiful women' but also to 'lozenges of hair à la Garçonne' as well as to the made-up face of the stylish woman where 'eyes' and 'lips' were all produced in the form of *losanges* (plate 61). The diamond shape of the 'lozenge', it was claimed, typified a modern optics: 'The lozenge! Evocative symbol of the age of cinema. *Losange* . . . Los . . . Angeles! We really do live in the era of the lozenge. Its sharp points are a synthesis of our visual acuity [. . .].'[8] This 'acute' vision through which the female form was represented in terms of artifice (jewellery and make-up) and body fragments (ears,

hair, eyes, lips) – as the object, in other words, of a fetishising gaze – characterised not only the cinema but also the modern street as defined by fashion and advertising. These examples from *La Revue de la Femme* and *L'Art et la Mode* reveal the extent to which the conventions of fashion journalism and photography reiterate the 1925 Exhibition's representation of the city as an extension of woman's toilette – hardly surprising given the importance of *haute couture* and *publicité* for the French section of this Exhibition.

As we have seen, the Parisienne in the street – woman as shopper – was a particularly ambivalent and unstable figure, constituting on the one hand the reassuring object of an anxious male gaze, and on the other, more theateningly, the female subject of a desiring look. As an aspect of her toilette, shopping – the look into the shop-window – involved the same narcissistic gaze as that directed into her mirror (or *nécessaire*). Although the attribution of narcissism functioned to demean woman's capacity for authorship (to ascribe to all woman's 'art' the status of instinctive self-adornment) it also implied a specifically feminine power: the power of woman to stage herself and hence her ability to recognise, and take some measure of control over, that gaze directed at her. It is as woman's acknowledgement and assessment of that gaze that we might read the smile of mannequins, as both inviting and menacing – the models in the *Revue de la Femme* photographs as fashion's updated version of the Mona Lisa's enigmatic smile. The idea of woman's narcissistic look thus posed some degree of threat, a threat which it was necessary to counter. Here then lies a further significance of the Purist representation of the city, where a covert fetishisation of the 'modern' object involved the denial of woman's subjecthood and hence also of her potential as author.

With images such as the male motorist and Diogenes' barrel, the discourse of L'Esprit Nouveau proposed a series of metaphors based on the encased male body in order to describe both the modern street and the modern domestic interior. This involved (in the case of the latter) an appropriation of the time-honoured persona of the *femme au foyer*. In *The Decorative Art of Today* Le Corbusier narrativised the rise of a masculine predominance in the arrangement of the home:

> it looked as if decorative art would founder among the young ladies, had not the exponents of the *decorative ensemble* wished to show, in making their name and establishing their profession, that male abilities were indispensable in this field: considerations of *ensemble*, organisation, sense of unity, balance, proportion, harmony.[9]

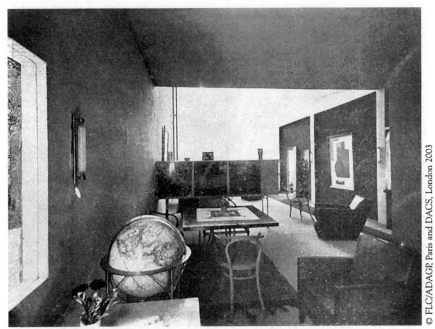

© FLC/ADAGP, Paris and DACS, London 2003

62 Interior of the Pavillon de L'Esprit Nouveau from Le Corbusier, 'Le Pavillon de L'Esprit Nouveau', *Almanach d'architecture moderne*, 1926, p. 158

The composition of the ensemble, now identified as a specifically masculine profession, was no longer associated with the well-dressed woman and the 'art' evolved in connection with her toilette. The *ensemblier*, however, concerned with the selection of artistically crafted objects for the interior constituted an intermediate stage in Le Corbusier's conception of the evolution of a male ascendancy. The skills of the *ensemblier* – selection (shopping) and arrangement – were perhaps still too obviously analogous to those ascribed to woman. By contrast, the architect-engineer 'equipped' the modern home with a suitable battery of objects 'purified' by mechanical selection. Such standardised objects emerged, Le Corbusier emphasised, as the result of economic and industrial processes, they were not the product of individual choice or aesthetic sensibility. The appropriate analogy was now modern *male* dress.[10]

This was the argument embodied by the Pavillon de L'Esprit Nouveau whose interior formed a pointed contrast to the lavishly decorated rooms on show elsewhere (plates 62 and 63). The 1925 Exhibition was intended as a showcase for the *ensemblier*, whose ability to co-ordinate luxurious furnishings was presented as a specifically French

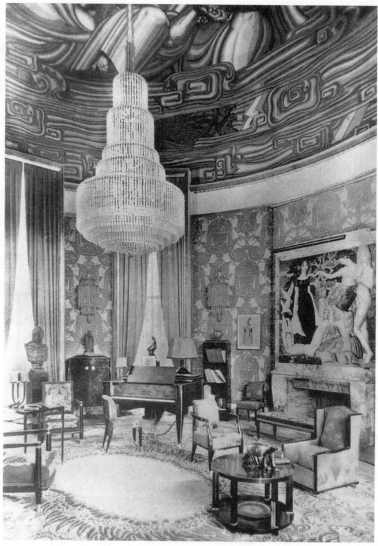

63 Interior of the Pavilion of a Rich Collector at the 1925 Paris Exhibition

skill.[11] Here, fifteen years after the debates provoked by the German exhibits displayed at the 1910 Salon d'Automne, was the opportunity to demonstrate the intrinsic Frenchness – and modernity – of the *ensemblier*'s role.[12] In 1925 (as indeed since the late nineteenth century) ideas on femininity were crucial for such articulations of national identity. *Ensemblier* and stylish Parisienne appeared as mutually compatible figures (both equally 'French'), but it was – significantly – woman's

fashion which afforded the paradigmatic means of defining the ensemble as modern. The Bonney sisters in their guidebook to shopping in Paris, for example, drew attention to what they saw as a recent and influential development:

> All this time the French woman was developing the idea of an *ensemble*, a consciously harmonious selection of costume, shoes, purse, hat, stockings [. . .]. With the changes that have come since the war, the penetration of large numbers of Americans into Europe, the need of the French dressmaker for an American market, the result on American store purchases, and consequently advertising, and the invasion of the *couture* world by young Frenchmen with young ideas, there has developed in America an ensemble idea of dress.[13]

The 'ensemble idea' was not, of course, solely the province of 'young Frenchmen'. Delaunay's Simultaneous designs at the 1925 Exhibition perfectly illustrated the range of accessories necessary to the composition of a fashionable ensemble: on show in the *vitrines* of the Boutique Simultanée were scarves, buttons and handbags. Even the motor car, as we have seen, could be mobilised as part of this *batterie d'ensemble*.

But this notion of the ensemble had to do with more than the appearance of women's outfits (or of an interior). It also defined new modes of marketing and patterns of consumption. In his book *Advertising the American Dream* Roland Marchand identifies the 'mystique' of the ensemble as evidence of a 'mature consumption ethic'; for certain industries, he claims, the ensemble proved the solution for inducing people to buy more.[14] The concept of the ensemble as a marketing strategy (which Marchand dates as originating sometime around the mid-1920s) involved the promotion of changes in fashion as opposed to an emphasis on the functional. This redefinition of utilitarian objects as components of an ensemble relied heavily on changes in colour. Whereas Ford had allowed his customers to choose any colour they liked for their Model-T 'as long as it was black', the motor car as fashion accessory was subject to the dictates of fashionable colour. Marchand cites numerous examples of American manufacturers' attempts to market cars in this way; the Ternstedt Company offered automobiles with 'ensemble sets' of vanity and smoking cases while Dupont proclaimed 'Your car – it too can change its garment'.[15] Other traditionally black-encased products – such as typewriters and cameras – were also offered in a range of fashion colours.

Wearing a fashionable colour signified being up to date (hence the establishment of style and colour forecasting agencies). At the

same time, it was claimed that colour revealed an 'individual' personality. As Marchand points out, the ensemble was the means of rescuing the consumer from the dangers of mass-production – a successful ensemble was evidence of both individuality and good taste. And one of the most important ways of verifying correct taste was through reference to Paris and, in particular, Parisian *haute couture*. Kodak claimed that its 'Kodak Petite' (which came in 'five alluring colors') was 'Paris-inspired'. Hupmobile advised its customers to judge its cars by the same criteria as those involved in assessing a Paris gown. Similarly the Reo Motor Car Company claimed that its car finishes were based on that season's Parisian designer colours. And Oneida Ltd advertised its silverware with pronouncements quoted from 'the Fashionables returning from Paris'.[16] What this potentially endless list reveals is not so much that the idea of the ensemble originated in Paris, nor even that fashion's changes were first evinced in the French capital, but rather that 'Paris' functioned as the sign and guarantor of the fashionable. This notion of Paris was thus a crucial aspect of post-war marketing, vital to the expansion of sales in the United States as well as in France.[17]

It was in this sense that 'Paris' itself became a commodity to be marketed and sold to both a national and international *clientèle*. If in the United States references to Parisian style were used to sell mass-produced goods from cars to cutlery, it was through association with high fashion and luxury that 'Paris' aroused desire in the consumer. Hence the importance of maintaining the status of Paris as 'exclusive'. One of the most important effects of the 1925 Exposition Internationale des Arts Décoratifs et Industriels Modernes was to reproduce and sustain such representations of Paris. The photograph juxtaposing Sonia Delaunay's fashions and car with a well-known landmark of the Exhibition (the Pavillon de Tourisme) thus constitutes not merely a particular instance of fashion photography but part of this discourse on Paris. Considered in this light, the Exhibition's much criticised emphasis on luxury and ostentatious display was not so much *retardataire* as symptomatic of a modernity based on developments in consumer culture.

The Pavillon de L'Esprit Nouveau was a challenge to the representation of the French capital as world-centre of luxury shopping, an attempt to redefine that city acknowledged as modern only to the extent that its women were well dressed. According to the theoretical framework which proposed a Citrohan House or a Plan Voisin, Delaunay's decorated car was an anachronism, a throw-back to a more 'primitive' stage of culture. The protagonist of L'Esprit Nouveau was the engineer as opposed to the female consumer so vaunted by the

1925 Paris Exhibition. At one level, Le Corbusier's formulation of the architect-engineer (a role not necessarily restricted to men) might be interpreted as progressive – more socially aware than either the woman shopper or the *ensemblier* – and potentially more democratic, involving a concern with housing as opposed to *haute couture* outfits or expensive interiors. Only when the figure of the architect-engineer is read as a denial of woman's subjectivity as figured by the chic Parisienne does the full ideological thrust of Le Corbusier's urbanistic discourse become evident. Hence the importance of juxtaposing the more ephemeral (and ostensibly frivolous) aspects of the 1925 Exhibition – such as boutiques and fashion photographs – with the Pavillon de L'Esprit Nouveau project as conflicting representations of the city. The 'rational' clarity of the Plan Voisin, it then emerges, was as much a dream and an illusion as the glittering woman's city so dramatically staged by the Exhibition.

Notes

1 'Courrier de Paris – héritage – le semainier', *L'Illustration: Histoire d'un Siècle 1843–1944*, vol. 13: 1920–1925, SEFAG et L'Illustration, 1985, p. 281.

2 'Architecture – décoration peinte et sculptée – l'architecture à l'Exposition', *Encyclopédie*, vol. 2, p. 21.

3 *Ibid.*

4 See 'Classe 37: Cinématographie – Section Française', *Encyclopédie*, vol. 10, p. 78.

5 On the imagery of Diana at the 1925 Exhibition, see pp. 250–5 of Romy Golan's PhD thesis 'A Moralised Landscape: The Organic Image of France between the Two World Wars', University of London, 1989. For another discussion of the 'new body' promoted by *L'Esprit Nouveau*, see Ute Lehrer, 'Le Corps nouveau', *L'Esprit Nouveau*, 1987, pp. 240–1.

6 S. Camille, 'Élégance & Féminités', *Journal Illustré des Arts Décoratifs et Industriels Modernes*, 1 July 1925, no. 4, p. 58.

7 'L'Art décoratif dans la toilette', *La Revue de la Femme*, 1 May 1928, p. 29.

8 Pierre de Trévières, 'L'Age du losange', *L'Art et la Mode*, 4.4.25, n.p.

9 Le Corbusier, 'The hour of architecture', *The Decorative Art of Today*, p. 134.

10 However, as Nancy Troy ('The paradoxes of Modernism', *Modernism and the Decorative Arts*, p. 228) points out:

> Setting himself up as the arbiter of mechanical selection, Le Corbusier tried to show in the Pavillon de L'Esprit Nouveau that anonymous industry, rather than the individual artist, is the source not only of modern design but of style itself. Yet it was of course the aesthetic authority he exercized as an individual artist that empowered him to determine which objects of industrial production had attained the level of style.

11 See, for example, Maurice Dufrène, *Authentic Art Deco Interiors from the 1925 Paris Exhibition*, Antique Collectors' Club, Woodbridge, Suffolk, 1989; and my

review of this in *The Journal of Design History*, 1991, vol. 4, no. 1. For a discussion of the impact of the 1925 Exhibition, see Jonathan M. Woodham, *Twentieth-Century Design*, Oxford University Press, Oxford and New York, 1997, especially pp. 76–81.

12 On the *ensemblier*, see the *Encyclopédie*: vol. 1, 'Mobilier', p. 43 ff. and 'Programme de l'Exposition [. . .]', p. 91; vol. 4, 'Ensembles de mobilier', pp. 9–10. For discussions of the 1910 Salon d'Automne, see N. Troy, 'Toward a redefiniton of tradition in French design, 1895 to 1914', *Design Issues*, 1984, vol. 1, no. 2, pp. 53–69; Silver, *Esprit de Corps*, p. 170; and N. Troy, 'Responses to industrialisation and competition from Germany', chapter 2 of *Modernism and the Decorative Arts in France*.

13 T. and L. Bonney, 'Accessories', *A Shopping Guide to Paris*, pp. 68–9.

14 Roland Marchand, *Advertising the American Dream: Making Way for Modernity 1920–1940*, University of California Press, Berkeley and Los Angeles, 1985, p. 132 and p. 137.

15 *Ibid.*, p. 133. See also David Gartman, *Auto Opium: A Social History of American Automobile Design*, Routledge, London and New York, 1994.

16 *Ibid.*, pp. 133–6.

17 Neil Harris discusses the impact of 1925 Exhibition shop design on American marketing in 'The drama of consumer desire', *Cultural Excursions: Marketing Appetites and Cultural Tastes in Modern America*, University of Chicago Press, Chicago and London, 1990. See also Penny Sparke, '"The selling value of art": women and the moderne', *As Long as it's Pink: The Sexual Politics of Taste*, Pandora, London, 1995.

⟪ SELECT BIBLIOGRAPHY

Official publications

Ministère du Commerce et de l'Industrie des Postes et des Télégraphes, *Catalogue général officiel: Exposition Internationale des Arts Décoratifs et Industriels Modernes*, Imprimerie de Vaugirard, Paris, 1925.

Encyclopédie des arts décoratifs et industriels modernes au XXème siècle, Office Central d'Éditions et de Librairie, Paris, n.d., 12 volumes as follows:

1 *Préface: Évolution de l'art moderne. L'esprit nouveau dans les arts décoratifs et industriels. Évolution au XXe siècle. Vue d'ensemble.*

2 *Architecture et décoration fixe. Décoration sculptée. Décoration peinte.*

3 *Décoration fixe de l'architecture: art et industrie de la pierre, du bois, du métal, de la céramique et de la verrerie.*

4 *Le mobilier et son ensemble. Art et industrie du bois et du cuir dans l'ameublement. Hygiène, art et lumière. Matières et techniques. Mobiliers luxueux et usuels. Art colonial.*

5 *Accessoires du mobilier. Tabletterie, maroquinerie, ferronnerie, incrusteurs, émailleurs, laqueurs, orfèvres, graveurs sur acier, horlogers, armuriers, bronziers, fondeurs, médailleurs, doreurs et argenteurs. Vaisselle et cristallerie.*

6 *Art et industrie des textiles. Tissus, lampas, brocards, brochés. Papiers peints et imprimés.*

7 *Le livre. Art et industrie du livre. Le papier. Impression, illustrations, brochage, cartonnage, reliure. Édition et librairie. Fondeurs de caractères. Imprimeurs, illustrateurs, relieurs, éditeurs, livres de luxe, bibliophiles.*

8 *Jeux et jouets. Instruments et appareils de sport. Appareils scientifiques. Instruments de musique et de radio. Moyens de transports: chemins de fer, autos, avions, navires, etc.*

9 *La parure. Accessoires du vêtement: bas, gants, chaussures, chapeaux, lingerie, dentelles, mode, fleurs et plumes, parfumerie, bijouterie, joaillerie.*

10 *Théâtre. Introduction. Arts du théâtre. Photographie. Cinématographie.*

11 *Rue et jardin. Plans de villes, aménagements urbains. Décor et mobilier de la rue. Décor publicitaire. Arts des jardins. Parc et jardin. Arbres et arbustes. Plantes et fleurs. Décors et mobiliers du jardin.*

12 *Enseignement. Enseignement professionnel, artistique, technique. Travail de la pierre, du bois, du métal, de la céramique, du verre, des textiles, du papier et des matières végétales ou animales (produits de remplacement).*

Journal Illustré des Arts Décoratifs et Industriels Modernes, 1925 (official magazine of the 1925 Exhibition).

US Department of Commerce, *Report of the Commission Appointed by the Secretary of Commerce to Visit and Report upon the International Exposition of Modern Decorative and Industrial Art in Paris 1925*, Washington DC, 1926.

British Department of Overseas Trade, *Reports on the Present Position and Tendencies of the Industrial Arts as Indicated at the International Exhibition of Modern Decorative and Industrial Arts, Paris, 1925: With an Introductory Survey by Sir H. Llewellyn Smith*, HMSO, London, 1926.

Magazines and journals

L'Amour de l'Art

L'Architecte

The Architectural Review

Architecture Vivante

L'Art de France

Art et Décoration

L'Art et la Mode

L'Art Français Moderne

L'Art Vivant

Les Arts de la Maison

Les Arts Plastiques

Beaux-Arts: Revue d'Information Artistique

Le Bulletin de l'Effort Moderne

Le Bulletin de la Vie Artistique

Chasse, Pêche, Élevage

La Construction Moderne

Le Correspondant

Le Crapouillot

La Femme, le Sport, la Mode

Gazette des Beaux-Arts

Illustration

Les Nouvelles Littéraires

Parade: Revue du Décor de la Rue. Journal de l'Étalage & de ses Industries

La Renaissance de l'Art Français et des Industries de Luxe

Revue de l'Étalage: Revue de la Confection et de la Nouveauté

La Revue de la Femme

Revue des Arts Décoratifs

Vendre: Tout ce qui Concerne la Vente et la Publicité

Vogue (French edition)

For more detailed references, see the Notes to each chapter.

Books and exhibition catalogues

Abelson, Elaine, *When Ladies Go A-Thieving: Middle-Class Shoplifters in the Victorian Department Store*, Oxford University Press, New York, 1989.

Adburgham, Alison, *Shops and Shopping 1800–1914*, Allen & Unwin, London, 1964.

Adler, Kathleen and Marcia Pointon (eds), *The Body Imaged: The Human Form and Visual Culture since the Renaissance*, Cambridge University Press, Cambridge, 1993.

Allwood, John, *The Great Exhibitions*, Studio Vista, London, 1977.

Angé, Louis, *Traité pratique de publicité commerciale et industrielle*, 2 vols, Éditions Pratique de Publicité Commerciale et Industrielle, Paris, 1922.

Anscombe, Isabelle, *A Woman's Touch: Women in Design from 1860 to the Present Day*, Virago, London, 1984.

Apter, Emily and William Pietz, *Fetishism as Cultural Discourse*, Cornell University Press, Ithaca and London, 1993.

Aragon, Louis, *Paris Peasant*, Picador, London, 1971.

Arminjon, Catherine *et al.*, *L'Art de Vivre: Decorative Arts and Design in France 1789–1989*, Thames & Hudson, London, 1989.

Arts Council of Great Britain, *The Architecture of Adolf Loos*, ACGB, London, 1985.

Arts Council of Great Britain, *Le Corbusier: Architect of the Century*, ACGB, London, 1987.

Ball, Susan L., *Ozenfant and Purism: The Evolution of a Style 1915–30*, UMI Research Press, Ann Arbor, Michigan, 1981.

Baudelaire, Charles, *Baudelaire: Selected Writings on Art and Artists*, Penguin, Harmondsworth, 1972.

Bayard, Émile, *Les Arts de la femme: encyclopédie pratique*, Librairie Delagrave, Paris, 1904.

Benjamin, Walter, *Charles Baudelaire: A Lyric Poet in the Era of High Capitalism*, New Left Books, London, 1973.

Benton, Charlotte, 'Modernist tendencies in French design before 1925', 'The International Exhibition of Modern Decorative and Industrial Arts, Paris, 1925' and 'Furniture as an architectural element in the avant-garde interior', in Tim Benton, Charlotte Benton and Aaron Scharf, *Design 1920s*, and Open University course 'History of architecture and design 1890–1939', both The Open University Press, Milton Keynes, 1975.

Benton, Tim, *The Villas of Le Corbusier 1920–1930*, Yale University Press, New Haven and London, 1987.

Bibliothèque Nationale, *Sonia & Robert Delaunay*, Bibliothèque Nationale, Paris, 1977.

Bizet, René, *La Mode*, F. Rieder et Cie., Paris, 1925.

Bizot, Chantal and Micheline Béranger, *Bibliographie 1925*, Société des Amis de la Bibliothèque Forney, Paris, 1976 (compiled at the time of the *Cinquantenaire de l'Exposition 1925* exhibition at the Musée des Arts Décoratifs, Paris; see below).

Blanc, Charles, *Art in Ornament and Dress*, Chapman & Hall, London, 1877.

Bloch, Jean-Jacques and Marianne Delort, *Quand Paris allait 'à l'Expo'*, Librairie Arthème Fayard, Paris 1980.

Bonney, Thérèse and Louise, *A Shopping Guide to Paris*, Robert M. McBride & Co., New York, 1929.

Bouin, Philippe and Christian-Philippe Chanut, *Histoire française des foires et des expositions universelles*, Baudouin, Paris, 1980.

Bowlby, Rachel, *Just Looking: Consumer Culture in Dreiser, Gissing and Zola*, Methuen, New York and London, 1985.

Bowlby, Rachel, *Shopping with Freud*, Routledge, London and New York, 1993.

Bowman, Sara, *A Fashion for Extravagance: Art Deco Fabrics and Fashions*, Bell & Hyman, London, 1985.

Brandstetter, Gabriele and Brygida Maria Ochaim, *Loie Fuller: Tanz, Licht-Spiel, Art Nouveau*, Verlag Rombach Freiburg, Freiburg im Breisgau, 1989.

Brunhammer, Yvonne, *Art Deco Style*, Academy Editions, London, 1983 (first published as *Lo stile 1925*, Gruppo Editoriale Fabbri, Milan, 1966).

Brunhammer, Yvonne, *The Nineteen Twenties Style*, Cassell, London, 1966.

Brunhammer, Yvonne and Suzanne Tise, *French Decorative Art: The Société des Artistes Décorateurs 1900–1942*, Flammarion, Paris, 1990.

Buck-Morss, Susan, *The Dialectics of Seeing: Walter Benjamin and the Arcades Project*, MIT Press, Cambridge (Mass.) and London, 1989.

Buckberrough, Sherry A., *Sonia Delaunay: A Retrospective*, Albright-Knox Art Gallery, Buffalo, New York, 1980.

Cabanne, Pierre, *Encyclopédie Art Deco*, Somogy, Paris, 1986.

Caumery, *Bécassine, son oncle, et leurs amis*, Gautier et Languereau Éditeurs, Paris, 1926.

Centre Georges Pompidou, Paris, *Art & Publicité 1890–1990*, Éditions du Centre Pompidou, Paris, 1990–91.

Chadwick, Whitney and Isabelle Courtivron (eds), *Significant Others: Creative and Intimate Partnerships*, Thames & Hudson, London, 1993.

Chasseguet-Smirgel, Janine, *Creativity and Perversion*, Free Association Books, London, 1985.

Clark, T. J., *The Painting of Modern Life: Paris in the Art of Manet and his Followers*, Thames & Hudson, London, 1984.

Clouzot, Henri, *Les Métiers d'art: orientation nouvelle*, Payot, Paris, 1920.

Cohen, Arthur A., *Sonia Delaunay*, Abrams, New York, 1975.

Cohen, Arthur A., *The New Art of Color: The Writings of Robert and Sonia Delaunay*, The Viking Press, New York, 1978.

Cohen, Jean-Louis and André Lortie, *Des fortifs au perif: Paris les seuils de la ville*, Picard Éditeur, Édition du pavillon de l'Arsenal, Paris, 1991.

Collomb, Michel, *La Littérature art déco: sur le style d'époque*, Méridiens Klincksieck, Paris, 1987.

Colomina, Beatriz (guest ed.), *Revisions 2: Architecture and Reproduction*, Princeton Architectural Press, New York, 1988.

Colomina, Beatriz (ed.), *Sexuality & Space*, Princeton Papers on Architecture, Princeton Architectural Press, New York, 1992.

Colomina, Beatriz, *Privacy and Publicity: Modern Architecture as Mass Media*, MIT Press, Cambridge (Mass.) and London, 1994.

Cottington, David, *Cubism and the Politics of Culture in France 1905–1914*, PhD Thesis, University of London, 1985.

Damase, Jacques, *Sonia Delaunay: Rhythms and Colours*, Thames & Hudson, London, 1972.

Damase, Jacques, *Sonia Delaunay: Fashion and Fabrics*, Thames & Hudson, London, 1991.

D'Avenel, Georges, *Le Mécanisme de la vie moderne*, A. Colin, Paris, 1902.

De Clérambault, Gaëtan Gatian, *Passion érotique des étoffes chez la femme*, Collection Les Empêcheurs de Penser en Rond, Paris, 1991.

De Grazia, Victoria (ed.) with Ellen Furlough, *The Sex of Things: Gender and Consumption in Historical Perspective*, University of California Press, Berkeley, Los Angeles, London, 1996.

De Lauretis, Teresa, *Alice Doesn't: Feminism, Semiotics, Cinema*, Macmillan, London and Basingstoke, 1984.

Delaunay, Sonia, *Nous irons jusqu'au soleil*, avec la collaboration de Jacques Damase et de Patrick Raynaud, Éditions Robert Laffont, Paris, 1978.

Delorme, Jean-Claude, *Les Villas d'artistes à Paris de Louis Süe à Le Corbusier*, Les Éditions de Paris, Paris, 1987.

Dermée, Paul and Eugène Courmont, *Les Affaires et l'affiche*, Dunod Éditeur, Paris, 1922.

Deshairs, Léon, *Une ambassade française, organisée par la Société des Artistes Décorateurs*, Éditions Charles Moreau, Paris, 1925.

Deslandres, Yvonne and Florence Mueller, *Histoire de la mode au XXe siècle*, Éditions Somogy, Paris, 1986.

Divoire, Fernand, *Découvertes sur la danse*, G. Crès et Cie., Paris, 1924.

D'Udine, Jean, *Qu'est-ce que la danse?*, H. Laurens, Paris, 1921.

Dufrène, Maurice, *Ensembles mobiliers – Exposition Internationale 1925*, Éditions Charles Moreau, Paris, 1925.

Dufrène, Maurice, *Les Intérieurs français au Salon des Artistes Décorateurs en 1926*, Charles Moreau, Paris, 1926.

Dufrène, Maurice, *Authentic Art Deco Interiors from the 1925 Paris Exhibition*, Antique Collectors' Club, Woodbridge, Suffolk, 1989.

Duncan, Alastair, *Art Deco*, Thames & Hudson World of Art, London, 1988 (Reprinted 1991).

Ellis, Havelock, *The Dance of Life*, Constable & Co., London, 1923.

Escholier, Raymond, *Le Nouveau Paris: la vie artistique de la cité moderne*, Éditions Nilsson, Paris, n.d.

L'Esprit Nouveau: Le Corbusier et l'Industrie 1920–1925, Museum für Gestaltung Zurich and Wilhelm Ernst & Sohn Verlag, Berlin, 1987.

Etherington-Smith, Meredith, *Patou*, Hutchinson, London, 1983.

Evenson, Norma, *Paris: A Century of Change, 1878–1978*, Yale University Press, New Haven and London, 1979.

Falk, Pasi and Colin Campbell (eds), *The Shopping Experience*, Sage Publications Ltd, London, 1997.

Fausch, Deborah, Paulette Singley, Rodolphe El-Khoury, Zvi Efrat (eds), *Architecture: In Fashion*, Princeton Architectural Press, New York, 1994.

Félix-Faure-Goyau, Lucie, *L'Évolution féminine: la femme au foyer et dans la cité*, Perrin, Paris, 1917.

Fer, Briony, David Batchelor and Paul Wood, *Realism, Rationalism, Surrealism: Art between the Wars*, Yale University Press, New Haven and London in association with the Open University, 1993.

Fishman, Robert, *Urban Utopias in the Twentieth Century: Ebenezer Howard, Frank Lloyd Wright, and Le Corbusier*, Basic Books, Inc., New York, 1977.

Flugel, J. C., *The Psychology of Clothes*, The Hogarth Press (The International Psycho-Analytical Library), London, 1930.

Ford, G. B., *L'Urbanisme en pratique: précis de l'urbanisme dans toute son extension pratique comparée en Amérique et en Europe*, Éditions Ernest Leroux, Paris, 1920.

Ford, Henry (in collaboration with Samuel Crowther), *My Life and Work*, Garden City Publishing Co., Garden City, New York, 1922.

Foster, Hal, *Compulsive Beauty*, MIT Press, Cambridge (Mass.) and London, 1993.

Francastel, Pierre, *Robert Delaunay: du cubisme à l'art abstrait*, SEVPEN, Paris, 1957.

Freud, Sigmund, *On Sexuality: Three Essays on the Theory of Sexuality and Other Works*, The Pelican Freud Library, vol. 7, Penguin Books, Harmondsworth, 1977.

Freud, Sigmund, *Art and Literature*, The Pelican Freud Library, vol. 14, Penguin Books, Harmondsworth, 1985.

Friedberg, Anne, *Window Shopping: Cinema and the Postmodern*, University of California Press, Berkeley, Los Angeles and Oxford, 1993.

Frisby, David, *Fragments of Modernity: Theories of Modernity in the Work of Simmel, Kracauer and Benjamin*, Polity Press, Cambridge and Oxford, 1985.

Fuller, Loie, *Fifteen Years of a Dancer's Life with Some Account of her Distinguished Friends*, Herbert & Jenkins, London, 1913.

Gabetti, R. and C. Olmo, *Le Corbusier e L'Esprit Nouveau*, Einaudi, Turin, 1975.

Galerie Fanny Guillon-Laffaille, *Rob Mallet-Stevens dessins 1921 pour une cité moderne*, Galerie Fanny Guillon-Laffaille, Paris, 1986.

Garb, Tamar, *Sisters of the Brush: Women's Artistic Culture in Late Nineteenth-Century Paris*, Yale University Press, New Haven and London, 1994.

Gartman, David, *Auto Opium: A Social History of American Automobile Design*, Routledge, London and New York, 1994.

Gee, Malcolm, *Dealers, Critics, and Collectors of Modern Painting: Aspects of the Parisian Art Market between 1910 and 1930*, PhD Thesis, Courtauld Institute of Art, University of London, 1977.

Gérin, Octave-Jacques and Charles Espinadel, *Commerce et industrie – les procédés modernes de vente – la publicité suggestive théorie et technique*, H. Dunod et E. Pinat, Paris, 1911.

Ginsburg, Madeleine, *Paris Fashions: The Art Deco Style of the 1920s*, Bracken Books, London, 1989.

Golan, Romy, *Modernity and Nostalgia: Art and Politics in France between the Wars*, Yale University Press, New Haven and London, 1995.

Green, Christopher, *Léger and the Avant-Garde*, Yale University Press, London, 1976.

Green, Christopher, *Cubism and its Enemies: Modern Movements and Reaction in French Art, 1916–1928*, Yale University Press, New Haven and London, 1987.

Greenhalgh, Paul, *Ephemeral Vistas: The Expositions Universelles, Great Exhibitions and World's Fairs, 1851–1939*, Manchester University Press, Manchester, 1988.

Gresleri, Giuliano, *L'Esprit Nouveau Parigi–Bologna: costruzione e recostruzione d'un prototipo dell'architettura moderna*, Electa, Milan, 1979.

Gresleri, Giuliano, *Le Corbusier Viaggio in Oriente*, Marsilio Editori, Venice and Fondation Le Corbusier, Paris, 1984.

Hamp, Pierre, *La Peine des hommes: les métiers blessés*, Éditions de la 'Nouvelle Revue Française', Paris, 1919.

Harris, Neil, *Cultural Excursions: Marketing Appetites and Cultural Tastes in Modern American*, University of Chicago Press, Chicago and London, 1990.

Henriot, G., *Nouvelles devantures: façades et agencements de magasins*, Ière série, Charles Moreau, Paris, 1927.

Herbst, René, *Devantures, vitrines, installations de magasins à l'Exposition Internationale des Arts Decoratifs Paris1925*, Éditeur Charles Moreau, Paris, 1925.

Herbst, René, *Modern French Shop-Fronts and their Interiors by René Herbst with a Fore-word by James Burford (Associate Royal Institute of British Architects)*, John Tiranti & Co., London, 1927.

Herbst, René, *Nouvelles devantures et agencements de magasins présentés par René Herbst*, Éditions d'Art Charles Moreau, Paris, 1930.

Hillier, Bevis, *Art Deco: A Design Handbook*, The Herbert Press, London, 1985 (first published 1968).

Hounshell, David A., *From the American System to Mass Production 1800–1931: The Development of Manufacturing Technology in the United States*, The Johns Hopkins University Press, Baltimore and London, 1984.

Huddleston, Sisley, *In and about Paris*, Methuen & Co. Ltd, London, 1927.

Hunt, Lynn (ed.), *Eroticism and the Body Politic*, The Johns Hopkins University Press, Baltimore and London, 1991.

Imbert, Dorothée, *The Modernist Garden in France*, Yale University Press, New Haven and London, 1993.

Janneau, Guillaume, *L'Art décoratif moderne: formes nouvelles et programmes nouveaux*, Bulletin de la Vie Artistique, Paris, 1925.

Jencks, Charles, *The Language of Post-Modern Architecture*, Academy Editions, London, 1978.

Jencks, Charles, *Le Corbusier and the Tragic View of Architecture*, Penguin Books Ltd, Harmondsworth, 1973 and 1987.

Jones, Amelia, *Postmodernism and the En-gendering of Marcel Duchamp*, University of Cambridge Press, Cambridge, 1994.

Jowitt, Deborah, *Time and the Dancing Image*, University of California Press, Los Angeles and Berkeley, 1988.

Kahn, Gustave, *L'Esthétique de la rue*, Bibliothèque-Charpentier, Paris, 1901.

Krauss, Rosalind E., *The Optical Unconscious*, MIT Press, Cambridge (Mass.) and London, 1993.

Le Corbusier, *The City of Tomorrow*, The Architectural Press, London, 1971 (originally published 1925).

Le Corbusier, *Towards a New Architecture*, The Architectural Press, London, 1972 (originally published 1923).

Le Corbusier, *Le Corbusier et Pierre Jeanneret: œuvre complète*, vol. 1: *1910–1929*, 11th edn, edited by W. Boesiger and O. Stonorov, Les Éditions d'Architecture, Zurich, 1984.

Le Corbusier, *The Decorative Art of Today*, MIT Press, Cambridge (Mass.), 1987 (originally published 1925).

Le Corbusier (Charles-Édouard Jeanneret), *Journey to the East*, MIT Press, Cambridge (Mass.) and London, 1989.

Le Corbusier, *Précisions: On the Present State of Architecture and City Planning*, MIT Press, Cambridge (Mass.), 1991 (originally published 1930).

Le Corbusier, *Almanach d'architecture moderne*, Éditions Connivences, Paris, n.d. (originally published 1926).

Léger, Fernand, *Functions of Painting by Fernand Léger*, Thames & Hudson, London, 1973.

Lemoine-Luccioni, Eugénie, *La Robe: essai psychanalytic sur le vêtement*, Éditions du Seuil, Paris, 1983.

Léon, Paul et al., *Exposition Internationale des Arts Décoratifs et Industriels Modernes Paris 1925*, 'Vient de Paraître', Paris, 1925.

Lhote, André (ed.), *Sonia Delaunay: ses objets, ses tissus simultanés, ses modes*, Librairie des Arts Décoratifs, Paris, 1925.

Lista, Giovanni, *Loie Fuller: danseuse de la Belle Époque*, Stock-Éditions d'Art Somogy, Paris, 1994.

Loos, Adolf, *Adolf Loos: Spoken into the Void. Collected Essays1897–1900*, Oppositions Books, MIT Press, Cambridge (Mass.) and London, 1982.

Mac Orlan, Pierre, *La Boutique*, M. Seheur, Paris, 1925.

McMillan, J. F., *Housewife or Harlot: The Place of Women in French Society 1870–1940*, Harvester, Brighton, 1981.

Malochet, Annette, *Atelier simultané di Sonia Delaunay 1923–1934*, Fabbri Editori, Milan, 1984.

Marchand, Roland, *Advertising the American Dream: Making Way for Modernity 1920–1940*, University of California Press, Berkeley and Los Angeles, 1985.

Marie, Grand Duchess of Russia (Mary Pavlona), *A Princess in Exile*, Cassell & Co., London, 1932.

Marrast, Joseph, *1925 Jardins*, Éditions d'Art Charles Moreau, Paris, 1926.

Martin, Marc, *Trois siècles de publicité en France*, Éditions Odile Jacob, Paris, 1992.

Miller, Michael B., *The Bon Marché: Bourgeois Culture and the Department Store, 1869–1920*, George Allen & Unwin, London, 1981.

Morand, Paul, *1900*, Flammarion, Paris, 1930.

Mulvey, Laura, *Visual and Other Pleasures*, Macmillan, Hampshire and London, 1989.

Musée des Arts Décoratifs, Paris, *Les Années 25, Art Déco, Bauhaus, De Stijl, Esprit Nouveau*, Musée des Arts Décoratifs, Paris, 1966.

Musée des Arts Décoratifs, Paris, *Cinquantenaire de l'Exposition de 1925*, Musée des Arts Décoratifs, Paris, 1977.

Musée des Arts Décoratifs, Paris, *Le Livre des Expositions Universelles 1851–1989*, Éditions des Arts Décoratifs Herscher, Paris, 1983.

Musée des Arts Décoratifs, Paris, *Rythme et couleur de l'Art Déco. Edouard Bénédictus: gouaches, pochoirs, tissus (1922–1930)*, Flammarion, Paris, 1986.

Musée des Arts Décoratifs, Paris, *Les Années UAM 1929–1958*, Musée des Arts Décoratifs, Paris, 1988.

Musée d'Art Moderne de la Ville de Paris, *Léger et L'Esprit Nouveau (1918–1931): une alternative d'avant-garde à l'art non-objectif*, MAM, Musée d'Art Moderne de la Ville de Paris, Paris, 1982.

Musée d'Art Moderne de la Ville de Paris, *Le Centenaire Robert et Sonia Delaunay*, MAM, Musée d'Art Moderne de la Ville de Paris, Paris, 1985.

Museum of Modern Art, New York, *High & Low: Modern Art and Popular Culture*, Museum of Modern Art and Thames & Hudson, London, 1990.

Nesbit, Molly, *Atget's Seven Albums*, Yale University Press, New Haven and London, 1992.

Nevill, Ralph, *Paris of To-Day*, Herbert & Jenkins Ltd, London, 1924.

The New Painting: Impressionism 1874–1886, Phaidon, Oxford, 1986.

Ory, Pascal, *Les Expositions Universelles de Paris*, Ramsay 'image', Paris, 1982.

Ostergard, Derek, *Art Deco Masterpieces*, Hugh Lauter Levin Associates, Inc., New York, 1991.

Ozenfant, A. and C.-É. Jeanneret, *La Peinture moderne*, Éditions Georges Crès et Cie., Paris, 1925.

Paris and its Environs with Routes from London to Paris: Handbook for Travellers, Karl Baedeker, Leipzig, George Allen & Unwin, London, and Chas. Scribner, New York, 1924.

Paris Arts Décoratifs 1925: guide de l'Exposition, Librairie Hachette, Paris, 1925.

Paris: Black's Guide Books. Black's Guide to Paris., A. & C. Black, London, 1925.

Paris and its Monuments: Promenades in the Neighbourhood – International Exhibition of Modern Decorative and Industrial Arts, The Tourists' Handy Guides, Thiolier Guides, 1925.

Parker, Rozsika and Griselda Pollock, *Old Mistresses: Women, Art and Power*, Routledge & Kegan Paul, London, 1981.

Parrot, Nicole, *Mannequins*, Catherine Donzel, Paris, 1981.

Perry, Gill, *Women Artists and the Parisian Avant-Garde: Modernism and 'Feminine' Art, 1900 to the Late 1920s*, Manchester University Press, Manchester and New York, 1995.

Pinchon, Jean-François (ed.), *Rob. Mallet-Stevens: architecture, mobilier, décoration*, Action Artistique de Paris, Philippe Sers Éditeur, Paris, 1986.

Pinet, Hélène, *Ornement de la durée: Loie Fuller, Isadora Duncan, Ruth St. Denis, Adorée Villany*, Musée Rodin, Paris, 1987.

Poiret, Paul, *My First Fifty Years*, Victor Gollancz, London, 1931.

Pollock, Griselda, *Vision and Difference*, Routledge, London, 1988.

Pommier, Henriette, *Soierie lyonnaise 1850–1940*, Éditions du CNRS, Paris, 1980.

Prendergast, Christopher, *Paris and the Nineteenth Century*, Blackwell, Cambridge, (Mass.) and Oxford, 1992.

Quenioux, Gaston, *Les Arts décoratifs modernes*, Larousse, Paris, 1925.

Rabinow, Paul, *French Modern: Norms and Forms of the Social Environment*, MIT Press, Cambridge (Mass.) and London, 1989.

Raynal, Maurice, *Anthologie de la peinture en France de 1906 à nos jours*, Éditions Montaigne, Paris, 1927.

Reekie, Gail, *Temptations: Sex, Selling and the Department Store*, Allen & Unwin, Australia, 1993.

Rifkin, Adrian, *Street Noises: Parisian Pleasure 1900–1940*, Manchester University Press, Manchester and New York, 1993.

Riotor, Léon, *Le Mannequin*, Bibliothèque Artistique et Littéraire, Paris, 1900.

Rob Mallet-Stevens architecte, Éditions Archives d'Architecture Moderne, Brussels, 1980.

Rydell, Robert W., *World of Fairs: The Century-of-Progress Expositions*, University of Chicago Press, Chicago and London, 1984.

Saisselin, Rémy, *Bricabracomania: The Bourgeois and the Bibelot*, Thames & Hudson, London, 1985.

Salmon, André, *La Jeune Peinture française*, Société des Trente, Paris, 1912.

Salmon, André, *L'Art vivant*, G. Crès, Paris, 1920.

Salon d'Automne, Paris, *Catalogue: Salon d'Automne 1924 du 1er Novembre au 14 Décembre*, Paris, 1924.

Scarlett, Frank and Marjorie Townley, *Arts Décoratifs 1925: A Personal Recollection of the Paris Exhibition*, Academy Editions, London, 1975.

Schivelbusch, Wolfgang, *Disenchanted Night: The Industrialisation of Light in the Nineteenth Century*, Berg, Oxford, New York and Hamburg, 1988.

Schmitter, Marie-Thérèse, *Exposition de Soieries Modernes d'Ameublement*, École de Tissage, Ville de Lyon, 1934.

Schneider, Sara K., *Vital Mummies: Performance Design for the Show-Window Mannequin*, Yale University Press, New Haven and London, 1995.

Schor, Naomi, *Reading in Detail: Aesthetics and the Feminine*, Methuen, New York and London, 1987.

Schuster, Peter-Klaus, *Delaunay und Deutschland*, DuMont Buchverlag, Cologne, 1985.

Searing, Helen (ed.), *In Search of Modern Architecture: A Tribute to Henry-Russell Hitchcock*, MIT Press, Cambridge (Mass.), 1982.

Sézille, L.-P., *Devantures de boutiques*, A. Lévy, Paris, 1927.

Sheringham, Michael (ed.), *Parisian Fields*, Reaktion Books, London, 1996.

Silver, Kenneth, *Esprit de Corps: The Art of the Parisian Avant-Garde and the First World War, 1914 –1925*, Princeton University Press, Princeton, 1989.

Silverman, Debora L., *Art Nouveau in Fin-de-Siècle France: Politics, Psychology and Style*, University of California Press, Berkeley, Los Angeles and London, 1989.

Sparke, Penny, *As Long as it's Pink: The Sexual Politics of Taste*, Pandora, London, 1995.

Spate, Virginia, *Orphism: The Evolution of Non-Figurative Painting in Paris 1910–1914*, Clarendon Press, Oxford, 1979.

Squiers, Carol (ed.), *The Critical Image: Essays on Contemporary Photography*, Lawrence & Wishart, London, 1991.

Stekel, Wilhelm, *Sexual Aberrations: The Phenomena of Fetishism in Relation to Sex*, John Lane, The Bodley Head Ltd., London, 1934.

Steele, Valerie, *Paris Fashion: A Cultural History*, Oxford University Press, New York and Oxford, 1988.

Storez, M., *L'Architecture et l'art décoratif en France après la guerre: comment préparer leur renaissance*, A. Aubert, Verneuil-sur-Aure, 1915.

Suleiman, Susan Rubin, *Subversive Intent: Gender, Politics, and the Avant-garde*, Harvard University Press, Cambridge (Mass.), 1990.

Sutcliffe, Anthony, *The Autumn of Central Paris: The Defeat of Town Planning 1850–1970*, Edward Arnold, London, 1970.

Tate Gallery, *Degas: Images of Women*, Tate Gallery, Liverpool, 1989.

Tise, Suzanne, 'Les Grands Magasins', in *L'Art de Vivre: Decorative Arts and Design in France 1789–1989* by Catherine Arminjon *et al.*, Thames & Hudson, London, 1989.

Troy, Nancy, *Modernism and the Decorative Arts in France: Art Nouveau to Le Corbusier*, Yale University Press, New Haven and London, 1991.

Underhill, Nancy D. H., *Making Australian Art 1916–49: Sidney Ure Smith Patron and Publisher*, Oxford University Press, Australia, Oxford, New York, etc., 1991.

Valmy-Baysse, Jean, *Tableau des grands magasins*, Nouvelle Revue Française, Paris, 1925.

Van Doesburg, Theo, *Theo van Doesburg: On European Architecture. Complete Essays from 'Het Bouwbedrijf' 1924–1931*, Birkhäuser Verlag, Basle, Berlin and Boston, 1986.

Vauxcelles, Louis, *Histoire générale de l'art français de la Révolution à nos jours*, Librairie de France, Paris, 1922–25.

Verne, Henri and René Chavance, *Pour comprendre l'art décoratif moderne en France*, Hachette, Paris, 1925.

Vidler, Anthony, *The Architectural Uncanny: Essays in the Modern Unhomely*, MIT Press, Cambridge (Mass.) and London, 1992.

Vitou, Élisabeth, Dominique Deshoulières and Hubert Jeanneau, *Gabriel Guévrékian (1900–1970): une autre architecture moderne*, Connivences, Paris, 1987.

Warnod, André, *Les Bals de Paris*, G. Crès, Paris, 1922.

Whiting, Sarah, Edward Mitchell and Greg Lynn, (eds), *Fetish*, Princeton Architectural Journal (vol. 4) and Princeton Architectural Press, New York, 1992.

Wigley, Mark, *White Walls, Designer Dresses: The Fashioning of Modern Architecture*, MIT Press, Cambridge (Mass.) and London, 1995.

Williams, Rosalind H., *Dream Worlds: Mass Consumption in Late Nineteenth-Century France*, University of California Press, Berkeley, Los Angeles and Oxford, 1982 and 1991.

Wilson, Elizabeth, *Adorned in Dreams: Fashion and Modernity*, Virago, London, 1985.

Wilson, Elizabeth, *The Sphinx in the City: Urban Life, the Control of Disorder, and Women*, Virago Press, London, 1991.

Wilson, Robert Forrest, *Paris on Parade*, The Bobbs-Merrill Company, Indianapolis, 1924–25.

Wolff, Janet, *Feminine Sentences: Essays on Women and Culture*, Polity Press, Cambridge, 1990.

Wollen, Peter, *Raiding the Icebox: Reflections on Twentieth-Century Culture*, Verso, London, 1993.

Woodham, J. M., *Twentieth-Century Design*, Oxford University Press, Oxford and New York, 1997.

Zola, Émile, *Ladies' Delight*, Bestseller Library, Paul Elek Ltd, London, 1960.

INDEX

Note: 'n' after a page number indicates the number of a note on that page; illustration numbers are indicated by 'pl.' and are given after page numbers.